Naseej

"In its vivid close-ups of the diverse and dynamic communities for whom Palestine was home, *Naseej* offers both a heart-breaking account of what colonists have cost the world, and a hopeful template for the future. This is the book that *is* Palestine."

—Ahdaf Soueif, novelist

"A remarkable book of creative personal essays, poems, and scholarly investigations that illuminate the wondrous tapestry that was Palestine before the Zionists imposed their vision of exclusionary ethnonationalism and racialized rule. Unrecognizable today, except in subtle vestiges of interwoven lives and shared solidarities, this book reveals how a land could be called home by diverse people and communities of tangled origins, living side by side as neighbors and kin. As Palestinians."

—Lila Abu-Lughod, co-editor of *Nakba: Palestine, 1948, and the Claims of Memory*

Naseej

Life-Weavings of Palestine

Edited by
Arpan Roy and Noura Salahaldeen

PLUTO PRESS

First published 2025 by Pluto Press
New Wing, Somerset House, Strand, London WC2R 1LA
and Pluto Press, Inc.
1930 Village Center Circle, 3-834, Las Vegas, NV 89134

www.plutobooks.com

British Library Cataloguing in Publication Data
A catalogue record for this book is available from the British Library

ISBN 978 0 7453 5084 4 Paperback
ISBN 978 0 7453 5085 1 PDF
ISBN 978 0 7453 5086 8 EPUB

This book is printed on paper suitable for recycling and made from fully managed and sustained forest sources. Logging, pulping and manufacturing processes are expected to conform to the environmental standards of the country of origin.

Typeset by Stanford DTP Services, Northampton, England

Simultaneously printed in the United Kingdom and United States of America

Contents

PART III: TOPOGRAPHIES

PART IV: FAMILIAR PLACES

Figures

Acknowledgments

The editors would like to thank, above all, Rema Hammami for her guidance, patience, and kindness during the weaving of this naseej. We thank also Nadeem Karkabi, Dina Zbeidy, Laura Adwan, Rhoda Kanaaneh, Khaled Furani, and all others at Insaniyyat—the Palestinian Society of Anthropologists—where this book was born. We could not have completed this book without Bisan Samamreh's careful assistance. We are grateful also to Salim Tamari, Lila Abu-Lughod, Jumana Kayyali, Mahmoud Abu Hashhash, Danilyn Rutherford, Penny Mitchell, Adam Talib, Kifah Abdel Halim, Rawan Samamreh, Nadera Shalhoub Kevorkian, Diana Allan, Eman Sharabati, Anne Routon, the A.M. Al-Qattan Foundation, and the Palestinian American Research Center. The wonderful maps that appear at the beginning of each part were hand-drawn by Besan Khamis. Funding for this book was generously provided by Insaniyyat and the Wenner-Gren Foundation. Finally, we thank Tom Etherington for the beautiful book cover that takes inspiration from artwork appearing in a 1976 issue of *Shu'un Falastin*, the Palestinian Liberation Organization's magazine published in Beirut.

BESAN KHAMIS

Introduction*

Arpan Roy and Noura Salahaldeen

In his final poem before he was killed by Israeli bombing in Gaza in December 2023, the poet Refaat al-Areer wrote: "If I must die, you must live to tell my story." We started weaving *Naseej* in 2021, and we finished our weaving in 2024. Our moment in time now is vastly different from our starting point. In the course of these three years, and especially since October 2023, Palestine has ruptured the world. Al-Areer's words have found their way into the consciousness of the world, making way for stories that the people of Palestine tell in poems, in protests, in legends, in music and arts, and in blood.

Al-Areer's story begins long before his poem. It is the Palestinian story, and it begins before the genocide, before the intifadas and the empty peace agreements, and before Zionism and Israel. To faithfully tell the Palestine story is to displace it from its present afflictions. If a construction of the past is merely a projection of the present, as the philosophers say, then Palestine's present also displaces its past. *Naseej: Life-Weavings of Palestine* is an invitation to tell again the Palestinian story, but on our own terms. It is an invitation to recover lost aspects of this story, to articulate the lapses of memory and silences, and to bring forward a grammar and vocabulary to celebrate the diversity in forms of life, and in ways of living, that we feel is true to the Palestinian story. It is because of the subversive position from which we craft this book that we do not have at our disposal an already established vocabulary with which to make our case, neither to the world nor to ourselves. The story, then, requires a substantial prologue.

The Palestine that we have come to know today—reduced, fragmented, but still surviving—is to a great extent the outcome of the now over 150 years-long entanglement with the Zionist settlement project that began in the late nineteenth century. Zionism, as is well known, began as an ethnonational project addressing the Jewish Question in Europe, and all the pogroms, questions of assimilation and modernity, and biblical exegetical baggage that this entailed. But Zionism was always experienced differently by its victims. For Palestinians who were forced to host this project, it was a project of erasure, of flattening differences. It entailed the

* Because the editors of this volume are writing this introduction on behalf of the contributing authors—as well as on behalf of Insaniyyat, the Palestinian Society of Anthropologists—the affective relation to Palestine is narrated from the perspective of a "we," rather than drawing from the individual subjectivities of the two editors that may be "I" or "they," in place of (or in addition to) "we."

shattering of an organic process of a Palestinian national identity-formation based in local idioms during what was otherwise a zeitgeist of burgeoning nationalisms in the world. To *host*, as Jacques Derrida has pointed out, is to be *hostage* of the other.[1] The two words are closely etymologically related, and Palestinians, who hosted the Jews of Europe in their homeland, later became hostages to the imaginary of the guests who were also the colonizers. We do not know what kind of Palestinian society would have emerged had it not been kidnapped by Zionism, but this book dares to imagine the contours of this possibility.

Palestine of the late nineteenth century was a *naseej*, meaning "tapestry" or "woven fabric" in Arabic. It was a part of an Ottoman world of a diversity of communities, languages, and religious belongings. We adopt naseej as the metaphor by which to tell the story of a diversity of forms of life in Palestine, a diversity that nonetheless does not negate the collectivity of the Palestinian people. In Arabic, various terms help conceptualize this collectivity. Two of these are *qawwmi* and *watani*, both of which appear in official Arab and Palestinian discourses on nationalism. Qawwmi, especially since the mid-twentieth century, has typically been used to refer to a pan-Arab nation that transcends modern nation-state boundaries, whereas *watan* is more restricted to a nation contained precisely by these boundaries. The two terms appear in the official literature of the Palestinian Liberation Organization (PLO), which has historically used both terms, each at varying moments, in the title of its national charter.[2] Regardless of whether one draws the line at the level of qawwmi (meaning a transnational Arab nation of which Palestine is a part), or at watani (meaning a nation contained to the boundaries of what has historically been called Palestine), this book argues that modern nationalist language as such obscures a rich experience of heterogeneity latent in the Palestinian story, as it does in the story of the region to which it belongs. The Palestinian naseej, because of its intimate, local nature, cannot be satisfactorily captured by nationalist vocabularies that conceptualize belonging at grandiose levels of geopolitics.

Even more so than the language of nationalism, we distance ourselves from that of the politics of recognition. Often underlined by the term "pluralism," this is a politics closely tied to Euro-American forms of liberal government; forms that aim to produce rigid and essentialized group identities while simultaneously promoting a generic and secular public life—a trajectory that does not reflect the Palestinian or Arab reality.[3] "Diversity" is another possible term, but this is one that increasingly thrives as a marketing strategy in American corporate boardrooms, to the point that it has become void of any real meaning. "Difference" is a philosophical term that is satisfactory on some levels, but because of its generic nature, especially to the untrained ear, perhaps requires considerable elaboration. Although these terms appear in various ways in the contributions in this volume, and also in this introduction, we are hesitant to adopt any one of them as the central concept threading this book. Yet another term is "sectarianism," *ta'ifiya* in Arabic, and is the inverse of pluralism; pluralism gone wrong, as it were. It is the term used in a

recently published major work to describe the evolution of the collective in Arab politics through the centuries.[4] The painful truth of sectarian warfare ravaging the modern histories of countries closely related to Palestine like Lebanon and Iraq— the consequence of centuries of European intervention and more recent extractivist American imperialism—is undeniable. But sectarianism as such is one affliction, at least, that has spared Palestine.

Naseej takes a more intimate approach. In Palestinian Arabic, two terms that describe social relations and belonging to a collective are *sha'b*, meaning "people," and *ahl*, loosely translatable as "people of" or "family." Sha'b overlaps into official discourse, but it also just as often expresses peoplehood *against* official discourses, decrees, and regimes. It has a connotation of "common people," meaning a collectivity that tears through class boundaries, and is the autonym *par excellence* at protest demonstrations across the Arab world to redress regimes or elites that do not represent the common good. We do not negate the vitality of the word sha'b to Arab politics or affects, but we continue looking deeper into Arabic, and into the ways in which Arabic gives expression to the heterogeneity of the Palestinian experience in all its intimacy and subtlety. Ahl, unlike sha'b, does not seep into official discourse. It is particularly intimate, and is rich in its capacity to convey complex layers and levels of belonging, from kinship and clan, houses and other material structures (*ahl al-dar*, "dwellers of the house"), geographical locales and units (*ahl al-qarya*, "inhabitants of the village") and national belonging (*ahl al-balad*, "people of the country"). The term is also central in the Qur'an, in which it is used to refer to the household of the Prophet Mohammed, and to monotheists of previous revelations. Ahl also morphologically inflects into *ma'hul*, a word denoting a place that is inhabited and flourishing with inhabitants, and it also welcomes a visitor to a place instantly made familiar, best exemplified by the Arabic greeting *ahlan wa sahlan*.

In Palestine, which has for millennia been a crossroads for travelers, migrants, seekers of refuge, merchants, and pilgrims, the arriving stranger was always told: *ahlan wa sahlan*. Through this the stranger was made familiar, and adopted into a local mode of belonging that we explore through the eighteen contributions in this book. It is this model of the stranger becoming familiar, even family, that has made Palestine into a naseej.

* * *

The Palestinian naseej came to being through centuries of civilizational exchange, and through (and in spite of) the governing sensibilities of different empires ruling over Palestine and its surroundings. For approximately 400 years, the Ottoman Empire governed using the concept of *millet*, literally meaning "nation," but effectively denoting "religious community." Despite being a caliphate, meaning the political seat of Islam in the world (albeit contentious), the Ottoman Empire was arguably also the predecessor to a liberal politics of recognition. The Ottoman

millet system granted minority rights to Christians and Jews in their empire in a way that was anomalous in a Christian Europe that for centuries abided by the Catholic dogma of *un roi, une loi, une foi*.[5] What distinguishes the millet system is that it is not citizenship on the basis of *jus soli* or *jus sanguinis*, but rather, a form of Islamic governance rooted in how the Islamic legal tradition outlined the treatment of non-Muslims, dating as far back as what is known as the Constitution of Medina, a treaty drafted between the Prophet Mohammed and non-Muslim Arabian tribes in 622–624 CE. On another level, the Ottoman millet system was a realist adaptation to the facticity of administering a cosmopolitan empire, in an interconnected world in some ways more resembling ours than that of previous empires, and without imposing the abject violence of permanent apartheid.

Although sometimes criticized retroactively by liberal logic for a majority/minority political structure based around religion, it is nonetheless important to note that sectarian purges like the expulsion of Jews from England in 1290 or the Spanish Inquisition in the fifteenth and sixteenth centuries simply did not occur in the Ottoman Empire. Only during the empire's rapid decline and ultimate collapse did preexisting communal tensions find expression in massacres.[6] A partial list of this deteriorated coexistence includes anti-Christian pogroms in Damascus in 1860, and later the genocide of the Armenians and the deportation of Syriac and Rum Orthodox Christians during the transition from caliphate to the modern Turkish state—events that ricocheted into the social and political makeup of post-Ottoman territories, including Palestine. In these territories, the diversity in forms of life extinguished in parts of Turkey still survives. It is important to note here that Palestine has historically welcomed both Muslims and non-Muslims into its fold, like Armenian Christians fleeing genocide, or a century prior, Circassian Muslims escaping persecution from the Russian Empire. *Naseej* collects such stories: Antranik Cassem in his contribution to this volume explores the trajectories of the descendants of these Armenian refugees in Palestine in an interview with Dr. Gaby Kevorkian, a Palestinian-Armenian doctor from Jerusalem, and Hawa Batwash offers a beautiful literary account of the founding of Kafr Kama, a Circassian village in the Galilee. At the same time, the sealing of Palestine's historically open borders since 1948 and the subsequent Israeli control of movement and migration has produced a certain restricted localness—a sealing off of a history of comings and goings of the people of the world.

* * *

The overview of the Ottoman millet system discussed above is cursory, leaving out various intricacies and exceptions. The point to make here is that the Ottomans conceived of difference in religious terms. However, in 1908, at the tail end of major reforms, the Ottomans overturned the millet system and offered universal Ottoman citizenship to their subjects. It was a turn away from politics organized along religious lines, and an effort to incorporate the Ottoman state into the emerging liberal

world order. But the Ottoman Empire fell in 1922, and subsequent regimes that ruled over Palestine revived the logic of the millet.

The first official census of what is today understood as "Historic Palestine," with its almost universally recognizable borders, follows a millet logic. Taken in 1922 by the British Mandate government,[7] Palestine's population of 757,182 individuals was demographically divided into categories of 590,890 Muslims, 83,794 Jews, 73,024 Christians, and 7,617 "Others," consisting of religious groups like Druze, Samaritans, Shi'a Metawalis and Baha'is, and curiously, 408 Sikh laborers imported from British India. There are contexts behind these numbers. Approximately half the Jews in the census were Zionist settlers who arrived in Palestine during the so-called Second Aliyah in the decades prior. Many Palestinian Christians had also by that point begun leaving their towns and villages for entrepreneurial reasons, seeking their fortunes in the Americas and elsewhere, and thus reducing their absolute numbers in a period of exponential population growth.[8] Such details aside, the wider context—and the point that we would like to make—is that the logic used by the British in collecting data for a census as such inherited existing standards of government from their Ottoman predecessors, ones that conceived of society as organized by religious groups. Where the British departed from the Ottomans, however, was issuing identity documents classifying two national groups: "Arab" and "Jew," a new typology that created new antagonisms while also giving unprecedented legitimacy to the European Jewish settlers. These new categories also had unprecedented consequences for Palestinians, as the generic category of "Arab" was not one discursively tied to any clearly defined territory, whereas the Jews, as per the Balfour Declaration of 1917, were decreed a nation entitled to a national home in Palestine. Locally, it disentangled Jewish religion from Arabness for perhaps the first time in history.[9] Julia Elyachar's contribution offers a portrait of her grandfather, a Palestinian Jew from Jerusalem, whose religious identity became subsumed by a new national identity at a great emotional price.

Israel succeeded the British in governing with millet logic, albeit with differences. Burdened with the colonial responsibility of administering personal status laws and granting the basics of religious freedom to its colonized subject population, Israel recognizes the following categories of "non-Jews" in its legal apparatus: Sunni Muslims, two sects of Eastern Orthodox Christians, five sects of Catholics, two Armenian Churches, Druze, the Evangelical Episcopal Christians, and Baha'i. It also created new national categories based on religion, like "Aramean,"[10] meaning those who draw from an Aramaic-speaking Christian heritage pre-dating Islam, in an attempt to further jeopardize the expression of a Palestinian nation. Israel's vassal regime in the West Bank, the Palestinian Authority, also recognizes 13 Christian denominations under its nominal jurisdiction—moves made since the establishment of semi-autonomous rule in the Palestinian territories in the 1990s as per the Oslo Accords.

This book is a rejoinder to such modes of conceiving difference in Palestine. It is a rejoinder both to these historical conceptions determined by top-down political forces as in the book-keeping of empires, and also to religion as the only category by which to conceptualize the heterogeneity of the Palestinian naseej. We acknowledge the richness of the religious traditions mentioned above and their contributions to the Palestinian naseej, but we ask: What other means of difference did Palestinians historically encounter, and continue to encounter, and negotiate in everyday life? Moreover, what were the forms of life not only "found" in Palestine as such, but also created by Palestinians? Christianity is only one instance of religious life emerging natively from Palestinian soil—and, as such, is an instance of Palestinian creativity. There are more, and this book is an invitation to inaugurate long-neglected discussions of not only Palestinian identity, but also Palestinian creativity.

* * *

Naseej is an alternative to millet logic. But there are two possible ways to conceive this alternative. One is a "vertical" naseej, which, as per our metaphor, is layer upon layer of threads, like an embroidery. The second is "horizontal," in which the threads weave across the expanse of the fabric that is the land. The first of these, the vertical naseej, is Palestine as an accumulation of its pasts, of the successive peoples and empires (both great and small) that have dwelled in Palestine since the earliest historical records. A partial list of this includes Canaanites, Jebusites, Philistines, Phoenicians, Israelites, Romans, Byzantines, Umayyads and Abbasids, Fatimids and Ayyubids, Ottomans, all of which weave into the modern Palestinian Arab. This is a fairly uncontroversial position, consistently maintained by Palestinian intellectuals for at least a century, from folklorists in the 1920s and 1930s like Tawfiq Canaan and Stephan Hanna Stephan to later intellectual giants like Edward Said and Mahmoud Darwish. Khaldun Bshara in this volume asks what remains of the material culture left behind by these previous iterations of Palestinians.

The second, "horizontal," naseej, is the raison d'être of this book. This is a difficult endeavor because, again, our project does not build on existing vocabularies or bibliographies. We have already overviewed the insufficiency of existing terminologies, as well as the reluctance of Palestinian intellectuals to directly engage with the questions that our project raises.[11] A remarkable poem by Najwan Darwish in this volume is an exception to this. There are more exceptions, if one knows where and how to look—not so much in the form of a clear treatise, but as linings in the crevices of the Palestinian story.

Because *Naseej* is an exploration of difference in places and forms of life where it is not obvious, we find inspiration from the Indian social theorist Ashis Nandy, following whom we propose a certain "mnemonic difference" in how the Palestinian naseej has woven together over centuries.[12] Mnemonic difference is intimate in nature, and deeply rooted in centuries of living together, learning one another's signs, internalizing them, often without verbal expression, and transmitting this

intimate knowledge of oneself and the other across generations. On the street and in public, mnemonic difference is, so to say, *not a big deal*; it is *just there*, as an everyday experience of the social, in contrast to contemporary standards of announcing one's own cultural singularity, as promoted by American identity politics and liberal multiculturalism. This is part of the reason why the Palestinian naseej has not been sociologically articulated. Rather, mnemonic difference, as Nandy writes, is "memory-driven," and that which covers "our intimate relationships, private hatreds, traumatic or life-altering experiences, dreams and encounters with the sacred."[13] In a sense, this difference is part and parcel of the social, in the way that one's childhood is forever part of the unconscious, but which does not easily find expression in speech and language. To limit this secret self to mere religious difference, as millet logic and liberalism both have done, is nothing more than a vulgar reductionism.

Nor is mnemonic difference accessible to statist projects. Take, for instance, the aforementioned PLO charter, arguably the first official manifesto to have considered who or what is Palestinian. Drafted in 1964, the PLO charter took a regional perspective on who is a Palestinian, confirming that anyone with normal residence in Palestine is a Palestinian, in the same way that anyone who lives in France may be French or who lives in Mexico may be Mexican, without the ideological qualifications of a national identity based on religion or kinship ties. This is nowhere clearer in the charter than in its specification that Jews who lived in Palestine before the advent of Zionism would be eligible for Palestinian nationality. In their contribution, Jumana Manna and Saleem al-Bahloly discuss exactly this complexity of different Jewish communities in Palestine having had different orientations and affects, even those who arrived as late as the nineteenth century, and not all belonged to the settler-colonial project. Later, however, in a revision to the charter after the Oslo Accord of 1993, when Palestinians were (falsely) promised some version of statehood, this clause specifying a place for Palestinian Jews in the Palestinian nation was removed. Removal of the possibility of a Palestine with Jews—that is, Arab Jews who had lived with their Muslim and Christian neighbors for centuries, and those who did not come as colonizers—signaled a victory for Zionism to the extent that it reaffirmed Judaism and Jewishness as an ethnonational category external to the Palestinian Arab. For us it was a loss, as being a Palestinian became an endemic category, and a possible Palestine based on regional openness became—at least for now—strictly mnemonic.

* * *

Naseej collects the work of historians, poets, visual artists, architects, dramaturgists, storytellers, archivists, and more, but above all it is a work of anthropological imagination. It privileges anthropology—the science of experience—in its mode of narrating the intricacies and untold stories of the Palestinian naseej. Crucially, it is not an inventory of the various communities and groups that one finds in Palestine. If it were this, then several groups would be missing. Rather, it looks to sensitivities,

subtleties, and intimacies, and pays attention to minor details of everyday life and experience to tell the Palestinian story anew.

The eighteen contributions in this book are divided into four thematic parts. Part I, "Itineraries," begins with a riveting poem by Najwan Darwish, in which the poet traces a history of migrations to Palestine from Southern Europe, the Caucasus, Central Asia, and more—all of which is filtered through an Arabic lifeworld that gave shape to the Palestinian naseej. The part then continues to explore these lines of flight. Noura Salahaldeen follows the lives and journeys of three members of the African community of Jerusalem. Traveling alongside these three individuals, the essay crosses into Egypt and Jordan, seeking to find movements and continuities of people, communities, and ideas between Jerusalem and elsewhere in the region. Following this itinerary, Arpan Roy traces what remains of Romani communities in Palestine today, and some of the itineraries of Palestinian Romanies also to Egypt and Jordan after the expulsions of 1948 and 1967—expulsions that affected Romani people no less than any other "kind" of Palestinian. These essays by Salahaldeen and Roy make the case for Palestine having been an essential node for travelers and nomadic communities of the region—a node that has been severed from its surroundings by the advent of Israel. Turning the focus back to Jerusalem, Antranik Cassem, a literary scholar and translator of Iraqi-Armenian heritage, interviews Dr. Gaby Kervorkian, a Palestinian-Armenian doctor from Jerusalem. In the wide-ranging discussion, the two go in depth into Dr. Kevorkian's life trajectory as a medical student in the Armenian Soviet Socialist Republic, and as an activist for Palestinian liberation both there and in Lebanon. Through this life trajectory, we get a nuanced history of the Armenian community in Jerusalem, and a unique vantage point on the place of Armenians in Palestinian nationalist movements. Closing Part I, Intimaa Alsdudi and Hadeel Assali offer a portrait of a man named Abu Fahad al-Hamidi, nicknamed "Ibn Battuta" after the famous medieval traveler. Abu Fahad is a Tarabin Bedouin living in the buffer zone of the southern Gaza Strip, but is also known as Ibn Battuta because of his extensive travels and wisdom. A bearer of both ancestral knowledge and modern university degrees, his travel stories highlight the ways in which he navigates multiple identities as a trickster to bypass checkpoints and borders, drawing on an unconventional knowledge of geography and social relations. A cosmopolitan Gazan, but also a Bedouin steadfastly holding onto his land, Abu Fahad demonstrates the richness of an identity that is rooted in Palestine while also an accumulation of itineraries in motion.

Part II, "Directions of Prayer," explores the centrality of Palestine as a destination for pilgrimage and as a hub for spirituality. In the first essay in this part, Tyler Kynn shares vignettes from his research on Muslim pilgrims from medieval India to Mecca and Palestine. Visiting Jerusalem and Hebron in tandem with performing the hajj, Indian pilgrims would be a common and accepted part of medieval Palestine's social fabric. Exploring other aspects of this theme, in their contribution Dalal Odeh and Eman Alyan embark on a journey through their native Jerusalem,

focusing on the living remnants of three Sufi lodges (*zawaya*), each having origins in Islam's Persianate "East"—Bukhara, Afghanistan, and India. Odeh and Alyan document aspects of this past and present with special attention to the biographies of the contemporary descendants of the lodges' long-time custodian families. In his essay, Salim Tamari discusses the contested shrine of Simon the Just, the last high priest of the Jewish Temple of antiquity, in the Sheikh Jarrah neighborhood of Jerusalem. Simon's shrine once hosted an annual festival with participation from not only Jews but also Muslims and Christians, and Tamari carefully illustrates this history of shared communal life in Palestine that was lost after Zionism—a stark contrast to a contemporary Jerusalem where the sanctity of the shrine is exploited to establish a Jewish majority in the area. Closing Part II, Amir Odeh presents scenes from the past and present of the Ahmadiyya Muslim community of Palestine. Originating in the village of N'ilin, located in the present-day West Bank, but following an ostensibly Indian form of Islam, this community today resides on Mt. Carmel in Haifa. The essay illuminates the community's genealogical roots, religious conversion and expansion, domestic architecture, fabric of social relations, economic life, and political positioning in the context of the Israeli state's peculiar version of "multiculturalism."

Part III, "Topographies," delves into the vertical layers of the Palestinian naseej. Aamer Ibraheem invites the reader to reimagine Palestine from the standpoint of one of its neighboring regions—the Syrian Golan Heights. Ibrahim engages with a doctoral thesis written by Adib Souleiman Bagh, a Golani geographer, translating a key passage and offering poignant introductory remarks that situate the Palestinian naseej in a regional context. In the next essay, Khaldun Bshara underlines the particularities of Palestinian heritage buildings, and the historical, civilizational and class-based components that have produced similar but not quite the "same" built heritage across history. Following Bshara's contribution, we reprint Yugoslav anthropologist Nina Sefrović's 1981 study of a Bosniak community that settled in Caesarea, on the Palestinian coast, in the late eighteenth century. The study was originally written in Serbo-Croatian and is reprinted here in translation. The final essay in Part III is a conversation between artist Jumana Manna and anthropologist Saleem al-Bahloly in which the two discuss Manna's film on musical traditions in Palestine. Because the film was based on Jewish archives and draws from the work of a researcher closely associated with the Zionist project, the two discuss the traps inherent in using enemy archives in constructing the Palestinian story. The two also discuss the complex history of Arab Jews in Palestine, focusing especially on Zionism's later expansion to include Jews from the wider Middle East as part of what had initially been an European settlement project.

Part IV, "Familiar Places," brings *Naseej* into the intimate spaces of family life in Palestine. Set in an erased Bedouin village in the vicinity of Haifa, Sheikha Hussein Helawy offers a short story recounting an elderly woman's love for the legendary Egyptian singer Umm Kulthum, and intersperses this story with a coming-of-age

story of her granddaughter. In the next contribution, Maisan Hamdan shares a section from her novel on the conflicts and complexities of Druze communities in Palestine, focusing on the prison experience of a young man who refuses to follow an order while serving in the Israeli military. Next, Radi Shehadeh narrates the establishment of a theater in al-Maghar, a village in the Galilee with a religiously mixed population of Muslims, Christians, and Druze. Shehadeh offers a philosophical account of how a group of rebellious youth push social norms and boundaries, and pave the way for cultural life in the village. In the next contribution, Hawa Batwash shares a piece of short fiction that brings to life the Circassian migration to her native village of Kafr Kama in the Galilee, founded in 1878 after the expulsion of many Muslims from the Russian Empire. Lastly, Julia Elyachar writes about the life of her Jewish grandfather in pre-1948 Palestine. Elyachar's grandfather grew up in Jerusalem before emigrating to the United States after the establishment of Israel. Coming back to visit his hometown decades later, the now elderly grandfather could no longer recognize the city of his childhood. Through a very personal and emotive register, Elyachar asks what may have been lost of Jewish life in Palestine after the ruptures of Zionism and Nakba.

<p style="text-align:center">* * *</p>

There is one final point to make in considering the historical arc of the Palestinian naseej. This is that the Palestinian naseej, in both its vertical and horizontal axes, was irreversibly shaped by the arrival of Islam and (especially) by its Arab bearers in 637 CE. Ostensibly a linguistic identity rooted in the Arabic language, an "Arab" is an individual who speaks Arabic in any of its dialectic variations, but is at the same time bound to other Arabic-speakers through the shared formal register of al-fusha,[14] through the classical language of the Qur'an regardless of belonging or non-belonging to Islam, and more recently, a shared experience of colonialism and imperialism in the Arab region in its French, British, Italian, Israeli, and American varieties. If one is to accept this partial view of Arabness—for there is surely more to the story—then there are at least two important consequences. For one, because of its essentially decentralized linguistic nature, the "Arab" component of the "Palestinian Arab" does not negate any of the other "layers" of the Palestinian naseej, whether they be religious, civilizational, mnemonic, or even linguistic. On the contrary, it is precisely the Arabness of Palestine that is the reason why the Palestinian naseej is able to accommodate layer upon layer of forms of life. This is as true in Palestine as it is elsewhere in the Arab world. Here we take pride in the inclusivity of Arabness over the bigoted techniques of belonging practiced by our colonizers.

It is also true that the permissibility of Arabness lends itself to a certain plasticity. It is an identity that is responsive, at times, to cultural and political signs of the times; and we cannot deny the plurality of interpretations of what Arabness means to a given people at a given moment in time.[15] There is no consensus on the matter nor easy way out, but we find solace in the poem by Najwan Darwish, in which the

poet traces the lines of flight of Arabness through Kurdistan, Armenia, Anatolia, North Africa, Andalusia, the Hijaz, Shiraz, Isfahan, and Bukhara. He writes: "And by anything less than this, one is not an Arab." These lines of flight also land in the pages of this book.

The second consequence of the unique parameters of Arabness is the reverberation of Palestine's colonial present wherever Arabic is spoken. Palestine is the last major European colony remaining in the Arab region, and arguably the world. The immense pain that this reality generates for other Arabs is difficult for non-Arabs to grasp. In this sense, it is the Palestinian experience of colonialism that helps sustain a continuity of Arab unity, for the assault on Palestinian existence is an assault on all Arab existence.

But Palestine is not only pain and suffering. It is also creativity, it is an encounter with the sacred, it is lines of flight from Kurdistan to Bukhara, it is hosting the otherness of others. It is everything that has been denied to a people but that which, with the incomparable pleasure of the forbidden, the same people continue to register in their mnemonic ledger and preserve for generations ahead to inherit, like a piece of jewelry passed down a family line but, for now, locked away.

Refaat Al-Areer wrote prior to his martyrdom: "If I must die, you must live to tell my story." *Naseej* is a collection of story after story, from Gaza, Jerusalem, Haifa, Nablus, the Galilee, the Naqab, and from elsewhere in a world that has turned its eyes toward Palestine. We tell these stories keeping Al-Areer's words in mind, as they are also his story, and so that his last poem was not written in vain. The "you" that Al-Areer entrusts with his story is not a stranger, but someone who is familiar, someone who is entrusted with a family heirloom or treasure. This "you" belongs to the "we" with which we have weaved *Naseej*.

NOTES

1. Jacques Derrida, *Acts of Religion* (London: Routledge, 2002). The observation works in both French and English.
2. Iterations of Palestine's national charter: *Al-mithaq al-qawwmi al-filasteeni* (1964), and the revision, *Al-mithaq al-watani al-filasteeni* (1968).
3. For the problems in the wholesale adopting of Western models of secular liberalism in the Arab world, see Saba Mahmood, *Religious Difference in a Secular Age: A Minority Report* (Princeton, NJ: Princeton University Press, 2015).
4. Azmi Bishara, *Sectarianism without Sects* (Oxford, UK: Oxford University Press, 2021).
5. "Un roi, une loi, une foi" ("One king, one law, one faith") was the motto of Louis XIV.
6. For a comprehensive overview of this topic, see Ussama Makdisi, *Age of Coexistence: Ecumenical Frame and the Making of the Modern Arab World* (Berkeley, CA: University of California Press, 2020).
7. See https://archive.org/details/PalestineCensus1922.
8. On the topic of exponential population growth in the period in question, see Edward Hagopian and A.B. Zahlan, "Palestine's Arab Population: The Demography of the Palestinians," *Journal of Palestine Studies*, 3(4) (1974): 32–73.

9. For more on the Arab Jew, see Ella Shohat, *On the Arab-Jew, Palestine, and Other Displacements: Selected Writings* (London: Pluto Press, 2017).

10. In 2014, Israel recognized Arameans as a national group. Previously, those eligible for Aramean nationality had been classified as "Arabs."

11. Darryl Li, in an article in the *Journal of Palestine Studies* published in 2015, comes closest to doing this. See Darryl Li, "The Herzegovinian Muslim Colony in Caesarea," *Journal of Palestine Studies*, 45(1) (2015): 69–92.

12. An extensive discussion of mnemonic difference is provided in: Arpan Roy, *Relative Strangers: Romani Kinship and Palestinian Difference* (Toronto, Canada: University of Toronto Press, 2024).

13. Ashis Nandy, "Memory Work," *Inter-Asia Cultural Studies*, 16(4) (2015): 598–606.

14. *Al-fusha*, meaning "the most elegant," is the formal register of Arabic print and media that is usually known in English as "Modern Standard Arabic."

15. For instance, on the tensions between Arab identity and Amazigh identity in Morocco, see Bruce Maddy-Weitzman, *Amazigh Politics in the Wake of the Arab Spring* (Austin, TX: University of Texas Press, 2022).

PART I

Itineraries

1
Identity Card[*]

Najwan Darwish

Despite—as my friends joke—the Kurds being famous for their severity, I was gentler than a summer breeze as I embraced my brothers in the four corners of the world.
And I was the Armenian who did not believe the tears beneath the eyelids of history's snow that covers both the murdered and the murderers.

Is it so much, after all that has happened, to drop my poetry in the mud?

In every case I was a Syrian from Bethlehem raising the words of my Armenian brother, and a Turk from Konya entering the gate of Damascus.
And a little while ago I arrived in Bayadir Wadi al-Sir and was welcomed by the breeze, the breeze that alone knew the meaning of a man coming from the Caucasus Mountains, his only companions his dignity and the bones of his ancestors.
And when my heart first tread on Algerian soil, I did not doubt for a moment that I was an Amazigh.

Everywhere I went they thought I was an Iraqi, and they were not wrong in this.
And often I considered myself an Egyptian living and dying time and again by the Nile with my African forebears.
But above anything I was an Aramaean. It is no wonder that my uncles were Byzantines, and that I was a Hijazi child coddled by Umar and Sophronius when Jerusalem was opened.

There is no place that resisted its invaders except that I was one of its people; there is no free man to whom I am not bound in kinship, and there is no single tree or cloud to which I am not indebted. And my scorn for Zionists will not prevent me from saying that I was a Jew expelled from Andalusia, and that I still weave meaning from the light of that setting sun.

[*] Translated from the Arabic by Kareem James Abu-Zeid.

In my house there is a window that opens onto Greece, an icon that points to Russia,
a sweet scent forever drifting from Hijaz,
and a mirror: No sooner do I stand before it than I see myself immersed in spring-
time in the gardens of Shiraz, and Isfahan, and Bukhara.

And by anything less than this, one is not an Arab.

2
Tales and Imaginaries from a Traveling City

Noura Salahaldeen

At the time of contemplating and writing this text, two events occurred: the first is the birth of baby Lilas, grandchild of the late Omar Bernawi, the second, the death of Fatima Bernawi. Between this birth and death, the journey of al-Jaliya comes to life. To this journey, to this new life, and to the memory of the fierce Fatima Bernawi, I dedicate this text.

Implanted in the Old City of Jerusalem, this essay began its life as an endeavor of writing and exploring the travels of the African community of Jerusalem, al-Jaliya al-Afriqiya, following its members. It unfolded as a tale of Jerusalem, its travels and travelers. The city and its dwellers bleed into one another, forming a location inhabited through geographies of belonging, repudiating topographies of alienation and erasure. This location viewed as a fractured mirror reflects at, onto, and into its own distortions, emulating imag/es/inations within and without. The following passages are those of roots, routes, journeys, homes, exiles.

CAIRO: UNDER NASSER'S EYES

I sat at the edge of a bed recounting the events of the previous day. A poster celebrating Gamal Abdel Nasser's 100th birthday anniversary from 2018 hangs on the bedroom door. As typical of commemorative pictures of Nasser; his gaze leaps toward a vast horizon, only for it to sadly bounce off the bright pink bedroom wall. While he looked over the room, his eyes missed me by a few decades and some centimeters.

Nasser had some company in that Cairene apartment; other portraits and pictures displayed on the walls of my hostess's apartment indicated a life that surpassed the bounds of a single existence, and transgressed the folds of time and space. Fatima Bernawi's life as observed on walls and table tops contained dualities that not many people could withstand.

In the living room, Fatima smiled behind a desk in a blue police uniform. Her husband, Akka's Fawzi al-Nimer, stood next to her while celebrating his release in Tunisia in the 1980s. Yasser Arafat watched over the couple's *katb kitab* (marriage ceremony) agreement. Fatima stood between her mother and Othman, her oldest brother, who had been exiled to Cairo with Hajj Amin al-Husseini.[1] A young, smiling Fatima with her head tilted sideways as she posed for the camera while

17

being escorted by a police officer and a man in dark sunglasses who seemed to be a Shin Bet agent. In that particular moment, captured on the day of her arrest, as Fatima recalled, she was wearing her fanciest piece of clothing, a knee-length white dress, and her most prized pair of shoes.

Earlier that evening, it occurred to me that "Bernawi" had always seemed to be something of a middle name, always followed by "the bombing of cinema Sahioun" or "the first Palestinian woman prisoner." She spread tens of pictures on the small coffee table in front of us, and in these pictures Fatima Bernawi unfolded. The fighter, the *fida'i*, the nurse, the police woman, the prisoner and the jailer, the sister of Ihsan Bernawi, the child of the Nigerian Mohammed Bernawi and the Jordanian Sarah, the exiled and the returnee, the Jerusalemite, the daughter of al-Jaliya al-Afriqiya, the loyal Fatah member, the friend of Yasser Arafat.

Each picture told a story, brought jokes, curses, laughter, tears, nostalgia, and heartbreaks; and Fatima was a determined storyteller that evening. The 1990s Egyptian television program *Hawanem Garden City* played in the background. I held a picture of two seated elderly black men. Both of the men wore white keffiyehs, accompanied by two smiling teenage girls sitting in between them under a white tin roof. One of the men was smiling, the other looked away. I asked her who these people were. They were her father, her uncle, and her sister and niece. Behind them a row of men and women sat under that same tin roof, waiting to visit their imprisoned loved ones in Ramla prison.

Ramla is close to the Mediterranean. The heat and humidity of that bedroom in Cairo, reflected off that prison roof in the picture. Ramla's prison was built as a palace in 1934 during the British mandate, almost five years before Fatima was born, and not too long after Mohammed, the father, had arrived in Jerusalem. Fatima always called her home in Jerusalem "the prison," but I am not sure if she was aware that her prison was a palace, nor if her father had ever heard of Eichmann, who saw his last days at the same palace complex.

While the way from Ramla to Tunisia was a few steps in the direction of the living room, with quite a long stop in Beirut, the way to Abuja was much closer. Abuja was hidden behind a couple of pictures on the same table. Fatima sitting next to Miryam Abacha, wearing an embroidered shawl given to her by Fatima. Fatima's visit to Nigeria as a member of the PLO left a mark on her. Fatima had an official state welcome, and was celebrated as a local hero. She met with the president and his wife, she went to her father's village, she met the "Amir," and she brought back a Nigerian passport.

I wondered if this too was a return, by way of the PLO, or was the return to Gaza via Oslo her only return? Were they both returns? But Gaza is not Jerusalem, and after almost eleven years in prison, and many more in Lebanon and Tunisia, her return to Jerusalem remained transient.

Fatima took her last trip in November 2022, and Nasser's eyes were finally buried under Gaza's sands.

AL-QUDS: MAHMOUD TOURS UNINTERRUPTED

Message 1: "Good morning, I am stuck in traffic. I need a bit more time to reach you. Are you already in your office? If the group reaches you before me, go ahead with the tour. I will catch up with you."
Message 2: "I am in my office. The group is running late. They are still in Ramallah."
Message 3: "Great! I am almost there."

I parked the car and rushed down Nablus Road, toward the Old City, to meet Mahmoud before the tourists arrived. Most of my meetings with him start in Bab al-Amud,[2] with its large, open wooden gates, the frisking of children and young men, the produce sellers, the green and blue carts carrying merchandise, drivers pushing them from the back yelling: "Ya walad! Ya binet!" Mahmoud Jiddah sits in his self-proclaimed "office"—the stone terrace across from the new checkpoint at Bab al-Amud—in an elaborate invisibility among floods of tour guides carrying their maps and documents. He is also armed with those, but I have rarely seen him use them.

Since our tourists were still in Ramallah, we had some time to have juice and coffee. As always, I took the opportunity to ask him some questions. Thankfully my intrusiveness never seemed to bother him. This time my curiosity revolved around his work as a tour guide. He responded in his usual poetic sense: "We closed our eyes and I would walk them through the Old City. I know every alley in it. I would build a map. We would imagine the smells, the sounds, the tastes, the food."

As all of our meetings began at the office, so began most of his stories in jail, a place he entered when he was 18 and unexpectedly left in the middle of his thirties through a prisoner exchange. Since his release he had not stopped walking. I have always noted that he walks the Old City with a particular ease and lightness that makes it seem like the paths move under his feet by themselves. Sometimes Jerusalem acts as if it knows its inhabitants. The city predicts his movements and allows itself to bend to his will, his steps never forceful on its grounds. Whether we are climbing stairs or going uphill to Bab al-Jadid,[3] the city is not heavy under his feet.

Our European tourists, our freshly arrived development consultants in Ramallah, finally reached Bab al-Amud. We had been waiting for almost an hour. It was their first time in the Old City. They apologized for being late; apparently, they still did not know their way "around" Qalandia checkpoint,[4] so they went through it. Mahmoud introduced himself as their tour guide, and introduced me as his assistant tour guide.

We began the tour with the remains of the 1967 War: bullet holes on historical walls. We stood inside the entryway to the Old City. It was too sunny outside. One of the tourists asked Mahmoud about his origins. Having anticipated the question, he pointed his finger toward the Old City and playfully answered "Little Africa." Mahmoud smiled as he knowingly puzzled them:

Yes, Little Africa, that's where I am from. You see, Jerusalem is the center of the world. Everyone is here. The African community's neighborhood is here, we have the Indian Zawiya here, the Armenian quarter, the Moroccans had their own neighborhood, but not anymore, and we have *nuris*[5] in Bab Hutta. It is truly a mosaic. We have everyone here. All of this is in less than one square kilometer. Can you imagine?!

Mahmoud constantly asked me if I could imagine. *Tkhayali.*[6] He walked all the way from here to Amman. *Tkhayali*, when the war broke out[7] my legs carried me from al-Eizariya. *Tkhayali.* The Jordanians refused to give me a passport. *Tkhayali.* No one used to lock their doors in the old days. *Tkhayali.* My comrade took it upon himself that we were caught and arrested. *Tkhayali.* How our mothers looked at those Jaffa oranges the soldiers gave us in 1967. *Tkhayali.* Bashir and I wanted to fight right here. *Tkhayali.* The French ambassador wanted to move Ali and me to France or Chad or some other place. *Tkhayali.* How hard it was to get a ball to play football. *Tkhayali*, the first time we saw a tomato in jail. Was he asking me to imagine or to call into being shadows and spirits? Will those 17 years ever be restored into reality? Will the 18 before them stay in the realms of shadows? Are they imaginaries or are they *khayalat*?[8] These are questions I do not dare to ask.

The tourists did not need to "imagine" for much longer. We passed the star that shows where the *amud*[9] of Bab al-Amud used to be. Ali is sitting at the coffee shop on the right. We walk toward al-Wad Street, with its shops selling colorful candies on either side. But this time it was a tour of lost houses and multi-lock doors. While guiding us through beautiful architectural eras, we heard stories of house takeovers by Jewish settlers. Sometimes these stories had elements of scandals, and can only be partially told. The group wanted to go to Little Africa, but I could not join on that particular day. I disappeared into another crowd, a crowd that stood at the checkpoint in front of the neighborhood spying on Hawa's merchandise. I am not sure what the Israeli guide told them at that point in their tour, but he surely did not call it Little Africa, nor did he call Bab al-Almud his office. Even though I did not continue with Mahmoud's group that day, I have had enough experience with Mahmoud's tours to be able to imagine the details that Mahmoud must have narrated. He probably explained that the African community neighborhood is a rather small street right outside of al-Majlis al-Islami al-A'ala[10] gate to al-Aqsa Mosque, and is home to about 350 people, mostly Africans originating from Chad, Nigeria, Sudan, and Senegal (and, to Mahmoud's amusement, from Hebron[11]). The two old Ottoman prisons across the street from one another are home to the community. They are the heart of the neighborhood.

I remember my first visit to the neighborhood. I remember Ali in his house saying that he was born in a prison. I remember my first visit with Mahmoud. I remember the tree in the middle of the courtyard, the smells of Friday lunches, and the sound of gossip in languages unknown, I remember Fatima's room, piles of

peanuts for the roaster, stories unrecorded, donkeys standing next to a shop, buildings being renovated, boys playing football in between the two prisons, kicking the ball inside the mosque, the gunmen goal keepers couldn't catch, streetlights where children learn to read, the community center and its youth, and black skin that acts as a blue identity card.[12]

Toward the end of his tours, as he walks groups back outside, leaving the Old City cosmos, Mahmoud usually says one of two things, or both:

1. "If you didn't take enough pictures, I can show you to the local police station, there you will find your visit on tape. Please ask for a copy."
2. "All of these places and communities, are tesserae in the mosaic called the Old City of Jerusalem":

> ... but sometimes we take routes in silence. A silence that is encapsulated in the mundanity of Jerusalem's everyday life, a silence that allows for the route to unfold into new events for our senses to grasp. And when we get tired of walking these non-horizontal routes, we sit down. But the city keeps becoming, its living monuments render themselves visible, people greeting us, passing by, inviting us ...

AMMAN: THE DISCIPLE OF SOUQ AL-DAHAB

"Remember Um Katakir?", he asked me as he inhaled his way down the path of his memory. "Um Katakir the peanut seller? She used to roast peanuts here." I answered with a yes. In fact, I am not sure if I remember Um Katakir nor the smell of roasted peanuts in Bab al-Amud. I mimicked Mahmoud's inhale in an attempt to traverse through my memory, or perhaps my imagination.

It did not matter whether I remembered or not. The smell of roasted peanuts did emanate from a particular rainy day in Wast al-Balad[13] in Amman from my childhood, and also from the tin-roofed maze at the Qalandia checkpoint around the same time. I am not sure if that memory familiarized Amman, or estranged Jerusalem. I came to associate that particular smell with movement and travel, but also prolonged checks and waiting lines. Little did I know that this memory emanating from Amman is nothing but a trace of Bab al-Amud, and a trace of Um Katakir herself. As it turned out, Mahmoud and I had both indeed been inhaling the smells of Um Katakir's peanuts. Omar Bernawi, Um Katakir's disciple and her chosen brother, died a few years earlier. He passed, along with his heavy Arabic accent and his dream to return to the Jerusalem he left before the 1967 War broke out. Um Katakir shared the secrets of her trade with him. At first he sold his roasted peanuts at Bab al-Amud, and later moved on to Amman. He stationed his roasting tray at the Amman-al-Quds[14] bus station. Before the bus line, its passengers and

the empty peanut shells disappeared into the Jordan River, and before he and Souq al-Dahab[15] arrived to each other.

In his daughters' apartment a wall is filled with framed snippets of newspaper articles about him. One article about Omar Bernawi, "The Nigerian fan of the Jordanian Faisaly football club," caught my eye. In fact, his name was not Omar, and he might not have known what Faisaly was, as his daughter Ala'a humorously remarks. Omar died at a very old age, but he did not die of old age, his death was abrupt and unnatural. To his daughters he seems to have been old his entire life. He was hit by a car on his way home to Jabal al-Jofah from his roasting stand one day. From the top of Amman's citadel, Ala'a pointed to Jabal al-Jofah, she traced Hay al-Tafayleh where she grew up, and she showed me around the historic citadel and her former "air catching" spots, now out of reach for most Jabal al-Jofah residents and safely secured by a wall of fees. "Throughout his entire life, he only knew his way from Jabal al-Jofah to Wast al-Balad," she told me. "He would get lost if he strayed away from taking the same route up and down." We walked down the hill through Hay al-Masarweh, and in Wast al-Balad she proudly showed me around "her area," where now, to her amusement, most peddlers and street vendors called for her attention in English.

Al-Saha al-Hashimiya, Souq al-Balabseh, Souq al-Haramiya, and finally Souq al-Dahab, where we stood in front of a formal street sign telling about Omar Bernawi and his stand, now a royal protectorate. I do not know a lot about Um Katakir, other than her name, the smell of her peanuts, and the fact that she took the trip from Nigeria to Bab al-Amud. She spoke a mysterious language everyone seems to call "Rtanneh," a "mens'" language brought from afar. Um Katakir disappeared from Bab al-Amud, along with many other traces of an elsewhere called Palestine. But here we were in Amman standing in front of a remnant of hers that traveled across borders, space and time to remind those who could read the language of place that another world is possible; a world that comes back from memory and imagination alike.

NOTES

1. Hajj Amin al-Husseini was the controversial leader of the Palestinian national movement during the British Mandate.
2. In English, Bab al-Amud is known as Damascus Gate.
3. In English, Bab al-Jadid is known as the New Gate.
4. Qalandia is an Israeli checkpoint north of Jerusalem.
5. *Nuris* are Dom Romani communities.
6. *Takhayali* in Arabic is "imagine" in English. It is derived from *khayal*, which can hold several meanings, including "imagination," "specter," "shadow," and "delusion."
7. This is a reference to the Six-Day War of 1967.
8. *Kahayalat* refers in this context to shadows.

9. *Amud* means "column." Damascus Gate is known as the "gate of the column" in Arabic, in reference to a long-disappeared Roman column.
10. In English, al-Majlis al-Islami al-A'ala refers to the High Islamic Council, which was established in 1922 during the British mandate period and lasted until 1951.
11. A large percentage of Jerusalemites are of Hebronite origins. For further information on the migration of Hebronites to Jerusalem, see Murad al-Bustami, "Hebronites Migration to Jerusalem before 1948: The Exodus and the Curse of the City," *Majallat al-Dirasat al-Filasteeniyya*, 128(1) (2022): 103–123.
12. Blue identity cards are documents issued by the Israeli authorities to residents of Jerusalem.
13. Wast al-Balad means "city center."
14. In English, al-Quds is Jerusalem
15. Souq al-Dahab is the gold market in Amman's city center.

3
The Story of Romanies in Palestine Is a Microcosm of the Palestinian Story

Arpan Roy

Aristotle thought that all stories have one of two basic plots: that of a hero setting off on a journey, or that of a stranger coming to town. The story of Romani people is both. We do not know when the current configuration of Romani groups first came to Palestine, but we have every reason to think that other groups preceded them. Romani tribes have traversed Arab lands since at least the early centuries of Islam. Fascinating new research by the historian Kristina Richardson discusses likely Romani characters first appearing in Arabic works by legendary Basra-based authors Ibn al-Muqaffaʿ and al-Jahiz in the eighth century, and becoming a recurring presence in Arabic letters by the tenth century. It is only logical that Palestine, especially Jerusalem—the axis mundi of the world—would also be a destination for Romanies. But the Palestine of today is not the Palestine of yesterday. Sealed off from its surrounding territories, wrapped in barbed wire, closed military zones, checkpoints, and mine fields, Palestine is no longer a destination for Romanies nor any other kind of strangers. It has become the country without the essential ingredient that makes societies vibrant—immigrants. What would Palestine be like if its borders were open, as they had been for most of history? Who would be the travelers that today come to this precious land and rent rooms in cheap residential hotels in working-class districts of Palestinian cities, slowly buy land and build homes, have families, and form an ethnic enclave? What would be the foreign tongue that loans words and sounds to Palestinian Arabic that slowly come to distinguish it from other dialects, and perhaps even form a language? To consider the past and present of Romani people in Palestine is to consider such impossible questions.

Romanies are an ethnolinguistic category of people spanning several continents, and with various subgroups, clans, and related languages, such as the Roma and their Romani language in Eastern Europe, or the Calé Romanies of Spain, or Doms and the Domari language—the most numerous Romani group in Palestine and the wider Middle East. There are varying ideas among scholars regarding how to classify such a diaspora, but Romanies themselves tend to relate affectively to the reality of a Romani diaspora in spite of classificatory debates. All linguistic evidence points to the Romanies having at some point emigrated from the Indian subcontinent, and evidence from Domari is no exception. A Swadesh list of terms, a directory

developed by the Swiss linguist Morris Swadesh for words that tend to not significantly change in a given language when language groups come into contact with one another, shows a hodgepodge of loan words in Palestinian Domari, including from Arabic, Kurdish, and Persian. But some key Swadesh terms are of Indian origin, like *pani* ("water"), the basic condition of life, and *nam* ("name"), the name for the names of things. We are fortunate to have such linguistic data, much of it collected by the Israeli sociolinguist Yaron Matras, as the future of Domari in Palestine is discouraging. Only spoken by elders, now greatly reduced in number after the COVID-19 pandemic, the last generation of Domari speakers in Palestine will soon fold into the crevices of the Palestinian story. This language, and its enormous significance in reconstructing the history of difference in Palestine, must now be done from stages outside of Palestine where Domari is still spoken.

For Doms themselves, the overwhelming scholarly evidence suggesting an Indian origin coexists with other modes of narration. Doms in Palestine and the wider Arab region locate their origin not only to India, but also to the Hijaz—the Holy Land of Islam—and the *harb al-basus* ("Basus War"), a 40-year war said to have taken place in pre-Islamic Arabia. In Dom folklore, the characters involved in the Basus War are all Doms. Many of history's bravest heroes are also Doms, including Abu Zaid al-Hilali, the eleventh-century Shiʿa hero, and Nur al-Din al-Zenki, the Seljuk emir of Damascus and Aleppo. Individual and local variations of Dom genealogies include some of the *sahaba*—the companions of the Prophet that populate the pages of the hadith literature, and for Doms in Jerusalem, Salah al-Din al-Ayyubi, the liberator of Palestine from the Crusaders, is also one of them. At no point does any of this come into conflict with the Indian origin theory. The two origins coexist with one another, sometimes narratively linked, and at other times at peace with the contradiction. In this way, however, Palestine's Doms become a resolutely local people, having saturated their own history with Arab history, Islamic history, and Palestinian history.

The ease with which Dom genealogy adapts to changing conditions is a testament to the elastic nature of Romani history in the region. This brings me to a crucial point: Romanies are the only people in Palestine to never have owned property of any kind. Ibn Khaldun, the fourteenth-century Tunisian scholar, divided Arab society into categories of *fellaheen* ("peasants") pastoral Bedouin, and urban society of merchants, government functionaries, artisans, religious leaders, etc. A close perusal of Ibn Khaldun's typology reveals that these categorical divisions are not spatial nor exactly conceived through modes of production, such as the town/country premise for premodern Britain as famously proposed by Raymond Williams, but rather, are ultimately conceived through property ownership—collective land ownership (*mashaʿa*) for the fellaheen, livestock for the Bedouin, and businesses and other enterprises for the urban population. Romanies of the Arab world should constitute a fourth category of people who are not within the sphere of property ownership. We can only speculate as to why Ibn Khaldun would have

excluded these people who, as mentioned earlier, have likely been present in the region at least since the beginnings of Islam. It is as if property ownership is the sole condition by which a people become visible in politics, a position held even by the great anarchist Proudhon, who despite having made his famous decree of property being theft, conceded that property is also a kind of precondition for speech and action in society. Whatever the reason for Ibn Khaldun's exclusion, we can at least correct this historical injustice to articulate a place for the numerous Romani groups, their total population likely numbering millions in the contemporary Middle East: in Afghanistan, Iran, Turkey, the Gulf countries, Syria, Lebanon, Jordan, Palestine, Egypt, Sudan, Libya, Algeria, and beyond.

Over the last several decades, Doms in Palestine have acquired property for the first time. Thousands of Doms and other Romanies having been expelled during the Nakba in 1948 and the Naksa in 1967, those who remained settled into permanent housing, mostly in Jerusalem and Gaza. In Jerusalem, Doms first rented homes in the Bab Hutta neighborhood of the walled medina, and eventually moved out and bought homes in the working-class peripheries of the city. In Gaza, Doms remained nomadic until the late 1980s, but then the political violence of the two intifadas and later the siege of Gaza beginning in 2007 created new problems. Having begun the process of acquiring property in Gaza at various stages, succeeding chapters of the Palestinian tragedy set the Gaza Doms back each time. Before the genocide, a mass migration of Doms from Gaza to the West Bank had been occurring; an unlikely migration given the spartan restrictions on movement out of Gaza. Humanity, however, somehow finds a way under conditions of inhumanity. Together with Gaza Christians, who are also leaving the Strip en masse, Doms constitute the wholesale exodus of a historic community from Gaza. Gaza Doms recently arrived in the West Bank, aided by modern real estate schemes, are now buying apartments in the rapidly urbanizing localities around Ramallah. Usually on the same street and often in the same building, these settlements likely inaugurate the beginnings of new ethnic enclaves. Deleuze and Guattari thought of such deterritorialization and reterritorialization as a primary instinct that humans share with animals, but also that which shapes uniquely human relations like those between polis and clan, labor and capital, and so forth. As such, these movements are constitutive of the Palestinian polity. But what happened to the Romanies who left Palestine in 1948 and 1967? What can their experience tell us about Romani life and history in Palestine?

* * *

"I am Palestinian," Abu Kemal tells me. We are sitting outside his tent in the industrial outskirts of Amman, drinking tea so sweet that it shoots into my molars. Everyone around me is speaking Turkmançi, a Turkic language that was once also a language of Palestine. Only I am being addressed in Arabic. Abu Kemal and his clan are Turkmen Romanies, a people with no probable linguistic ties to other Romani

26

groups, but belonging to what the Yaron Matras calls (unfortunately) "Gypsy 1," meaning Romani groups who are linked by a shared history and lifestyle, irrespective of origin or language. Today, as always, Turkmen tend to live alongside Doms, although the two profess their distinction from one another. Abu Kemal was born and lived for part of his childhood in Nablus until he and his family were expelled in 1967. They went first to Baghdad, joining the already populous Turkmen communities there, only to leave again during the abject poverty caused by the American sanctions against the Saddam Hussein regime in the 1990s, this time for Amman. The Turkmen in Jordan, like Romanies elsewhere in the region, are only recently acquiring property, first pitching simple tents in newly purchased land and gradually transitioning to villas built over long periods. In spite of this novel entry into property relations, Turkmen still practice an ambulant commercial lifestyle, usually selling clothes and accessories to diners at restaurants, bars, and sidewalk cafés. Because police attitudes towards such labor are always in flux, so are the Turkmen, who travel wherever conditions for such business are favorable.

In a derelict residential hotel in Cairo, I visit Turkmen who have recently migrated from Amman to Cairo—a strange migration given that it is a move in the reverse direction of economic mobility. They are miserable, as they have swapped the personal space and comfort of their tents and villas in Amman for a hotel that has one bathroom per floor. One bathroom per floor in which there are six rooms, and around six people per room, means that there is one bathroom per 36 people. Human feces ferment in the stairways of the hotel, cheap synthetic drugs run rampant, and at the time of my visit, a mysterious rash is infecting the hotel's residents. Why would anyone remain in Cairo under these conditions? Yet the Turkmen are in a historical crux. Free to practice their trade in Cairo by the police but otherwise miserable, and still tied to Amman by their newly acquired property but unable to make ends meet there, the Turkmen are in a historical terra incognita. It is very possible that, in the past, Turkmen who have left Amman as such would never return, that Cairo would only be a passage en route to new frontiers. But property creates new burdens, responsibilities, and attachments. It is dangerous to reconstruct the past based on present circumstances, but in the story of the Turkmen we can get a glimpse of the story of Romani people in Palestine and the wider region to which Palestine organically belongs.

<p align="center">*　*　*</p>

Nablus—Baghdad—Amman—Cairo. Perhaps we are beginning to see how the story of Romani people in Palestine is also a story of Palestine in its geographic and historical context. It is a story of the *bilad al-sham* and of the Arab empires, of modern wars and displacements, of global flows of capital. The Romanies may have come and gone from Palestine, but they have left part of their legacy wherever one looks; but one has to look carefully. In the Galilee, for instance, there are no more Romanies, but there remain place names that are waymarkers of a past Romani

movement: *maqbara an-nawar* ("Cemetery of the Gypsy"), *'ayn an-nawar* ("Spring of the Gypsy"). One can also look to some of the most foundational material of Palestinian cultural heritage. The much-loved Palestinian folk song "Wein a Ramallah," according to Doms, is a song composed during the bygone days when Doms would travel in itinerant bands offering services like folk dentistry, handicrafts, and musical entertainment to villages and towns. The song is one of longing, sung from the perspective of a woman whose beloved is wandering the cities of the Palestinian highlands, with lyrics that accommodate the playful with the desperate and the vindictive—"laysh tajafeeny wa aysh haly aameltu lesh tajafeeny?" ("Why do you abandon me, and what is my sin for which you abandon me?") Such fatalism aside, its melody is utterly joyful and its refrain endlessly singable.

As with most folk songs, it is nearly impossible to locate a precise moment of composition, but in this case, we can locate the moment in which it became wildly popular. This was in the 1970s with the Jordanian singer Salwa al-Aas and her husband Jamil, the virtuoso bouzouki player who was a Dom from Jerusalem. But if Romanies did not sign their name into this permanent contribution to Palestinian folklore, such an autograph is there, if one is attuned to such details, in the *tabal al-nawar* ("Gypsy Drum"), a percussion instrument used in *dabke*, the Levantine folk dance par excellence. There is nothing more Palestinian than dabke, but its rhythms announce a certain distinction.

The story of Romanies in Palestine is a microcosm of the Palestinian story. It is a microcosm of Palestinian folklore, geography, politics, and dispossession. It is true that over the last several decades the visibility of Romani culture, heritage, and languages has diminished. But Romani people in Palestine have not disappeared. If anything, with a healthy birth rate and, at least in the case of Doms in Jerusalem, access to the Israeli social welfare system, Doms in Palestine today are possibly as numerous as ever. Rather than disappearing *from* society, they have disappeared *into* society, into working-class neighborhoods, living in anonymous apartment buildings, working in construction and other manual labor like other Palestinians, and so forth. Their *being* Romani is expressed only within the private walls of the family, where a consciousness of not being quite like others, along with almost near universal cousin marriage, sustains Romani difference across generations. What had for centuries been a public performance of difference has now been reduced to the sphere of the family, where, within the private walls of the household, Romanies announce themselves as not exactly like others through constant jokes and codes that announce their being Romani.

With this retreat into the private sphere, Romanies have gradually disappeared also from their once prominent place in Palestinian cultural production, evident as recently as the 1990s. For instance, in Emile Habibi's 1991 literary adaptation of the folktale *Khurrafiyyat saraya bint al-ghul* ("Saraya, the Ogre's Daughter"), Saraya is a Romani girl. Michel Khlefi's 1995 film *Hikayat al-Jawahir al-Thalath* ("Tale of the Three Jewels") tells the story of a Romani girl in Gaza who bewitches a young

refugee boy against the tumultuous backdrop of the first intifada. The cult favorite Jerusalem-based art/folk band Sabreen's 1994 song "Al-Nuri" ("The Gypsy"), with lyrics written by the poet Hussein Barghouthi, is a monologue narrated from the perspective of a Romani woman, albeit one that ticks off every Romani stereotype imaginable. After this, Romanies largely disappear from Palestine cultural production, although they do not disappear as such from Lebanon, Syria, and Jordan, where Romanies continue to periodically achieve stardom.

* * *

Abu Hassan is a Dom sheikh who lives in the outskirts of Amman. He was born in the Ghor, the river valley that separates the West and East banks of the Jordan River, although he is not certain on which side. In any case, he spent much of his childhood wandering around Palestine with the kinds of itinerant bands mentioned above—that is, until 1967, when such movement became impossible.

His neighborhood in Amman is a curiously equal distribution of multi-story villas and tents, and even more curiously, it hosts a medley of various communities—mostly Doms and Turkmen, but also Akrad Romanies and Syrian refugees, and nearby, Bedouin tribes native to Jordan. In Amman, I experience visions of Palestine. A city of Palestinians built by Palestinians, it is strangely not Palestine at all. This recognition/misrecognition is marked not only by the things that one finds there that remind one of Palestine—after all, only one hour away by car—but also all that Palestine has been deprived of in its colonized isolation: immigrant communities of Bangladeshi and Pakistani migrant workers, the sounds of Arabic dialects from Iraq, Syria, Egypt, Yemen, and the Romani people that carved a niche among them for centuries.

Abu Hassan himself lives in an elegant two-story villa with Romanesque pillars and a curved stone facade, a structure financed with remittances sent by his sons who live in the Gulf. But for all the opulence, he sleeps in the courtyard, under the naked sky, as he always has. His days are also spent in the courtyard, where he sits cross-legged for hours, like a yogi, smithing hand-crafted knives and repairing metal objects for his neighbors for small change. I tell him that I am interested in music, and the next day when I visit him I find him building a rustic *rabab* (a lute-like instrument) from wood and tin.

I am sitting with Abu Hassan in his courtyard, watching him build his rabab, when two neighborhood Turkmen girls enter carrying empty jerrycans. They have run out of water. They look dirt-poor and are dressed in colorful, flowing salwars that jolt the imagination to Rajasthan or Bizet's Seville. Abu Hassan is not pleased by what seems like a routine intrusion. Water is expensive. Eventually he acquiesces, and I watch as the Turkmen girls scurry in with quick, small steps to fill their jerrycans. They leave the courtyard just as quickly, their heads bowed with humility, the hems of their salwars towing behind them.

4
Life in the Armenian Quarter: Dr. Gaby Kevorkian on the Genocide, Nakba, Naksa, and the Armenian Palestinians

Antranik Cassem

A young Jerusalemite is frustrated by frequent leg pain that pauses his jogging and wants to know why it is happening. He sends a query to *Balsam*, the magazine of the Red Crescent Society of Palestine, where Doctor Gaby Kevorkian is on hand to answer his questions and those of many others. Dr. Kevorkian is thorough and direct with his answers, the result of more than 30 years of practicing medicine out of his clinic in East Jerusalem. He suggests that the questioner rest and drink more electrolytes. Whatever the question is, he will respond, and I imagine he does so with great kindness and a willingness to help. Doctors, especially family doctors, have a unique window into society, as they often come to one's aid in a state of significant vulnerability and, as such, require a certain level of trust between the practitioner and their community. A level of trust that Dr. Kevorkian has undoubtedly earned. So much so that he invites you, the reader, to visit Issawiya, a neighborhood in the north of Jerusalem, where people still ask after him and would like another doctor like "Dr. Gaby" to practice there; yet I think it will be challenging to replace him.

The Kevorkians are Palestinian and, as you may already realize from their surname, Armenian.

Dr. Kevorkian speaks with great pride, care, and compassion for the community he serves. A vocation inspired partly by his mother, who was a practicing nurse in Beirut and, eventually, Jerusalem. She is an inspiring figure, and it is easy to understand what her story, memory, and practice meant for him, as beyond her service, he is the result of his father meeting her while in hospital for tuberculosis in Beirut. Dr. Kevorkian's father would eventually marry her and bring her to Jerusalem, where she continued to practice, delivering medicines, witnessing, and caring for many recently displaced from the creation of Israel in 1948. Dr. Kevorkian mentions how:

> she would describe how [both] poor, and rich Palestinians were dispossessed and arrived to Ramallah in the winter, [where] many arrivals committed suicide, because they could not accept the dispossession. She also mentioned how many of the new children being born were dying from the cold. My mother had this

experience, because she was a nurse, she used to tell us how the Palestinians were dying in the fields and how the rich Palestinians used to kill themselves. She used to tell us that daily she would wake up to the news that this [or that] person killed themself.

From these moments and experiences, Dr. Kevorkian is explicit in stating how his parents "implanted in us a love of the Palestinians and to not sympathize with the Israelis." A love he carried on into his clinic and daily life. Just as his mother used to go house to house injecting the new medicine of penicillin, Dr. Kevorkian, in whatever spare time he could find, also made frequent and free house visits for three decades. Even retired, he still takes the time to answer in his column the questions of those concerned; with a broader lens, we can see two generations of the same family caring for their community in Palestine, from the British Mandate to today.

Ultimately, the implantation of love for Palestinians was also teaching in love for oneself. The Kevorkians are part of Jerusalem's deeply rooted Armenian community, whose history dates back to the fourth century CE, and most likely even earlier. This community carries the singular honor of being the fourth Quarter of Jerusalem, after the Christian, Jewish, and Muslim quarters. It is in this Harat al-Arman, the Armenian Quarter, where Dr. Kevorkian was born, grew up, and lives today as part of the fabric of Jerusalem, as part of the oldest Armenian diaspora in Palestine. From the very beginning of our conversation, Dr. Kevorkian proudly describes this long history, how:

Armenia was the first state to adopt Christianity as the religion of state in 301 CE. [As a result], the Armenians start, knowing that this was the land of Jesus, came as pilgrims, and they stayed, because they came by land, on donkeys and camels, etc. Some used to go back, but some used to stay, so they established [themselves] in the southwestern corner of the city, they established the Armenian Quarter.

The quarter has a special place in history as it has been recognized and respected by various caliphates and empires since the Rashidun Caliphate in the seventh century CE.

Even the great Saladin evidenced this unique status in his reconquest of the city in the twelfth century CE, as he did not expel or enslave the Armenians but exempted them from paying the ransom money or taxes demanded from other Christians who came with the crusaders. Exemptions were even conferred on the Armenians of Jerusalem by the Mamluks. In the thirteenth century CE they allowed the walls of the Armenian Quarter to remain as they tore down many of their own to prevent crusaders from returning to use their battlements against them, an example of the level of trust they had with the Armenians. Such is the special status of the district that the Mamluks also exempted the Armenians from paying *jizya*, the yearly tax paid by non-Muslims, or *dhimmis*. Keeping these small historical examples in

mind, a deep resonance from history echoes through Dr. Kevorkian's clear articulation of his identity as Palestinian Armenian or Armenian Palestinian. The two should not be hyphenated, but rather exist wholly together as both exist as part of a whole rooted deeply into the fabric of the city of Jerusalem.

Dr. Kevorkian quickly points out the difference between the local and the genocide Armenians. While Jerusalem was under Ottoman rule for nearly three centuries and maintained many of the same rights as previous regimes, further to the north Turkish ethnonationalist sentiment led by Mustafa Kemal Atatürk gained currency. Atatürk's nationalist movement resulted in the systemic extermination, displacement, and dispossession of Armenians from the Armenian highlands between 1915 and 1917. A series of events led to the death of nearly 1.5 million people—resulting in the Armenian genocide. As our conversation continues, Dr. Kevorkian reveals that he is a composite of the local and arriving genocide Armenians, as his mother was a genocide survivor. One key aspect of the difference between local and genocide Armenians is language. Armenians of the quarter spoke Palestinian Arabic, and those of the genocide did not know Arabic when they arrived, typically only speaking Armenian or Ottoman Turkish. He explains how "the first refugees arrived in 1918. [They found that] the Armenian of the Armenians [in Jerusalem was] very poor and the Armenians who arrived taught the Armenians living in Jerusalem Armenian [language], [founding St. Tarkmanchatz Armenian school in Jerusalem]." Dr. Kevorkian says to me in Arabic, "They gave us Armenian, and we gave them Arabic and English." He frequently refers to the fact that his Armenian was "nil, zero," a point that some of the genocide Armenians would refer to by calling him *arabakhos*, which in Armenian means "Arabic speaker," while also saying to him, "Shame on you! You should learn Armenian!" They would quip to his mother:

"You are a genocide survivor; why do they have very poor Armenian?" My mother said, "I am living in a family where they all speak Arabic!" And [eventually] my mother became *arabakhos*. Her Armenian was excellent, but she started talking with us in Arabic. The communication with us was mainly in Arabic, and she was a genocide survivor, but the environment [she was in] was the native colloquial [Palestinian], and everyone spoke Arabic.

Fleeing the genocide, his mother did not go directly to Jerusalem. She was born in Gürün, in today's Turkey, and instead went to Aleppo after the events of the genocide. Aleppo was one of the most common destinations for Armenians fleeing the genocide. A point that both Dr. Kevorkian and I share as part of my family also sought refuge in Aleppo for some time before moving on to Iraq. After the events of the genocide, this ancient community of Armenians in Jerusalem, however distant in time and language, helped those arriving through a long process of recovery. Referencing stories from his mother and grandparents, Dr. Kevorkian states how:

When they came [to Palestine] we accepted and we supported them … part of them were accommodated inside the Armenian convent and others were distributed [around to Armenian families], our parents and grandparents took them inside their houses for several months until they started working, and started establishing themselves gradually. For the first ten [or] fifteen years, a big portion of them were [living] inside the Armenian convent, under the care of the Armenian clergymen and the others in our houses as we took care of them.

From this context, Dr. Kevorkian's mother, who aided the Palestinians fleeing the forced displacement from their lands in 1948, would often say, "Poor Palestinians." She did not speak from a place of pity, but rather from experience, often speaking of the events of the genocide and the Nakba on similar terms. These are layered histories that produce complex relations and solidarities.

Pausing from the strokes of our conversation momentarily, I find myself drawn back to the threads of a question I have considered for many years: the significance of being diaspora(ed) more than once—alternatively, the application of diaspora as a verb, or written as dispersed. Ruminating on the term evokes its once more common use, referring to the Jewish diaspora, but within our contemporary context it is not anchored only to one history, but to a plurality. Today there are many diasporas of people linked to specific tribes, ethnicities, religions, and nations spread across the world; however diverse and distinct they are, each does share a common modern aspect: displacement. Even in the aforementioned history, it is clear that Dr. Kevorkian's mother is part of one diaspora only to bear witness to another. It is also possible to be internally diaspora or exiled while remaining home.

The word diaspora in English originates from Greek (*dia+speirein*), to scatter across; its second meaning refers to spreading the culture or colonizing (as the Greeks did throughout the Mediterranean). Nevertheless, the modern use invokes a more forced dimension—flight by need and/or desperation. It is a broad and essential term that covers anything from the forced enslavement and kidnapping of millions from the West African coast to the Americas to the uprooting, genocide, and forced migration of Armenians or the destruction of homes, killing, and daily reinforcement of colonial power imposed on Palestinians. Three different contexts and histories that forcibly dispersed, or spread across, peoples into diasporas. Depositing unforeseen lineages to continue away from shared homes, perhaps, forming a similar bond to a new land. This new bond comes with its own set of consequences, politics, connections, languages, and cultures, which, while reading the story of an individual into history, may quickly involve being diaspora(ed) from Ottoman Armenia to Mandate Palestine or Iraq, only to see it happen again. My initial question stems from my family's experience, as our history involves displacement from the genocide only to be forced to flee again from Iraq in the 1990s. While there is much that separates Dr. Kevorkian and me, we have the unfortu-

nate honor of being a part of distinct yet overlapping Armenian diaspora(s)—our unique *spyurkner*.

Our conversation raises questions of diaspora, both internally and externally, but leaving Armenian-ness for a moment, Dr. Kevorkian is also quick to reiterate his Palestinian-ness. He states, "I consider myself Palestinian, my upbringing is Palestinian, I went to Palestinian schools, I was even a graduate of a private Muslim school. Its name was Ibrahamia College, my *tawjihi* [secondary school exams] are from a Muslim college in East Jerusalem." He says, "And let me put it this way because all my friends were Arab Muslims. We, the [Armenian] natives, went to Arab schools, but the genocide survivors chose to stay inside the convent and go to Armenian schools." Eventually, Dr. Kevorkian would attend an Armenian university for his medical education. As we will shortly see, he would bring Palestine with him as a Palestinian and member of the Armenian diaspora. In Yerevan, his Armenian would finally go from nil to relatively good, as he puts it, studying in a preparatory year with Armenians from across the diaspora. His mother proudly stated, as his Armenian was very good by the end of his seven years of studies, "My son is Armenian and now he is Armenian doctor and now he [is a] graduate from Armenian university."

Before heading to Armenia, however, Dr. Kevorkian witnessed and participated in the 1967 War. In 1967, Israel waged war against a coalition of Arab nations primarily involving Egypt, Syria, and Jordan. Caught by surprise, the coalition did not have sufficient time to scramble its forces, and the Israelis pushed as far as the Suez Canal; their objective was to force Egypt to open the canal to Israeli vessels. However, narrowing from the consequences for nations to the personal, it is essential to remember that mandatory conscription was common in many countries of the world in the late 1960s. Any young man without some form of exemption (medical or otherwise) was drafted for some time. For the young men in the Jordanian-administered West Bank, this service involved a tour of six months, after which one would be discharged and listed in the reserves—meaning one could be potentially deployable in a future conflict.

A kind of historical kismet, Dr. Kevorkian recently graduated from college and was applying to study in Armenian, but like everyone, was obligated to serve his tour in the winter of 1967 and was discharged that spring. Still waiting for his acceptance letter to study in Yerevan and free of military commitments, he began to work in a local souvenir shop in the Old City. However, as a freshly trained soldier and member of the reserves, naturally he was called to serve on June 5, 1967, the beginning of the war. He knew where he had to be, and went to the police station at Jaffa Gate.

Given the speed of events, he says there was no time for good-byes, just straight onto trucks in Jerusalem, and in his case, to Jericho. Already trained, the army provided him with a uniform and weapon. From day, working normally in the souvenir shop, to night, already in uniform with his unit, Dr. Kevorkian was already

on his way to the northern border at Jenin. After a speech from a brigadier-general on the situation, his unit was transferred to the border. As the situation transformed from a training scenario, he was more accustomed to something different. With weapons and now ammunition distributed, Dr. Kevorkian says, "When we were training we used to deliver the weapons to the store [after exercises], but there you kept the weapon with you." After a day of commotion and preparation and with all his equipment, he was told to "sleep with the goats and the weapons beside you. We slept like babies." Without knowing exactly where they were the following day, Dr. Kevorkian noticed small reflections of light in the distance, which appeared odd, as they usually covered their vehicles with mud to prevent any reflections. So he asked the officer candidate, *murashah*, in command if they were on the border, and he said, "Yes, we are in Tulkarem," which is near Jenin. At this moment, Dr. Kevorkian knew he was already facing the enemy. The subsequent events of the 1967 War are summarized succinctly; Dr. Kevorkian served in Tulkarem during the attack. Without more detail, he explains that a number of his colleagues and friends were killed, another escaped to Jordan, and some managed to escape Nablus to a Catholic convent. He also mentions that his unit of reservists arrived to defend against the Israelis; most were from Jerusalem, and a dozen or so Armenians served with him. However, the long-term consequences led to the end of the Jordanian administration of the West Bank and East Jerusalem and the occupation of both by Israel.

With the Naksa (or "setback") and defeat of the Arab coalition in the 1967 War, one's nationality no longer, even loosely, correlated to the territory where one resided. While this was not a new phenomenon as many were already stateless in Palestine, it did mean more complications for those who possessed Jordanian citizenship or identity documents, another alteration to their circumstances for Dr. Kevorkian and his family. While his mother was born outside Palestine, his father, the local Armenian, was born in 1917 in Ottoman Palestine, while Dr. Kevorkian was born in the British Mandate of Palestine, with a birth certificate in Arabic, English, and Hebrew. With the creation of Israel and the establishment of the Jordanian-administered West Bank, he and his family would receive ID cards, little more than residency or work permits. With the occupation, Dr. Kevorkian states an experience common for many, that he was "born here, and when the Israelis came here we only had an ID, no passports." An alienated dislocation resonates today and affects Arab and Armenian Palestinians alike. He says, "When a soldier stops me he treats me the same as any other. My Arabic is the same as Palestinian Arabic and even when they see my ID, they see that I am not a Jew." In essence, the enforcement of the differentiation between Jews and non-Jews by the Jewish state extends to an Armenian who is Palestinian, but places him at the same risk of the prejudiced abuse inflicted by Israeli forces on Arab Palestinians to maintain the apartheid system. Already living as part of a diaspora, but also conceptually diaspora(ed) within one's own home, a community continuously inhabiting the Harat al-Arman for 1,700 years.

The dislocation within one's home is felt at even the most microscopic interactions. For example, Dr. Kevorkian's passing remark: "The other day I was visiting my friend's shop and a group of students came and the teacher stopped them and said, 'Don't buy from there; they are not Jews.' One of the students said that they are Armenians, but the teacher said it is all the same." The consistent reification of religion by the Israeli state pushes me to ask Dr. Kevorkian about the Christian Armenian's place in Palestine and resistance organizations. He explains by comparison:

> If you will talk about religion, in the Israeli army and community, there is a [focus on] difference in religion. But in the Palestinian [community], there was no difference. The Popular Front for the Liberation of Palestine was led by George Habash (who was Orthodox Christian). There is a difference between religions, but it is not as extreme as it is in Israel—the Israelis only love the Jews.

Apartheid and its preferential treatment of one group over another fuels alienation and separation. Pushing people within and, eventually, out of a territorial entity into exile or diaspora, this manner of exiling also extends to the consistent restriction placed on the occupied group within a territory by refusing to admit they even belong—diaspora(ed) within. The Kevorkians, like generations of Armenians before them, are melded into Palestinian society and the land of Palestine. In Dr. Kevorkian's case, he is married to the long-time anti-violence and feminist activist and scholar Dr. Nadera Shalhoub-Kevorkian, whose work examines the colonial/apartheid abuses of power, violence, and trauma described here. From the physician's window, it is clear how deeply connected he is; as Dr. Kevorkian says, "They used to treat me as one of their families, people from every class … used to trust me with their family members." This trust is as strong as it is revealing, as from his clinic he would see the soldiers abusing families, soldiers throwing tear gas and grenades at people, and how they arrest children and young men. All this as the soldiers even came into the clinic to ask if he was hiding people. Nothing is out of the ordinary if the state checks in on Dr. Kevorkian's clinic, as it would invite him to see them to check up on him personally.

Israelis pay special attention to the community, just as Dr. Kevorkian will be stopped and treated with disdain by the military because he is not Jewish. Jerusalem is increasingly the scene of attacks carried out by fanatical Jews against Armenian clergymen and the vandalization of Armenian churches and cemeteries. He explains: "Recently, especially in the last fifteen years, we feel the racist behavior of the Israelis, especially the fanatic Jews, against Christianity. They insult our religion and our liturgy; they spit on the cross. They spit in front of convents, they vandalize our churches, our cemeteries, they vandalize graves, and crosses." He says, "As recently as six months ago, an Armenian clergyman was beaten and taken to hospital. They spat on him and knocked him to ground because he was wearing

the cross." These may be random instances, but they are acts of violence that are not prosecuted by the state. He clearly explains the differences between Jews, Christians, and Muslims, as well as between Palestinians and non-Palestinians, in the eyes of the Israeli state:

> If a Palestinian were to burn or vandalize a synagogue, they would put him in jail for ten years. But when these fanatic Jews vandalize, the Israeli government does nothing. We notice that the Israeli soldiers support the fanatic Jews and the settlers. If the same crimes are committed by a Palestinian they will put him in jail, while if it is committed by a radical Jew, they will do nothing to him. They vandalize, they kill Palestinians, they vandalize houses and churches, and they burned a family completely. The soldiers and the government did nothing.

From Dr. Kevorkian's mother to himself, the memory of the genocide and Palestine provide a potent perspective. One that is energizing and grounding, one that Dr. Kevorkian brought with him to Soviet Armenia. In Armenia, Dr. Kevorkian engages with Armenians from the Soviet Republic of Armenia and other parts of the diaspora for the first time—from beyond the confines of Palestine. Upon arriving in the Armenian Soviet Socialist Republic, he brought Palestine with him, where many were receptive to Dr. Kevorkian's politics and perspective, as long as he did not criticize the Soviet Union. Armenians from across the Middle East came to study, creating a potent mixing space within the Armenian university. Here another tension arises between acceptance and distance between the diaspora and the Soviet state, which ebbed and flowed. In one sense, as Dr. Kevorkian explains, the Soviet Armenians would relate to him as kin with love and pride, as those who left because of the genocide were, in a sense, returning. From the acceptance of the genocide Armenians by the local Palestinian Armenians to Dr. Kevorkian being warmly welcomed by a different group of local Armenians, a mutual camaraderie is tangible. However, in another sense, there were limits. Dr. Kevorkian says:

> When it came to criticizing the Soviet Union, they used to tell us, "You are foreigners. You have no right to criticize us." Yet when it came to being Armenian, they used to tell us, "You are Armenians. You see, we are from the same nation." So there was a dilemma. We were considered Armenians until it came to any criticism of the Soviets.

Dr. Kevorkian describes this camaraderie among Armenians, despite its limits, as a mutual feeling. He goes further to say how from within this context they were radical Armenians. Dr. Kevorkian studied in Armenia from 1967 to 1975, a period when new radical organizations blossomed. It was a radical time for Armenians and many others. With support for the Popular Front for the Liberation of Palestine (PFLP) and the Palestinian Liberation Organization building during Dr. Kevorki-

an's time and leading to Armenian organizations such as the Armenian Secret Army for the Liberation of Armenia that was founded in Beirut in 1975 by Harutiun Takoshian (*nom de guerre* Hagop Hagopian). The connections between Yerevan and Palestinian movements in Beirut were ripening in the same period that Dr. Kevorkian conversed with Armenians from across the Middle East. The energy was tangible. Without going into too much detail, Dr. Kevorkian tells me that he was influenced by many events he witnessed in this period, no less than he had been influenced by the experiences relayed by his mother and the 1967 War and its aftermath. His convictions and connection to Palestine brought him to Beirut, where he met with the famous Palestinian writer and revolutionary Ghassan Kanafani. Dr. Kevorkian was successful in trafficking *Al-Hadaf*, a magazine founded by Kanafani, to Yerevan. To be clear, Dr. Kevorkian states that he was not a member of the PFLP: "I was supporter, not a member." He did not participate in any of the activities of the PFLP, but merely distributed its magazine. He says of his understated but crucial role: "I used to distribute it and everybody was eager to have one. It is from the diaspora and we were in the Soviet Union. It was from our second home, which is the diaspora; so everybody was eager and interested to have one." Dr. Kevorkian mentions how even local Armenians in Yerevan, who were not always students, were very interested in having a copy. The connection between Soviet Armenia and the "second homeland" was made more pronounced by the groups of Arabic-speaking Armenians that had moved to Armenia. Many of their children, with whom Dr. Kevorkian studied, were not only keen on reading the magazine, but like him were from countries south of Armenia and, in a sense, were connected to home through the magazine.

From within this double-rootedness to Armenia and Palestine, Dr. Kevorkian would return to Palestine for a family visit, only to be confronted by the Israeli authorities who summoned him for interrogation. He describes a typical interrogation with some added intrigue:

> They gave me a lot of questions about who I am and who my friends in Armenia are. [But] I was still a student. It felt routine, not because I'm Gaby, [because] I felt that they already knew everything about me. They knew that I distribute [the magazine], but it seemed that they don't want problems with the Armenians, the Palestinian Armenians.

Nevertheless, these typical questions became more concerted after he graduated and returned home for another visit. They asked him if he was involved in activities against Israel. "Of course I was not in an armed struggle or activities: only sabotage … it was only political. So, for them, I'm not a dangerous man." Politically speaking, Dr. Kevorkian, as he put it, was someone to be watched. However, as an Armenian doctor, someone best to ignore, as the media would exploit such an image, and the Israelis didn't want problems with the Armenian community at the time, consid-

ering that the media would use the arrest of a Christian Armenian doctor against Israeli authorities, and as such, he was questioned but released.

* * *

Another day and another question: a concerned Jordanian sends a query to *Balsam* asking if the elderly need to take vitamin E. Dr. Gaby Kevorkian is on hand to explain the benefits of taking vitamin E after 40 years of age and how best to take it. I spoke to Dr. Kevorkian while he was in his study at home in Jerusalem, in the Armenian Quarter. For more than two hours I was thrilled to speak with another Western Armenian and to understand his perspective of being diaspora(ed) into a territory that today is controlled by a people who are constantly trying to internally exile a great part of its population. The Israeli interrogators were concerned about him, partly because he is Palestinian, partly because he fought with the Jordanians in 1967, partly because he is Armenian, partly because he cares and is political (even radical), and because he is connected to Soviet Armenia.

Already there are many points on the map to track, which undoubtedly, as he points out, the Israelis are well aware of. A large and connected map that holds many points together in the same instance and place. For Dr. Kevorkian, being Palestinian in no way precludes him from loving Armenians elsewhere in the world. Before the genocide, the total number of Armenians living in the highlands is estimated to have been between 1.75 million and 2.4 million. Of this population, 1 million to 1.5 million were exterminated, depending on the estimate. Dr. Kevorkian is connected to the genocide through his mother, a survivor of the genocide. In large part, to be diaspora(ed) means to survive and to carry on. Survive, that is, from a literal situation of genocide, as was the Armenian experience, or otherwise to persist while a state consistently tries to push you out. To carry on within this context means to fight, to love, and care for your community. Dr. Kevorkian has certainly done this from within the diaspora, within Palestine—his second home. His mother was proud that he was speaking Armenian and an Armenian doctor, but I am quite certain that his genocide-surviving mother is equally proud that he speaks Palestinian Arabic and worked for more than 30 years as a Palestinian doctor.

5
Ibn Battuta in Gaza

Intimaa Alsdudi and Hadeel Assali

FEBRUARY 12, 2018, FIELD NOTES: INTIMAA AND HER GUIDE BAKER MEET IBN BATTUTA

It was early morning when we went to see Ibn Battuta in the buffer zone on the eastern side of southern Gaza, between Khan Younis and Rafah. As we made our way, Baker, a young Tarabin guide, kept repeating what an honor it is to be meeting him. "You will find answers for all of your questions with him," he said, referring to him as an encyclopedia. Baker's enthusiasm was contagious, but he also warned against asking silly or stereotypical questions. When we arrived to Ibn Battuta's *shig*,[1] it was eerily silent except for the buzz of Israeli surveillance drones and dogs barking in the distance. We heard a loud motorcycle approaching. It was him, Ibn Battuta, a slender and dark 60-year-old man wearing a light brown *jalabiya* (loose-fitting tunic) and *keffiyeh* (traditional Arabic scarf). He gestured for Baker to move out of the way because his motorcycle had no brakes.

Ibn Battuta is a Bedouin hailing from the Tarabin tribe whose actual name is Najeh "Abu Fahad" al-Hamidi. He acquired the nickname because of his extensive travels and studies, and he is very highly regarded in his community. As we gathered around and settled into the shig, Baker announced that Ibn Battuta is also a poet. He then introduced us, explaining that we were researching Bedouins in Gaza, and then complained to him, "As you know, the *fellaheen* [peasants] are discriminating against us, and the Gazans (urbanites) are eating us!" Ibn Battuta immediately refuted him and reminded him that Bedouins even discriminate amongst themselves. He then lectured him on not falling for stereotypes of different kinds of people that serve to divide them. "Wherever you are, society accepts you based on trust, based on your honesty with the people—no matter who you are. One should not stereotype an entire society based on the actions of the few, for the good outweighs the bad." He declared that what mattered most in a person's character was *itkoon saadiq*, to be honest and trustworthy. He then took a phone call before our long interview and conversation began.

GAZA'S IBN BATTUTA

Ibn Battuta owns land in the buffer zone near the al-Awda "border"[2] crossing. After the Israeli military withdrew from Gaza in 2005, the crossing was closed. The

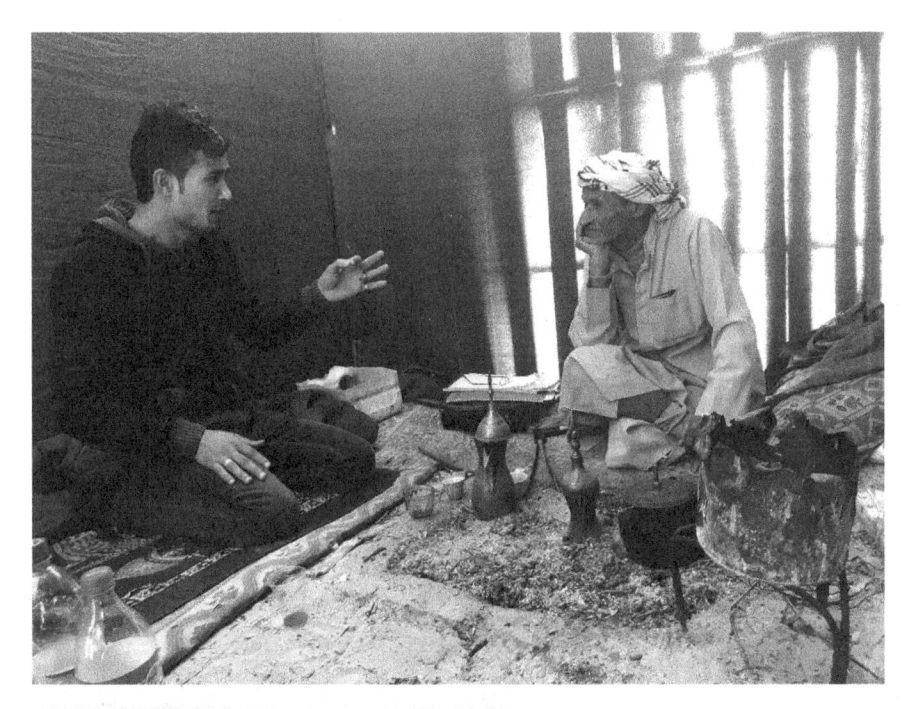

Figure 5.1 Ibn Battuta in his *shig.*

area, which had many farmlands, became a growing buffer zone where the Israeli military sprayed toxic chemicals and tested weapons, shooting anyone who came too close to the amorphous edges of this "border." Gradually a good portion of the buffer zone was abandoned. But Abu Fahad stayed, perched in his tent.

We had been researching southern Palestine—the land and its people—a largely "forgotten" area, according to historian Salman Abu Sitta.[3] Our starting point was southern Gaza, near Rafah, and we were quickly and unexpectedly taken into the world of Bedouins, for they are a significant portion of the population of southern Palestine. One of us (Hadeel) was unable to enter Gaza, and conducted interviews from the outside, mostly in the Sinai and the Naqab. The other one of us (Intimaa) was unable to easily leave, and conducted interviews inside, which is how we came to learn of Ibn Battuta, the Tarabin elder. The Tarabin, the largest of the Bedouin tribes of southern Palestine, span all the modern nation-state borders of the region. In addition to Gaza, Palestine, they are present in the Naqab (currently part of the state of Israel), in the Sinai Peninsula (part of Egypt), and in southern Jordan. We were interested in understanding their unique knowledge, history, and relationship with the land and each other that persisted despite the modern borders. But we also quickly became aware of the risks of writing about "Bedouins," especially in the context of long-standing Orientalist and colonial tropes and, more specifically, the anthropological categorizations of people that have been weaponized against Palestinians.

The category of Bedouin is complicated, especially in Palestine. There is no doubt that Bedouin populations have been marginalized, even among non-Bedouin Palestinians, as Baker complained about at the beginning of the first interview with Ibn Battuta. Bedouins themselves will often agree that they, too, tend to separate themselves—such as through marriage and so on, but our interviewees often said that these things are changing with the times. Bedouins are often stereotyped by non-Bedouins and associated with drugs, smuggling, and terrorism—or with collaboration with the colonizers. Colonial tactics have long depended on dividing people along ethnic or other categories and pitting them against each other, and while all "categories" are equally capable of collaboration, it is the Bedouins who have suffered the most from widespread stereotypes because of the actions of a few. At the same time there is a nostalgia and romanticization of a "traditional" way of life in the desert that many modern Bedouins do not fully or solely abide by. This is a sort of internalized Orientalism that works both ways. (Some) Bedouins and non-Bedouins often repeat stereotypes about each other in order to uphold the distinctions between them. While there are indeed distinctions between Bedouin and non-Bedouin communities, just as there are distinctions between refugee and non-refugee populations or urban and rural ones, politically, these distinctions are seized upon and sometimes inadvertently (often not inadvertently) sow divisions within the Palestinian polity. Israeli scholars have long displayed an Orientalist obsession with Bedouins; in fact, the enterprise of Israeli anthropology begins

with Bedouin populations, especially in the Naqab. Most Israeli scholars have positioned them within the framework of indigeneity in ways that have had the effect of reifying not only the divisions between other Palestinian populations (who do not fit their narrow category of indigeneity), but also old tropes of nomadism. These tropes of nomadism have in turn been weaponized about the very Bedouins they romanticized in order to oust them from their villages through ethnic cleansing mechanisms that continue even now. And while Palestinians have also taken up frameworks of indigeneity, they have been cognizant and critical of the ways it has been deployed in the context of Palestine.[4] Ibn Battuta, for example, rebukes Max von Oppenheim, a German archaeologist from the early 1900s who claimed to be an expert on Bedouins, casting them into origin stories and lineages that they do not recognize.

Bedouins have a stereotypical reputation as being *ruhhal* (nomads) who are less connected to specific places and lands than the *fellah*, a stereotype that continues to persist in Western tropes. However, this characterization of Bedouins is greatly exaggerated in the Orientalist imagination and seized upon and weaponized by colonial rule. Ibn Battuta is indeed a traveler, but one who always returns to his homeland. He has traveled more widely than most stateless Gazans, and has crossed many increasingly impenetrable borders and checkpoints in the surrounding region. His stories of crossings are reminiscent of trickster figures in folk tales who make use of ambiguities, especially at crossroads. In the case of our Ibn Battuta, he tells tales of shape-shifting into different identities on multiple occasions and in various locations in order to "pass." Typically, the trickster has "no direction home" and is destined to wander along borderlands. Gaza's Ibn Battuta, the trickster, has only one direction: home. But even there, too, he embodies a trickster's characteristics, for he insists on residing on his lands, lands that happen to lie in a crossroads of sorts, or at least an imposed crossroads near the Al-Awda crossing and in the buffer zone "border" area. Ibn Battuta's mere being is a lesson on the contradictions and complications of dominant understandings of Bedouins, of Gaza, and of Palestine in general.

Ibn Battuta laments the exclusions of the Bedouins from Palestinian history: "It is our fault that we did not document, but we need to document. We are the people of the earth, we are part of Palestine, we are part of Gaza." He referenced a book titled *The Forgotten Episode of the Palestinian People's Struggle* by Younis al-Katri, which highlighted the role of Bedouin and non-Bedouin freedom fighters in Palestinian liberation struggles. He recommended this book because the history of the role of Bedouins is largely absent from Palestinian Nakba histories and because there are many misconceptions about Bedouins and their allegiances. However, according to him, the unity of Palestinians across differences has always been strong, especially in the face of colonial forces. He recalls once meeting an Israeli researcher in southern Sinai who wanted to interview him because she was interested in Bedouins. He was already quite familiar with the Israeli tendency to separate Bedouins from the rest

of Palestinian society. When she asked him where he was from, he immediately answered "Gaza, Palestine."

IBN BATTUTA'S TRAVELS: 1976–

The original Ibn Battuta is a fourteenth-century Moroccan Berber of the Lawata tribe named Shamseddin Abu-Abdullah Mohammad Ibn Battuta (1304–1369). He was also a traveler, scholar, and explorer who visited the Arabian peninsula, Iran, Iraq, Anatolia, Central Asia, South Asia, and West Africa in a span of 30 years. He even passed through Gaza City at the end of one of his trips (1342–49) and found that it had been decimated by a plague during which up to 1,100 people died per day. He was one of the earliest sources of the genre of *rahhala*, the travelog. Gaza's Ibn Battuta faced different challenges from those of Moroccan Ibn Battuta, who traveled well before the modern world order of nation-states and increasingly militarized border crossings. Thus, our Ibn Battuta's stories center heavily on the risks and challenges of crossing borders.

Figure 5.2 Screenshot from Facebook: Baker posts a dedication to Ibn Battuta listing six different degrees, diplomas, and certifications.

In 1976, Ibn Battuta left Gaza and traveled to Beirut, Lebanon to study Arabic literature. A civil war had broken out, and two of his friends were killed at a checkpoint manned by Hezb al-Kata'b (the Phalange) because they were Palestinians. It was no longer safe to stay in Beirut, so he decided to run for his life. In the process, he used his Bedouin-ness, his *bedawa*, to shift his identity and nationality as he crossed borders. He had a Palestinian Bedouin friend who was from the West Bank who recommended that they go to his relatives near Nahr al-Bared and Beddawi Camps in northern Lebanon. Neither of them had been there before, and they needed to reach the camp before nightfall. From there, they could cross the border into Syria under the cover of night.

Before he began his journey, Ibn Battuta picked up his atlas to get a complete picture of the border. Knowing the four cardinal directions is easy for him, he explained, because he is not only a Bedouin, but a learned geographer and historian. Ibn Battuta knew that reaching Beddawi camp required stopping at the al-Qobi checkpoint, where his life as a Palestinian would be at risk. He decided to disguise himself as a drunk Yemeni. Ibn Battuta bought himself a Yemeni *jalabiya* and a can of beer. He sat next to the driver after spilling the beer all over his clothes. When the soldiers checked their passports, Ibn Battuta did not need to show any papers because they smelled the alcohol. "Drunk Yemeni, you are good," the soldier said, waving them through while making fun of him. Ibn Battuta made it safely to Beddawi camp with his friend.

Even though his friends' relatives were there in the camp, they were careful who to trust. "I see everybody as an enemy. The one who witnessed death and slaughter sees even his own son as an enemy." They decided not to stay long, and left after dark. Ibn Battuta describes how they traveled long distances, carefully avoiding houses, lights, or sounds. Remaining silent was essential when crossing borders. When they got tired, they slept until the sounds of nearby cattle awakened them. "We came across Syrian shepherds, so I pretended to be mute. If I had spoken, they would have realized that I was Palestinian," he explained. On the other hand, his friend from the West Bank could pass for a Syrian due to his dialect, similar to the Syrians in the south. Then, Ibn Battuta and his friend managed to go to the market to get a Bedouin Syrian jalabiya in Damascus. Ibn Battuta decided to head to Daraa, southern Syria, where Hourani tribes settle.

Houranis, among Bedouins, are known for keeping their promises and protecting their guests. "Even if you killed Bashar al-Assad, the Houranis won't harm you while you are their guest," he elaborated, contradicting his own statement earlier of seeing everybody as an enemy. It seems *some* are known and trusted among indigenous networks, such as the Houranis, and knowing this protected his life. Ibn Battuta asked the Houranis for their assistance in reaching Jordan, which they agreed to provide while warning him to be careful of thugs at the border. Under the cover of night, they managed to reach al-Ramtha in north Jordan. There, they

posed as Bedouins from Irbid who were searching for work in Syria but failed to find any. Ibn Battuta's friend decided to return to the West Bank.

Undeterred, Ibn Battuta sought to enroll in a Jordanian university to continue his studies, but he missed the registration deadline. It was then that he recalled a Bedouin from Gaza who had fled to Jordan in 1956 and married a Jordanian woman. He thought that they might be related, and set out to find him. The Bedouin network is strong, and it was not difficult for Ibn Battuta to locate him. When introducing himself, he used his mother's name instead of his father's, as he knew that the man had been raised in the same kinship network as his mother and aunts. The man was overjoyed when he found out that Ibn Battuta was the son of Salima. He warmly welcomed him, saying, "Welcome, my nephew, son of my sister." However, Ibn Battuta clarified that the man was not his uncle, but since his mother's family had raised him among their children, he considered them to be his siblings. The man led Ibn Battuta to another Bedouin man with strong connections in Jordan. This time, Ibn Battuta introduced himself as a member of the Ghawali Tarabin clan. The other man welcomed him by saying, "Ahlan ya Ghali," which means "Welcome, dear one." The word *ghali* means "dear" or "valuable," and is also used to refer to a member of the Ghawali clan. Because the Ghawali clan is one of the largest and most well-known among the Tarabin, Ibn Battuta's affiliation with Ghawali helped him be quickly accepted into Mu'tah University in Jordan due to his connections and clever use of identity politics. During his first year in school, Ibn Battuta earned very good grades and formed relationships with the Jordanian Bedouins. He fondly remembered spending time with his friend Adnan from the Bani Sakher, who had become like a brother to him. Adnan had invited Ibn Battuta to visit his family, who had insisted that he have lunch with them. After completing his first year, Ibn Battuta told Adnan that he needed to return to Gaza to see his family. Adnan's well-known and respected father tried to convince Ibn Battuta to stay, offering to help him obtain Jordanian nationality and a place to stay with his son. However, Ibn Battuta refused, confirming that there was no place like home, Palestine.

As soon as Ibn Battuta reached Gaza, the Israeli intelligence arrested him. They put him in an empty room with a desk and two chairs. A picture depicting Bedouin life was hanging on the wall. The Israeli officer entered the room and offered Ibn Battuta a cigarette, explaining that they knew he was a student in Jordan and had many friends there. He said it would benefit Ibn Battuta if he cooperated with them; they would pay for his school tuition and help him get in and out of the country. He claimed that many Bedouins work with them in Beersheba and are friends. Ibn Battuta needed to find a way to convince the Israeli officer that he would not work with them without showing his anger. How dare this colonizer think that Ibn Battuta could sell his cause and his people, he explained. He recalled a mental monologue at that moment:

I am not scared of them, but I refuse to be humiliated, dehumanized, and beaten. I don't fear them; I am wiser. I am the indigenous here, and they are the settlers; this is my land. I have dignity and pride, I won't allow them to lay a hand on me. I need to act quickly but smartly.

Yes, Bedouins are loyal to any state they reside in; like the Bedouins in Beersheba they are loyal to Israel. But here in Gaza, the majority of the people are fellaheen, not Bedouins; if they know that I work with you, they will kill me, they will slaughter me.

Ibn Battuta rejected the officer's offer by making use of the officer's own stereotypes of Bedouins as traitors who worked for the colonizing state. "Fellaheen hate Bedouins," he told him, "They don't marry us, and we don't marry them." He played on the colonizer's perceived divisions in order to render himself useless as an agent and spy for the Israeli state. Frustrated, the officer threw Ibn Battuta's ID card on the floor, and yelled, "You will be back, you will return to us like a dog."

NOTES ON WRITING DURING GENOCIDE

As we write this brief portrait several years after the first interview with Ibn Battuta, Gaza has been undergoing a genocide the scale of which has never been seen before. The death count keeps mounting, month after month (we are currently entering the sixth month), and all attempts to stop the bloodshed have fallen short. We have gotten in touch with Baker, the young Tarabin guide who led us to Ibn Battuta. He is still there in Gaza, displaced to Rafah and living in a tent with his family. It seems Ibn Battuta was outside Gaza when the genocide began, but we are unsure of his whereabouts. Writing part of his life story as Gaza is undergoing a genocide, even if to emphasize his insistence on his Palestinian-ness, feels rather futile. The most common refrain these days seems to be that *there are no words*, indicative of language's failure to capture the levels of inhumanity we are witnessing. In light of this, we wonder, *does writing make a difference?* Lila Abu-Lughod asked herself this question in her second book on Bedouins, *Writing Women's Worlds: Bedouin Stories*. She reflected on whether or not we can really escape the categories and institutions that have captured, categorized, and dehumanized so many, including the Bedouin. She too asks: Does writing make a difference? "Does using my knowledge of individuals for purposes beyond friendship and shared memories by fixing their words and lives for disclosure to a world beyond the one they live in constitute some sort of betrayal?"[5]

Indeed, during times of genocide, the risk or fear of betrayal is heightened. What good does sharing this story do? Abu-Lughod comes to the conclusion that "By insistently focusing on individuals and the particularities of their lives, we may be better able to perceive similarities in all our lives It is hard for the language of generalization to convey" nuanced experiences.[6] For her, allowing stories to stand

on their own—with some gentle curation—entails a "critical ethnography," one that defies standard anthropological generalizations. For Ibn Battuta, what mattered most was *itkoon sadiq*, to be honest and trustworthy. As such, we humbly offer this brief and very incomplete portrait of the beloved Ibn Battuta of Gaza. We hope this story serves as an example of Palestinian rejection of ongoing colonial attempts to divide the Palestinian people along Bedouin/non-Bedouin lines, even in this genocidal divide-and-rule moment. We remain inspired by Ibn Battuta's rejection of such divisions and of the borders imposed on them, by his trickster ways of subverting these borders, and ultimately by his commitment to Palestine.

NOTES

1. *Shig* is an Arabic word referring to the gathering place typical of Bedouins; traditionally this is a tent.
2. The "borders" around the eastern and northern Gaza Strip are in fact armistice lines from 1949, not borders, despite the mainstream reference to them as such.
3. Salman Abu Sitta has written about Gaza and its environs, including Beer Sheba, being the "forgotten half of Palestine." See Salman Abu-Sitta, "Beer Sheba: The Forgotten Half of Palestine," *Palestine Land Society* (June 2003), www.plands.org/en/articles-speeches/articles/2003/beer-sheba-the-forgotten-half-of-palestine.
4. Lana Tatour, "The Culturalisation of Indigeneity: The Palestinian-Bedouin of the Naqab and Indigenous Rights," *International Journal of Human Rights*, 23(10) (2019): 1–25. Mansour Nasasra, *The Naqab Bedouins: A Century of Politics and Resistance* (New York: Columbia University Press, 2017). Ahmad Amara, "Beyond Stereotypes of Bedouins as 'Nomads' and 'Savages': Rethinking the Bedouin in Ottoman Southern Palestine, 1875–1900," *Journal of Holy Land & Palestine Studies*, 15(1) (2016): 59–77.
5. Lila Abu-Lughod, *Writing Women's Worlds: Bedouin Stories* (Berkeley, CA: University of California Press, 1993), p. 41.
6. Ibid., p. 27.

PART II

Directions of Prayer

6
The Indians of Ottoman Jerusalem[1]
Tyler Kynn

In the year 1670 in the Ottoman city of Jerusalem, a woman named Amina, daughter of Muhammad ibn Omar Nabulsi, was paid one gold coin as part of a yearly stipend payment for people in the holy city of Jerusalem. However, Amina's stipend payment also noted that she was associated as part of a dervish lodge dedicated to Indian Sufis from Multan, in today's Pakistan, once a prominent city in Mughal India.[2] The Mughal Empire was the most prominent empire in South Asia from the sixteenth to the early eighteenth centuries, and at its greatest extent comprised what is the majority of modern-day India, Pakistan, and Bangladesh.[3] We do not know whether Amina was herself from Multan or if she was born in Palestine and simply descended from a diasporic Indian Muslim community in the region, as hinted at through the connection to Nablus in her name. Nevertheless, her name as connected to the Indian pilgrims from Multan in this Ottoman stipend register hints to the deep connection across the Islamic world between Ottoman Jerusalem and the Muslim communities of South Asia.

The core of my academic research is on the Ottoman pilgrimage to Mecca, and Ottoman sovereignty in the Hijaz. Through that research I have come to rely upon Ottoman stipend records, known as the *sürre*, for the holy cities of the Ottoman world. These documents provide an intimate view of Ottoman financial ties of charity and patronage in Islam's holiest spaces with the majority of records concerning Mecca and Medina, naming thousands of individuals who annually received payments from the Ottoman state via the hajj pilgrimage caravans. With these archival records, we are able to map the vast diverse networks of pilgrims who resided in these sacred spaces sponsored by the Ottoman state.

However, there is one other city included in the sürre registers from the early modern period besides Mecca and Medina—the holy city of Jerusalem. In any given year in the early modern era, the sürre included dozens of separate registers listing the names of stipend recipients in Mecca and Medina and usually one sole register for those pilgrims and foreign residents in Jerusalem. While relatively minor in comparison to the Ottoman stipend payments for pilgrims in the Hijaz, the Jerusalem register provides a unique window into the diverse and global networks sponsored by the Ottoman state in Jerusalem. In particular, the early modern Indian diaspora community of Jerusalem stands out in these records. The Ottoman stipend records for Jerusalem provide a tantalizing window into Ottoman Jerusalem's diverse Muslim community, and also provides evidence for the mobility

of Muslim women in the early modern era. Beyond representing the physical connection between Indian Muslims and the Ottoman region as shown in these stipend lists, they also point to the Ottoman sponsorship and charity designated for these "foreign" Muslims which can be understood as an Ottoman attempt to project its power and influence beyond its borders.

While it is not necessarily surprising to find Muslims from the Mughal Empire in Ottoman lands, the detailed sponsorship of this community by the Ottoman state in Jerusalem provides a more substantial view of how the Ottoman state positioned itself in the medieval Islamic world. Jerusalem was a city that stood at the geographic center of the Ottoman realm for centuries after its conquest from the Mamluks in 1516, and Palestine was part and parcel of a diverse Ottoman world and the many travelers that traversed it. Through travel accounts and stray anecdotes here and there, one can glimpse references to the many places in which Indians found themselves within the broader Ottoman world.

For instance, in the seventeenth century the Ottoman traveler Evliya Çelebi references the presence of Indian merchants at a regional market fair in Doyran, near modern-day Strumica in Macedonia, noting that "during the cherry season, 100,000 people gather in this plain. They come from … Hind and Sind … in short from all the seven climes."[4] While the reference to merchants from India (*hind*) may simply be a literary note to describe the diversity of people there, references to Indians of the Ottoman world can be found throughout his travel account. In Tanta in Egypt, Evliya mentions that "day after day a sea of men throng to this happy valley—from India, Yemen, Ethiopia, Persia, and Aden," essentially referencing Tanta's global connections through the Red Sea and the broader Indian Ocean world.[5] While describing his hometown of Istanbul, Evliya makes note of the Parsi community, noting them as "fire-worshiping Hindus," and then notes that nearby, in the Kağıthane neighborhood, there was an Indian Qalandar dervish lodge.[6] In one of Evliya's more fantastical tales, one about a girl who gave birth to an elephant, the legend begins with an elephant transported through a small village in Anatolia on its way to Istanbul as part of "a delegation from the sultan of India."[7]

Offering tangible proof of Indian presence in the Ottoman realm are the donations made by the Mughal Empire in Mecca. During the late sixteenth century, Gulbadan Begum, the aunt of Mughal Emperor Akbar and the biographer of the Emperor Humayun (her half-brother), embarked on the hajj.[8] As Gulbadan departed from Akbar's capital of Fatehpur Sikri, she reportedly carried 6,000 rupees expected to be charitable gifts to be disbursed in the sacred cities upon her arrival.[9] Although no documentation has surfaced which details how these gifts were used, a century following Gulbadan's pilgrimage an entry in the sürre shows Ottoman imperial funding of a lodge for pilgrims named in honor of Gulbadan Begum.[10] It appears that some of the funds provided by Gulbadan Begum's journey sponsored an inn for pilgrims—still operating a century later, though by then it was being financed by the Ottoman Empire's own endowment networks.

The inn for pilgrims in Mecca named for Gulbadan forms only part of a transportation network for Indian pilgrims, which included a caravanserai in the port of Surat, on the Gujarati coast, built by Mughal Emperor Shah Jahan for "pilgrims to the sacred Mecca and Medina."[11] Muslim Indian pilgrims would depart Surat on Mughal imperial sponsored ships through the Mocha fleet which would annually set sail for the Red Sea, the holy cities, and Ottoman lands.[12] It is not impossible to imagine that many Indian pilgrims would continue on with caravans from the Hijaz to the holy city of Jerusalem as well, as many guides for pilgrimage often include itineraries compiled together for Mecca, Medina, Jerusalem, and Hebron (the forgotten holy city of Palestine).[13] These pilgrimage routes connected Jerusalem to a vast sacred network of travel that itself connected Mediterranean and Indian Ocean worlds.

Beyond occasional references to traveling merchants and sufis from Mughal India in the early modern era, Evliya Çelebi also makes specific mention of the Zawiya al-Hindiya (Indian dervish lodge) in Jerusalem, noted as the "abode of Indians" in the Old City of Jerusalem.[14] However, unlike Evliya's other references to Indians in Ottoman spaces, the sürre registers can help support Evliya's reference to the presence of this community in cosmopolitan early modern Jerusalem. This is important, given that Evliya's claims are often considered unreliable as his travel narrative mixes both fact and fiction throughout.

The sürre registers designated for Jerusalem in 1670, the same era when Evliya visited the city, point to a clearly defined Indian Muslim diaspora community in the city. From this register we get the names of the members of this community, occasionally a reference to the city they hail from, and their stipend payment amount from the Ottoman state. While many foreigners, usually scholars in residence, are listed in the general category for stipend payments in the register, mentioned in the document as "*mücavirin* [foreign residents] in Jerusalem," the Indian community is given its own separate category in Jerusalem—categorized in the imperial register as *hunud*. One section in the register confirms yearly payments made to nine people who work at the Zawiya-i Hunud (dervish lodge of the Indians). Each of the nine were allotted one gold coin as a stipend and included payments to two women named Shamsah and Afifah. The next section in the register includes a list of names to be paid a stipend who were associated with the Zawiya-i Hunud Multani (dervish lodge of the Indians from Multan). The 15 names associated with the Multani dervish lodge also received one gold coin as a stipend from the Ottoman state and included seven stipend payments to Indian women. This section is followed up by another collection of 15 individuals noted as the "Indians of the Zawiya of Herod's Gate"—the known modern location of the Zawiya al-Hindiya (the Indian Hospice in Jerusalem), while the previous two lodges are now nonexistent.[15] Similarly, Indian Muslim women are highly represented in the records, in which five of the stipend recipients are women, including three sisters named as Afifa, Amina, and Arifa.[16]

While women form an important part of the Indian community in Ottoman Jerusalem, directly receiving a significant portion of stipend funds for the Indian dervish lodges, the Ottoman sürre goes further by providing direct funds designated for "Indian women who are of the group (ta'ifa) of imperial (sultani) Indians and those from Multan."[17] In this section, 12 individuals are listed, each receiving 20 gold coins from the Ottoman state in the register. While five of the entries are listed as men, presumably as legal guardians, the remaining seven entries are designated funds for individual women, where all we know about them are their names—Fatima, Saliha, Ayesha, Fakhra, and others—Indian women in the Ottoman world who left few traces in other surviving archival and narrative material but can be found here in the stipend registers.[18]

These same categories appear in other years in the Jerusalem sürre registers throughout the early modern period, attesting to the longevity of this diaspora community. In the sürre register for Jerusalem in 1730 we find the category for Indian women designated as being "imperial Indians" and from Multan.[19] It is unclear what the "imperial" designator means in this context; either these women have more of a connection to the Ottoman sultanate than others, or they have a connection to the Mughal Empire directly. Nevertheless, in the 1730 sürre we find the same twelve entries of 20 gold coins each, but now with new names taking their place. In some six decades between registers, the Indian women listed here changed while the stipends stayed the same, including the names of stipend recipients such as "the children of Safiya daughter of Hajji Halil" and "Fakhra daughter of Hajji Fathuddin."[20] Here we have two women who are noted daughters of hajjis, an honorific only received upon completion of the hajj pilgrimage in Mecca, giving some faint suggestion as to how these women ended up from South Asia in Jerusalem.

The designated presence of Indians in the sürre register for Jerusalem stands out in many ways. While the sürre registers for Mecca and Medina included separate stipend lists of foreign residents from South Asia, those registers also included lists for foreign residents from Egypt, Yemen, East Africa (habeş), West Africa (takrur), the Balkans and Anatolia (rum), and Central Asia and Iran (acam).[21] In the Jerusalem register, by contrast, only stipend recipients from South Asia, along with those from Balkans and Anatolia, are carved out a specific category in the register, hinting at the importance and visibility of this diaspora community in early modern Jerusalem. One reason that these categories may exist in the sürre registers is that they served a purpose beyond simple charity and helped to boost Ottoman prestige and image abroad for non-Ottoman Muslims who received these stipend gifts.

In the city of Medina the seventeenth-century Ottoman pilgrim and poet Yusuf Nabi writes the following about receiving a stipend from the sürre and finding his name written down as one of the sweepers of the Prophet's tomb in Medina. He writes: "Since my name was on the list of the feraşet [sweeper of the Prophet's tomb] service, which bestows a kind of legitimacy upon Ottoman rule, I put on the honorable belt of the feraşet, and served by lighting candles at the Prophet's tomb."[22] Nabi

explicitly states that these sorts of payments gave legitimacy to the Ottoman Empire and its rule in sacred spaces. The Ottoman dynasty and its sultans claimed the title of caliph among their honorifics, alongside their role as guardians of the sacred cities of Mecca and Medina.[23] However, despite holding these titles, a significant challenge for the Ottoman dynasty was their inability to trace their lineage to prestigious origins like other competing Muslim ruling dynasties such as the Mughals and Safavids. Specifically, they lacked descent from the Prophet Muhammad's Qurayshi tribe (in the case of the Safavids) or from the medieval Mongol conqueror Genghis Khan (in the case of the Mughals).[24] The Ottoman dynasty's strategy therefore was gift-giving and support for pilgrims and foreign residents in Islam's holy spaces—an important symbolic and political gesture for legitimacy both within the Ottoman domains and for Muslims traveling from outside the Ottoman world. It is not difficult to imagine that purchasing legitimacy was the desired outcome for singling out and highlighting Indian Muslims in the sürre registers of Jerusalem. It was a show of Ottoman sponsorship of a global Muslim community in one of its most sacred spaces. Moreover, the economic importance of the sürre registers was not insignificant for the Ottoman Empire. In the seventeenth century the amount of the sürre payments to thousands of recipients between Mecca, Medina, and Jerusalem amounted to 3 per cent of the total Ottoman imperial budget; enough to fund half a year of a military campaign against the Habsburg Empire.[25]

Palestine, through its role as a sacred hub of the Ottoman world, was shaped by cultures of exchange and spirituality. In 1678, while traveling from Istanbul to Mecca for the hajj, Yusuf Nabi chose to divert his journey from Damascus and travel to Ottoman Palestine and the city of Jerusalem.[26] While not on the traditional caravan route from Istanbul to Mecca, Ottoman Palestine nonetheless drew pilgrims like Nabi because of its sanctity. Palestine was at the geographic center of the diverse Ottoman and broader Islamic worlds, and as such served as an important cosmopolitan crossroads populated by pilgrims from across the world, Muslim and non-Muslim alike. The stipend payments by the Ottomans to the diverse communities of Jerusalem are a testament to the significance of Palestine within the Ottoman realm. Despite Ottoman political power being centered in cities like Cairo and Damascus, Jerusalem's sacred status bestowed upon it a pivotal role in Ottoman politics as a legitimizing force for the empire and as a space of cross-cultural encounter for pilgrims from across the early modern world. It was a rare space in the early modern world which could facilitate an encounter between a female dervish from Multan and a poet-pilgrim from Istanbul.

NOTES

1. A version of this essay appeared in the *Medieval and Early Modern Orients* blog on November 27, 2023. Special thanks to the editors for helping me put that earlier piece

together, which became the foundation for this essay. See https://memorients.com/articles/the-mughals-of-ottoman-jerusalem.

2. Başbakanlık Osmanlı Arşivi (the Ottoman Archives of the Prime Minister's Office) (BOA), *Sürre Defterleri* EV.HMK.SR 168, fol. 30. "Indian" will be used in this essay to reflect how the sources ascribe identity to people from early modern South Asia, which use *hunud*, translating to "Indians."

3. For more information on the Mughal Empire and its cultural, political, and religious connections of the "gunpowder empires," see Stephen F. Dale, *The Muslim Empires of the Ottomans, Safavids, and Mughals* (Cambridge, UK: Cambridge University Press, 2014).

4. Evliya Çelebi, *An Ottoman Traveller: Selections from the Book of Travels of Evliya Çelebi*, ed. and trans. Robert Dankoff and Sooyong Kim (London: Eland, 2010), 298.

5. Ibid., p. 404.

6. Ibid., p. 23. For more information on the Qalandar Sufi order, see Lloyd Ridgeon, "Shaggy or Shaved? The Symbolism of Hair among Persian Qalandar Sufis," *Iran and the Caucasus*, 14(2) (2010): 233–263.

7. Çelebi, *An Ottoman Traveller*, p. 98.

8. Michael Pearson, *Pilgrimage to Mecca: The Indian Experience 1500-1800* (Princeton, NJ: Markus Wiener Publishers, 1996), p. 109.

9. See Ira Mukhoty, *Daughters of the Sun: Empresses, Queens and Begums of the Mughal Empire* (New Delhi, India: Aleph Book Company, 2018), p. 96.

10. EV.HMK.SR, 166, fol. 22b.

11. C.R. Singhal, "Two Persian Inscriptions from Surat," in G. Yazdani (ed.), *Epigraphia Indo-Moslemica* (Calcutta, India: Government of India Central Publication Branch, 1925–26), p. 12.

12. See the Indian pilgrimage narrative of Safi ibn Vali: Safi ibn Vali Qazvini, *Anis al-Hujjaj*, Nasser D. Khalili Collection of Islamic Art, accession no. mss 1025; also, for South Asian maritime connections from Surat, see A. Jan Qaisar, "From Port to Port: Life on Indian Ships in the Sixteenth and Seventeenth Centuries," in Ashin Das Gupta and Michael Pearson (eds.), *India and the Indian Ocean, 1500–1800* (Calcutta, India: Oxford University Press, 1987), pp. 331–349, and Shireen Moosvi, "The 'State Sector' in Overseas Trade: The Imperial Mughal Shipping Establishment at Surat," *Studies in People's History*, 2(1) (2015): 71–75.

13. For an example of a pilgrimage guide (Menasik ül-Hajj) which includes sacred cities in Palestine, Şeyh ül-Harem Sinan Efendi Amasi, *Menasik-i Hac Sinan Efendi*, Süleymaniye Manuscript Library, Yazma Bağışlar, no. 3723.

14. Navtej Sarna, *Indians at Herod's Gate: A Jerusalem Tale* (New Delhi, India: Replika Press, 2014), p. 96.

15. See ibid., and BOA, *Sürre Defterleri* EV.HMK.SR 168, fols. 29–30. Given the layout of the sürre registers, it appears that these two other lodges are in separate locations and indicate different structures from the currently surviving building in Jerusalem; however, this is not definitive, and these could simply be references to different sections of the same dervish lodge for Indians.

16. BOA, *Sürre Defterleri* EV.HMK.SR 168, fol. 30.

17. Ibid., fol. 41.

18. Ibid.

19. Ibid.

20. Ibid.

21. See BOA, *Sürre Defterleri* EV.HMK.SR 165, 166, 167.

22. For a transcription and summary of Yusuf Nabi's account, see Menderes Coşkun, *Ottoman Pilgrimage Narratives and Nabi's Tufetü'l-Haremeyn*, PhD thesis (Durham, UK: University of Durham, 1999), pp. 192 and 457–458. See also Menderes Coşkun, *Manzum ve Mensur Osmanlı Hac Seyahatnameleri ve Nâbî'nin Tuhfetü'l-Harameyn'i* (Ankara, Türkiye: T.C. Kültür Bakanlığı, 2002). For a full manuscript copy, see British Library Add 7904 and Add 7853.

23. For more on the early modern Ottoman Caliphate, see Hüseyin Yılmaz, *Caliphate Redefined: The Mystical Turn in Ottoman Political Thought* (Princeton, NJ: Princeton University Press, 2018), pp. 273–276.

24. Ibid., pp. 220–221.

25. Mustafa Güler, *Osmanlı Devleti'nde Harameyn Vakıfları (16. Ve 17. Yüzyıllar)* (Istanbul, Türkiye: Çamlıca, 2011), p. 223. See also Suraiya Faroqhi, *Pilgrims and Sultans: The Hajj under the Ottomans* (London: I.B. Tauris, 1994), p. 89.

26. Menderes Coşkun, *Manzum ve Mensur Osmanlı Hac Seyahatnameleri ve Nâbî'nin Tuhfetü'l-Harameyn'i* (Ankara, Türkiye: T.C. Kültür Bakanlığı, 2002), pp, 219–221.

7
To and from Sufi Jerusalem*

Dalal Odeh and Eman Alyan

The unknown is revealed through acts of knowing.
(Abu Hamid al-Ghazali)

In Jerusalem, no matter where one turns, there is a story. Travelers and pilgrims from around the world continue to fill its alleyways, and perhaps only they understand the effect the city can have on one's soul. Jerusalem's Old City is a series of mazes, and over time one's senses learn to navigate through them. It is a maze of multiple communities and cultures spread across tightly packed lanes, a maze of spiritual journeys and epiphanies. Neighborhoods, sometimes at the scale of only a few houses, commemorate communities with origins outside Palestine: Hayy al-hunud (The Indian Neighborhood), Harat al-magharaba (The Moroccan Quarter), and so on. We, as two native daughters of Jerusalem, asked ourselves: *What makes Jerusalem's Old City different from other cities?* What is the secret of its historical and religious significance? What is the magnetic pull that brought so many of these communities to the city?

In exploring these questions, we listened to the stories of families who settled in Jerusalem and made their home in and around the city's medieval Sufi lodges, migrations and relationships connecting the past to the present that help us better understand the secrets of the city. Each of the three surviving Sufi lodges has origins outside Palestine—India, Bukhara, Afghanistan—and are therefore relics of a kind of cosmopolitanism no longer found in a city that has been cut off from its organic extensions to the region and the world. Many newspaper and magazine articles have been written about these lodges, but in our reading, something is always missing. Either the articles are too superficial, or perhaps too lacking in depth and understanding of the Palestinian experience in the city. In researching and writing this essay, we decided to undertake a mini-pilgrimage ourselves, imagining ourselves as medieval travelers entering the Holy City: through Bab al-Sahira, for example, or Bab al-Amud,[1] and we visited the surviving Sufi lodges as if it were we who were searching for an experience the present reality of the city could not normally offer us.

* Translated from the Arabic by Adam Talib.

Sufism is rooted in purification. It is the cleansing the heart of spite and other negative emotions and base impulses,[2] and is often seen as the interior spiritual experience of nearness to God. Purification can only be achieved by devotion to God, so the Sufi lodges of Jerusalem were (and are) all oriented toward that goal exclusively. But Sufism is also a formal tradition, with organized lineages, *tariqas* ("orders"), scholarly works, and hierarchies. The two Sufisms—one personal and one institutional—exist simultaneously, often uneasily, in Jerusalem and elsewhere. In Jerusalem, the three surviving Sufi tariqas are the Shadhiliyya tariqa, the Naqshbandiyya tariqa, and the Chishtiyya tariqa. But traces also remain of other tariqas that have disappeared from Jerusalem, namely the Rifaʿi and Qadiriyya tariqas. We will discuss the histories of these tariqas later in this essay.

Historians disagree about the number of Sufi lodges that once existed in the city, but the most probable estimate is 36, at the highest-point of Sufism in Palestine during the Mamluk period.[3] Three of these survive into the present. The others have all been converted into mosques, or into private housing as a result of changing demographic and political priorities. The Judaization of the Old City and the unrelenting encroachment on Palestinian rights have been major factors in this transformation. For pilgrims, too, Jerusalem today is very different from the city it once was when it overflowed with Sufi pilgrims. The armed Israeli soldiers who pollute our sight today make it difficult to imagine what the city was like when its streets thronged with pilgrims from around the world speaking a variety of languages, and having arrived by boat, by caravan, or by foot. The expulsion of Palestinians in 1948 and the occupation of East Jerusalem in 1967 cut pilgrims from neighboring Arab and Muslim lands off from the city, severing cultural and religious bonds that went back centuries. As a result, Jerusalem ceased to be the center of pilgrim delegations in their journey to Mecca, as it had always been. In order to better understand the city's Sufi lodges, one has to imagine traveling in medieval times, when there were no boundaries, and when the world was wide open and vast lands were inhabited by diverse communities, each moving in every which way. Only then can Jerusalem be understood.

* * *

We began our journey at the entrance to the Naqshbandi lodge, which stands across from the Convent of the Sisters of Zion on the Via Dolorosa. A small green sign beside the door announces the building's name. We climbed the steep stairs as though ascending to the sky. Once inside, the lodge looked to us like a museum of artifacts (tiles, manuscripts, old photos) from Central Asia and elsewhere. Musical instruments hung on the wall, and there was a wardrobe full of clothes once owned by the people who called the lodge home. These items are not on display for their aesthetic value, but rather to demonstrate the lodge's enduring connection to its homeland. Connecting the lodge also to other holy lands was a framed scrap of the

kiswa, the cloth covering the Kaaba in Mecca, a present given to the lodge by an exiled Sufi sheikh from Jerusalem.

The *silsila* (lineage) of the Naqshbandiyya tariqa stretches back to Abu Bakr as-Siddiq, a companion of the Prophet Muhammad, but the tariqa takes its name from its founder, Baha' al-Din Mohammad Naqshband, who was born in 1318 in a village near Bukhara, in present-day Uzbekistan.[4] The term *naqsh* ("engraving") refers to the mark the name of God impresses on one's heart, particularly through the Sufi practice of *dhikr* ("remembrance"). Baha' al-Din earned a reputation for asceticism and self-sustenance. He grew his own barley, which he made into bread, and he fed the poor, serving them himself. One thing that distinguished Baha' al-Din from other Sufis in his tariqa was that he preferred to perform dhikr in silence rather than audibly (although modern Naqshbandi Sufis observe both kinds of dhikr). Another notable aspect of the Naqshbandiyya tariqa is an emphasis on pure altruism, a philosophy based on Baha' al-Din's affinity with the poor. The tariqa also distinguishes between two types of travel: outward travel, that is between one location and to another, and inward travel (*safar dar vatan* in Persian), which requires the renunciation of all desires.[5]

Founded in 1616, Jerusalem's Naqshbandi Lodge was once a regular site of spiritual meetings and hospitality. Today it is the private home of Hala al-Bukhari, the widow of Sheikh Abd al-Aziz al-Bukhari, who passed away in 2010. The lodge is also known as the Uzbek Lodge because for centuries it hosted pilgrims from Bukhara and elsewhere in Central Asia, and provided aid and sustenance to poor Muslims from those same regions. "Sufi lodges were like consulates," Hala al-Bukhari told us. By this she meant that each Sufi lodge historically served pilgrims arriving in Jerusalem from a given country associated with a lodge. Some of them only came to pray and observe dhikr during a short stay, but others settled in Palestine, like Sheikh al-Bukhari's ancestors.

When the lodge was fully functional, prayers and dhikr circles were held on Thursday evenings, sessions that were accompanied by a meal prepared by novices. Under Ottoman rule, each Sufi lodge received a supply of bread and meat, which was later replaced by funds from a charitable endowment (*waqf*).[6] When times were tough, people looked forward to the weekly meal and not just the ritual, Hala al-Bukhari explained, so the money the lodge received took into account how many people were present on those Thursday evenings.

The Naqshbandi Lodge maintained its tradition of Thursday evening dhikr sessions and banquets over the years, attracting notable local sheikhs like Hajj Amin al-Husseini, as well as Naqshbandi sheikhs from Uzbekistan, Kazakhstan, and elsewhere. Hala al-Bukhari informed us that the lodge had "a string of 1,000 prayer beads that they used to keep count." The participants in the dhikr would sit in a circle and pass the prayer beads around until they had repeated the name of God and the Prophet 1,000 times. The traditions of the Naqshband Lodge carried on until the 1967 defeat and the occupation of East Jerusalem. For a while, only

members of the al-Bukhari family took part, and then even that came to an end. The rooms in the lodge were converted into housing for the family, except for a part of the lodge which became a new treasury for the office for a department of the Jerusalem Islamic waqf. Unlike some other Sufi lodges, leadership of the Naqsh-bandi Lodge is passed along hereditary lines, rather than by appointment, and is currently a vacant position.

* * *

The next stop on our pilgrimage was the Afghan Lodge, today (but not always) asso-ciated with the Shadhiliya tariqa. We visited on a Thursday evening, when prayers in the name of God fill the air and one gets a clear sense of the space's spirituality. As we walked through the entrance, we found ourselves in a circular courtyard that contains a garden, where cats wandered along with the sounds of dhikr and prayer. The lodge also features small rooms with green doors, arranged in a circle, which used to accommodate pilgrims who would come from lands that are today called Afghanistan and Pakistan. Many of these travelers, like countless other travelers, would stop in Jerusalem on a spiritual layover on their way to Mecca and Medina.

The Afghan Lodge was erected near the al-Ghawanmeh Gate of the al-Aqsa Mosque complex in 1663. The lodge was established by Muhammad Pasha, the Ottoman governor of Jerusalem, and was originally known as the Qadiriyyah Lodge because of its association with the Qadiriyya Sufi tariqa. The Qadiriyya tariqa takes its name from the Persian mystic Abdul Qadir Gilani. Gilani had originally gone to Baghdad from his native Gilan in Iran as a student, and later settled there, devoting himself to spiritual guidance and teaching. He taught students in his Qadiriyya circle until his death in 1166. Unlike the Naqshbandiyya, the Qadiriyya tariqa is known for its audible dhikr sessions during which participants move their bodies in ecstatic flow while repeating the names of God.[7]

Over time, owing to the preponderance of Afghan pilgrims and the priorities of the Tanzimat reforms in the late Ottoman period, the lodge was renamed the Afghan Lodge. An inscription over the main door declares:

> In the name of God, the most merciful and most compassionate, this Sufi lodge is dedicated to our guide and master, a beacon for mystics and the dean of the virtuous, Abdul Qadir Gilani, may God favor him, 1043/1633.

The rebranded lodge was led by sheikh Abd Allah al-Afghani, whose grandsons, Abd al-Karim al-Afghani and his brother Yusuf al-Afghani, are responsible for the lodge today.[8] "My grandfather came here from Afghanistan on his way to Mecca," Abd al-Karim, told us. "Do you know how he got here? He walked. It took him probably something like six months." He went on to explain that his grandfather arrived in Jerusalem as a young man on his own and had to learn Arabic. He later married a woman from Hebron, who was still alive at 100 years old when we visited

the lodge. Abd Allah al-Afghani took over the administration of the Afghan Sufi lodge, which continued to host pilgrims from Afghanistan and Pakistan in its 1.5 meter by 1.5 meter rooms until 1967.

Yusuf al-Afghani, the current head of the lodge, recalled for us how different Jerusalem used to be before the occupation:

> Before 1967, it was easy to move between countries, and Afghanis would come through Jerusalem on their way to Mecca. They marked the official start of their pilgrimage from the al-Aqsa Mosque, traveling via Medina on their way to the Holy Sanctuary, and they followed the same route on their return as well. The travel was all over land, from Turkey to Syria to Jordan to Saudi Arabia, and of course all the Syrians passed through Jerusalem, too. It's on the way, and there are plenty of holy sites to visit. We used to see Syrians, Turks, Afghans, people from all over the world. All kinds of people used to come for the holidays. At Easter, tens of thousands of Egyptian Coptic Christians would come to Jerusalem, in addition to Syrians, Lebanese, and Iraqis. Jerusalem was open to everyone. "The land that We have blessed for the worlds," as God says.

In 1980, the lodge was renovated and re-opened as a Shadhili Sufi lodge. Like the life trajectory of Gilani, the founder of the Qadiriyya, the Shadhiliyya tariqa's founder, Abu al-Hasan al-Shadhili, also lived a life of free movement across vast regions without political borders. Born in Morocco in 1196, al-Shadhili would go on to study Sufism in Tunis before settling in Alexandria. He was on his way to Mecca for pilgrimage in 1258 when he died in the desert near the medieval Red Sea port city of Aydhab.[9] The modern Shadhiliyya tariqa is also associated with Sheikh Ahmad al-Alawi, who lived and taught in French Algeria. Before going on to found his own tariqa, al-Alawi sought to make the Shadhiliyya compatible with European modernity. Sufism, as a practice, does not necessarily reject progress or modern lifestyles.

* * *

Our itinerary finally took us to a staircase to the right of Bab al-Sahira, where, ascending a few steps, we entered the world of the Indian Sufi lodge, associated with the Chishtiyya Sufi tariqa. The name of the lodge is written at the entrance on both sides of a green door, in Arabic on the right and in English on the left. Part of the lodge is now used as a United Nations Relief and Works Agency medical clinic for registered Palestinian refugees. There is another green door which separates the living quarters from the remainder of the space—one of the largest and most expansive in all of the Old City. The lodge contains a mosque and an important library collection, which includes old books, records, and archives, and photographs of the lodge over the decades, including photographs of visitors (Indian politicians, diplomats, ambassadors, etc.). Between the main door and the door, which leads

to the area where the lodge director and his family live, we walk along a tree-lined corridor beneath the sky.

The tariqa was established in the early centuries of Islam in Chisht, in what is now Afghanistan, by Abu Ishaq Shami, a descendent of Ali ibn Abi Talib. It was later brought to India by Mu'in al-Din al-Chishti, where the tariqa flourished and continues to do so. Perhaps because of its Indian origins far away from the homelands of many other tariqas, Chishtiyya rituals and customs differ significantly from the other tariqas in Jerusalem. For example, the Chishtiyya puts an emphasis on using music during their dhikr, and followers historically dressed in clothes that were dyed with the bark of acacia trees. Another interesting particularity can be found in Chishti initiation rites, which involve visiting the tomb of a holy person at the culmination of a 40-day fast.[10]

The Indian Lodge in Jerusalem was founded to commemorate Baba Farid Ganjshakar, a Chishti mystic from Punjab whose Sufi practice was similar to yoga in many ways. Baba Farid was believed to have traveled to Jerusalem in the twelfth century, where he found a cave near the al-Aqsa Mosque in which to perform a *chilla*, a 40-day meditation practiced by Sufis in South Asia. But Baba Farid is believed to have performed his *chilla* upside-down, like a yogi. We do not know when exactly the site was commemorated as the *maqam* (shrine) and lodge that it is today, nor how it became associated with the Chishtiyya, but we know from Mujir ad-Din al-Hanbali's classic history text *al-Uns al-jalīl bi-tārīkh al-Quds wa-l-Khalīl* that the lodge was originally founded for mendicants of the Rifa'i Sufi tariqa.[11]

Over the decades, the lodge had fallen into bad shape. Nazir al-Ansari, the current caretaker of the lodge, told us that Hajj Amin al-Husseini, the leader of the Palestinian nationalist movement during the British Mandate, visited the lodge in 1924 to pay his respects after the death of its director. To Al-Ansari, this visit demonstrates that the lodge has long been an important symbol of faith and diversity in the city. Hajj Husseini had himself traveled to India during this period to secure support from Indian Muslim leaders for the Palestine cause, and it was they who financed the renovations of the lodge and sent one Nazir Hasan al-Ansari (the current Nazir al-Ansari's grandfather) as its caretaker. The elder al-Ansari moved to Jerusalem to take up his new role, leaving two wives and children behind, but soon started a new life, marrying a woman from the city and then taking a second Indian wife. It was during his tenure that the lodge became a port of call for visitors from the Indian subcontinent and those with Indian origins. Al-Ansari continued working to renovate the lodge and improve the quality of its services throughout his directorship, which ended with his death in 1952.

As an Indian who somehow became Palestinian, al-Ansari is remembered as having dressed in both traditional Indian clothes and the Palestinian turban and *jalabiya* (loose-fitting tunic), and one of his wives suffered the most Palestinian of fates during the 1967 War—martyrdom. Al-Ansari's work was continued by his son and successor, Muhammad Munir al-Ansari, who passed away in 2024.

Muhammad Munir's son, Nazir al-Ansari, along with his brothers today continue to follow in the footsteps of the man who came to Jerusalem from India in the early twentieth century, to honor the memory of a man who came to Jerusalem from India in the twelfth century.

*　*　*

Everyone in Jerusalem today is fighting to survive. While all the lodges are registered as Islamic charitable foundations, they nonetheless continue to face multiple threats to their future. In this, each Sufi lodge has a unique strategy for preserving its historical character. For example, the Naqshbandi Lodge is vigilant about recording all the manuscripts and artifacts in its possession, many that can be traced back to Uzbekistan. Hala al-Bukhari continues to pursue her late husband's agenda of traveling to meet with Naqshbandi Sufi Muslims around the world and disseminating religious and moral instruction, as well as welcoming visitors to the lodge, part of which is now her private home. She believes that religious faith can be found not only in books and prayer, but also through connecting with others: "I'm motivated by my faith, and my trips abroad have helped me to see that it isn't enough just to study—not even if you read all the books in the world. You learn something new from every person you meet."

Her son, Izzeldin Bukhari, the rightful heir of the Naqshbandi lodge in Jerusalem, did not formally study Islam. However, having grown up in a milieu of dhikr and spiritual wayfarers, Izzeldin channels his Sufi values into a unique project in which he uses vegetarian Palestinian cuisine to highlight Sufism, kindness to animals, and spirituality through plants and food.

The Indian Lodge continues to be a little piece of India in Jerusalem. Nazir al-Ansari continues to welcome Indian and Indian-origin pilgrims and travelers, although today functioning more like a hotel, and the guests tend to be Indian or Pakistani Muslims holding citizenships of Western countries. Through this continuing relationship with India and Indians, the al-Ansari family maintains its ties to India while also being fully Palestinian. Palestinians in Jerusalem do not hold Israeli citizenship but are "residents" of the city, and the al-Ansari family continues to hold Indian passports. His son Yusuf is currently studying in India, in a university near Delhi, in order to strengthen his complex cultural identity, and so that one day perhaps he will be able to translate his grandfather's memoirs from Urdu into Arabic or English.

The Afghan Lodge is the only Sufi lodge in Jerusalem today that continues to hold regular dhikr circles. It opens its doors regularly to men on Monday and Thursday evenings, but during Ramadan the lodge also welcomes women from Jerusalem and across Palestine. However, due to the establishment of border regimes that came with the founding of the Israeli state, the lodge no longer hosts pilgrims from Afghanistan and Pakistan. As a result, it has been cut off from its geographical, historical, and cultural homeland. One of the al-Afghani family members remembered

that his grandfather used to wear the Afghan cloak and spoke an Afghan language, although he is not sure which. "His Arabic was poor," he told us, indicating that the family only recently (and quickly) became also a Palestinian family. "Our family is from Afghanistan, so it's natural that we long for the place. We long for our relatives, our people, the landscape. Anything Afghan. Of course, people miss their relatives and their homelands. But we're a part of this lodge, too."

* * *

Each member of the caretaking families belongs to multiple communities, so while one might introduce themself as "Indian," another is "Naqshbandi" or "Palestinian." Several refuse to reduce themselves to concise identitarian labels. Because Jerusalem has been cut off from the rest of the Sufi world, the younger generations of these Sufi families have had to invent their own means of connecting to their homelands, but the existential challenges of being a Sufi in Palestine, in Jerusalem, are also considerable. Nader al-Afghani, for instance, is the principal of the al-Aqsa Boys' Secondary School in the Old City, where his students are regularly beaten and arrested by Israeli soldiers. But how can one be a Sufi while facing Jerusalem's stress, anxiety, and oppression? Nader answers that one needs reserves of spirituality and faith to confront life's challenges. He argues that conventional ideas about Sufis rejecting the world and focusing on interiority do not apply to the situation in Jerusalem. "The more Sufi you are, the kinder you become," he told us. "And the kinder you are, the more Sufi you become." How can you know if your Sufi practice has made you kinder if you don't have to face life's challenges such as those we find in Jerusalem?

The Israeli occupation will one day end, as all occupations eventually end, but Jerusalem will remain. Each stone block in each of the three surviving Sufi lodges bears witness to the ghosts of people whose bodies have long since disappeared, but whose memories make the city what it is.

NOTES

1. Bab al-Sahira is known in English as Herod's Gate, and Bab al-Amud as Damascus Gate.
2. ʿAbduh Ghālib Aḥmad ʿĪsā, *Mafhūm at-taṣawwuf* (Beirut: Dār al-Jīl, 1992), p. 11.
3. Saʿed Abu Lawi, "Sufism in Jerusalem in the Mamluk Era (648–923 AH/1250–1516 AD) (Historical Study), master's thesis (Nablus, Palestine: An-Najah National University, 2007, pp. 63–92.
4. Muḥammad Darnīqah, *aṭ-Ṭarīqah an-naqshabandiyyah wa-aʿlāmuhā* (Tripoli, Lebanon: Jarrous Press, 2007), pp. 11–18.
5. Ibid., p. 25).
6. ʿĀrif al-ʿĀrif, *al-Mufaṣṣal fī tārīkh al-Quds* (Beirut, Lebanon: al-Muʾassasah al-ʿArabiyyah li-d-Dirāsāt wa-n-Nashr, 2007), pp. 720–722.
7. ʿĀmir al-Najjār, *aṭ-Ṭuruq aṣ-ṣūfiyyah fī Miṣr: nashʾatuhā, nuẓumuhā, wa-ruwāduhā* (Cairo, Egypt: al-Hayʾah al-ʿĀmmah al-Miṣriyyah li-l-Kitāb, 2007), pp. 106–116.
8. al-ʿĀrif, *al-Mufaṣṣal fī tārīkh al-Quds*, p. 722.

9. Shams ad-Dīn al-Dhahabī, *al-ʿIbar fī khabar man ghabar* (Beirut, Lebanon: Dār al-Kutub al-ʿIlmiyyah, 1985), p. 282.
10. ʿAbd al-Munʿim al-Ḥifnī, *al-Mawsūʿah aṣ-ṣūfiyyah* (Cairo, Egypt: Dār ar-Rashād, 1992), pp. 103–104.
11. Mujīr ad-Dīn al-ʿUlaymī al-Ḥanbalī, *al-Uns al-jalīl bi-tārīkh al-Quds wa-l-Khalīl* (Najaf, Iraq: Manshūrāt al-Maṭbaʿah al-Ḥaydariyyah, 1968), p. 48.

8

An "Air Smelling Event": The Metamorphosis of Simon the Just and His Shrine

Salim Tamari

An "air smelling event" is the term used to describe the spring festival of Simon the Just (Shimon ha-Tsiddiq, also known as Simeon the Just) in a 1927 review of this popular pilgrimage site in northern Jerusalem (see Figure 8.1). The coverage is visually striking due to the major transformation that engulfed this physical site and celebrations of the event as well as its audience during the 100 years or so that had elapsed since the First World War. During clashes in East Jerusalem in 2021, the shrine of Simon the Just became a focus point of Jewish zealot claims for a foothold in the Sheikh Jarrah neighborhood. The claims were linked not only to the historical entitlements over the tomb shrine, but also for the surrounding properties over leases belonging to Jews before the 1948 period.[1] One feature of this contestation was the meaning and relevance of saint shrines (*maqamat*) for popular religious belief and their transformation in the twentieth century from syncretic sites of worship and visitation to a nationalist and exclusive domain to their new "born again" adherents.[2] This is a development that marked several sites in the *bilad al-sham*, but also Palestine in particular. Nebi Musa (Jericho), Nebi Rubeen (Jaffa), St. George/al Khader (Lydda, Bethlehem), and Nebi Saleh (Ramleh) were leading sites in central and coastal Palestine that served Muslim, Jewish, and Christian adherents during their seasonal festivals (*mawasim*).[3] Their dominant service was in providing healing and therapeutic functions throughout the year. But they were mainly the sites of public festivities during the saint's season.[4] During the late Ottoman and early Mandate period, many of these sites of public celebration became a subject for communal and sectarian clashes as the Zionist movement began to turn into territorial claims over land. The process led to a "nationalization" of the shrine/maqam as an exclusive domain for its putative religious community. This was particularly the case with Nebi Musa (Moses), whose maqam turned into an arena for nationalist mobilization during the 1920s and 1930s.

In what follows I will examine and discuss the transformation of the shrine of Simon the Just in Sheikh Jarrah from a site of communal visitation to a nationalist shrine of territorial contestation. Although ostensibly a tomb for an ancient Jewish Rabbi, it came to be celebrated as a "coming of spring" (*shamm al-hawa*) festival for local Sephardic Jews, as well as Christian and Muslim Palestinian Arabs.

Figure 8.1 The only published image from Maynard Williams' "Simon the Just Festival" as it appeared in Edward Keith-Roach, "The Pageant of Jerusalem," *National Geographic*, 52(6) (1927): 635–681.

The historical roots of these celebrations indicate the substantial transformation which has engulfed popular attitudes toward the saint, as well as the manner in which nationalism and ethno-consciousness affected these attitudes. Simon the Just was the Jewish high priest during the period of Alexander's conquest of Palestine (333 BC) and held office for 40 years. According to both Josephus and other Jewish sources, he rebuilt the walls of Jerusalem which were destroyed by Ptolemy.[5] He was called "the Just" because of his maxim: "The world exists through three things: the Law, worship, and beneficence,"[6] Josephus claims that Alexander traveled to Jerusalem expressly to meet with Simon the high priest, where he demanded that a statue be constructed for him in the temple. Simon reputedly refused, promising that instead all sons of priests born that year would be named after Alexander.[7]

There is also a "Christian" Simon the Just, also known as "the Righteous," who is venerated by Catholics and the Orthodox Church. According to Charles Seymour, the Evangelist Luke Simeon (Symeon) in the Catholic tradition was the "just man" who received in his arms the infant Christ when he was presented at the Temple, "then took him in his arms and blessed God, followed by the 'Song of Simeon,' the Nunc Dimittis of the Latin Liturgy" (see Figure 8.2). According to this tradition, Saint Simon is buried three times: in Constantinople, in Croatia, and in Venice.[8]

It seems that the veneration of Simon the Just by Jewish pilgrims at the Sheikh Jarrah site was a later practice. In the twelfth century, Benjamin of Tudela identified Timna, near Tiberius, as the site of Simon's shrine. By the fourteenth century

Figure 8.2 Rembrandt, *Simeon with the Infant Jesus in the Temple* (*c.* 1669). Nationalmuseum, Stockholm, Sweden. www.wga.hu/ frames-e.html?/html/r/rembrand/14biblic/68newtes.html.

it shifted to the Jerusalem site, while others continued to visit it near the Sea of Galilee. Interest in the Jerusalem shrine was revived in the early nineteenth century, with increased pilgrimage to Jerusalem during the late Ottoman period.[9]

In 1871, Clermont-Ganneau, the leading French archeologist at the time, discovered an inscription in the supposed site of Shimon that made him, and later most contemporary archeologists, question the authenticity of Simon's grave site. "The inscription had been badly damaged by hammering, but the first line clearly read *Juliae Sabinae*, indicating to Clermont-Ganneau that the tomb was that of a Roman matron named Julia Sabina."[10] Historians and archeologists reached a consensus that the tomb was of Roman origin and could not be that of Simon the Just. This, however, did not deter continued Jewish worship at the site, and according to Isaac Reiter, a Jewish residential presence developed around the tomb in the last third of the nineteenth century. Simultaneously, the shrine became the center for shared communal spring celebrations by Muslims, Jews, and Christians, as witnessed by contemporary visitors.[11] This shared observance of the shrine of Simon the Just is most likely a modern nineteenth-century phenomenon, related, I would suggest, to increased security outside the city walls, and the growth of Sheikh Jarrah in the second half of the nineteenth century as a bourgeois neighborhood for Jerusalem's

primarily Muslim upper class. The naming of the event surrounding the season of Shimon ha-Tsiddiq as "al-Yahudiyyeh" attests to the recognition by Palestinian Arabs of the Jewish origins of the saint.

Two important sources are available for Shimon ha-Tsiddiq as a communal site of veneration in the twentieth century: the Palestinian musician and chronicler Wasif Jawharriyeh's description of *shat-hat al-yahudiyyeh* ("the Jewish Picnic") in the early part of the twentieth century, and William Owen Maynard's ethnographic notes and images from his visit to the site in 1927.[12] The latter are particularly relevant to our discussion since they contain unreleased and unpublished archival material (mostly photographs) of the shrine and its uses in the early Mandate period, before the transformation of these religious sites into arenas of exclusivity.[13]

It was during the liminal post-First World War period in which the shrine became a shared communal Palestinian event—"liminal" because Ottoman communal events were still celebrated, and because the impact of nationalist appropriation of religious motifs with the onset of Zionism had not yet set in. These shared ceremonies of Simon the Just were vividly captured in the 1920s by Maynard Owen Williams' camera during a commissioned work for *National Geographic*. Only one of his photographs appeared in the article published at the time under the exotic title of "The Pageant of Jerusalem."[14] The bulk of Williams' notes and his photographs remained dormant in the archives of the *National Geographic* until they became accessible in 2021. This cache constitutes an important eyewitness account for these communal celebrations described by local Jerusalemites for the pre-First World War period. In particular, Williams vindicates the observations of contemporary writers like Wasif Jawhariyyeh about the nature of the event and its attendees. He calls the event "an air smelling country fair" in reference to the Arabic term *"shamm al-hawa"*—or what the Egyptians call *"shamm al-nassim."*

THE JERUSALEMITE COMMUNAL OUTINGS

In his memoirs, *al-Quds al-Intidabiyya*, Jawhariyyeh refers to two spring festivals that took place in North Jerusalem. Those were the summer outings (*shat-hat*) of Sa'ad wa Sa'id, and the Yahudiyyeh picnic in Sheikh Jarrah. Both outings were held within the same area, separated by a distance of less than half a kilometer. Of the former, he narrates the tradition of a Christian-Muslim festival which had "no religious content," while for the latter he narrates a Jewish-Muslim-Christian event:

> The festival held in the Sa'ad wa Sa'id Quarter of Jerusalem was merely intended to provide locals, both Christian and Muslim, with an opportunity to go out, and had no religious basis like the other festivals. The Sa'ad wa Sa'id Quarter could be found between the Mosque of the Sa'ad wa Sa'id, opposite the Dominican Monastery on Nablus Road, and the road running behind al-Mutran English

School (Saint George School), near the entrance of Synhedria. To its south lie the recently built houses of al-Musrara Quarter, starting with the properties of the al-Duzdar family and stretching all the way to those of Hassan Bey al-Turjman. Olive trees abound in this area, and since it is close to the Old City, to Damascus Gate and Bab al-Sahira (Herod's Gate) in particular, the people of Jerusalem have long taken to the habit of going there at sunset when the gates of the city are closed. Thus, in summer, families with children left the city every afternoon and went there for a promenade.[15]

The al-Yahudiyyeh picnic, by contrast, was a much wider event involving Jews as well as Arab Christians and Muslims:

There are two caves in the quarter of Sheikh Jarrah in Jerusalem, near the lands of Abu Jubna's mortmain which Jews believe to be the graves of Shimon. I think Jews visited these graves twice a year, spending the day under the olive trees. Most of them were Eastern Jews who observed the Eastern traditions, the country's Arab traditions in particular. They had string bands. I remember Haim, the oud player from Aleppo who had a voluptuous high voice and sang Andalusian muwashah mostly. And so, everyone spent the entire day singing songs and uhzujas. The Christian and Muslim Arabs of Jerusalem celebrated with Jews, and families went along to take part in what is known to the Arabs as the Judea Festival [yahudiyya]. That part of the mountain was therefore crowded all the way down to the valley with locals and ambulant sellers. My brothers and I never wasted an opportunity to be among them.[16]

Jawhariyyeh distinguishes between Saʿad wa Saʿid festivals (which had no religious or communal basis), and al-Yahudiyyeh, which was based on veneration of Simon the Just. Nevertheless, the sectarian putative origin of the site did not impede its shared veneration, as indeed was the case of al-Khader (St. George), Nebi Rubeen (Rubin of the Old Testament), Nebi Saleh, and many other Biblical and Qurʾanic saints. Jawharriyeh also emphasizes the Sephardic Jewish presence (what he calls "Eastern Jewish"—yahudi sharqi) in al-Yahudiyyeh and makes a particular reference to the Aleppo band headed by Haim the Oud player performing Andalusian muawshahat. These observations about the syncretic nature of Simon the Just are unique since there is scarce reference to them in contemporary memoirs by European or local sources. An exception is Pinhas Grayevsky (1873–1941), the Jerusalem historian who lived in the Yemin Moshe neighborhood and wrote about the Jewish life in Jerusalem in the 1870s. He noted that Arabs participated in the festivities of Shimon ha Tsiddiq, and that "the wives of the Ishmaelites would also come and stake a permanent place on the hill facing the square."[17] Another Ashkenazi reference to the Jerusalem "Ishmaelites" comes from the local paper ha-Shkafah in 1905:

[At the military barracks] one of the Ishmaelite notables said a special prayer for the health of the respected majesty of His Majesty the Sultan, and all the assembled responded 'Amen,' and the army musicians played their music, and the soldiers presented their arms, all crying 'Amen! Amen!' After this, all the consuls, heads of the religions, and the scholars and dignitaries of our city came to the saraya [the governor's palace], and the army musicians played their music, and the soldiers presented their arms in honor of the esteemed guests who had come.[18]

The "Ishmaelites" here is not particularly a reference to Muslims, but jointly to Christian and Muslim neighbors.[19] I was not able to find this Ishmaelite reference, however, in Mizrahi literature, or even in literature pertaining to Sephardic communities. This could be because of the fact, one presumes, that they were already partaking in these joint activities, which made them some sort of Ishmaelites themselves. The reference is further significant not only because it acknowledges the Arab presence in the site from an early Jewish perspective, but also because of the archaic sectarian "Ishmaelite" reference to Arab women. It was not uncommon in the late Ottoman period to use this term by Ashkenazi Jews in Palestine, and it was not necessarily pejorative, although it performed a *distancing* function—perhaps in the same manner in which Syrian Jews and Karaites were differentiated by their Yiddish-speaking co-religionists. In many cases the term "Ishmaelite" was used by the Ashkenazi writers in reference to the families of the Palestinian Arab elite.[20]

Another source that sheds light on the changing character of these popular religious practices is Robert Lachmann, the German ethnomusicologist who moved to Sheikh Jarrah in the 1930s and lived in the vicinity of Simon the Just's shrine. Lachmann had already established himself as an authority on Arab popular religious music from his work on Jewish incantations from Jerba in Tunisia.[21] While in Jerusalem, Lachmann recorded a number of ritual and non-ritual performances by native musicians, as well as pieces by migrant Yemenis, Kurds, Moroccans, and Gypsies. Many of them were recorded *in situ*, such as the incantation of the Samaritan priest from Mt. Gerizim in Nablus, but mostly they were recorded in the studios of the Palestine Broadcasting Service on Prophets Street, where Lachmann had a program appropriately called *Oriental Music*.[22] I could not locate a recording made by Lachmann of any celebratory incantation from the festival of Shimon ha-Tsiddiq, but there are many similar recording of Coptic, Samaritan, Jewish, and Muslim festival music—all aimed at preserving the "purity" of the original performance from the perspective of Lachmann's orientalist and essentialist views. What is peculiar about this essentialism, however, is that it undermines and transcends the binary Arab–Jewish dichotomy which became a standard device of viewing folk traditions from this period.[23] One can see this subversion in several episodes recreating Lachmann's recordings in Jumana Manna's 2015 film *A Magical Substance Flows into Me*, in which we witness, among other items, a Jerusalemite Sephardic

singer chanting in Ladino and Arabic, and a Nabulsi Samaritan rabbi's incantation from the Torah.[24]

AN OLFACTORY MOMENT

In the Maynard Williams review mentioned above, the author refers to the Feast of Simon the Just as a remarkable event, "because at this time Jews, Moslems, and Christians get together near the beginning of Nablus Road at the extreme north edge of the city outside the walls for an 'air smelling' sort of picnic and country fair."[25] The caption is accompanied by a striking series of eight images that were never used with the original article. The "captured moment" takes the viewer to an era that has totally disappeared from the annals of Palestinian history—Arabs and Sephardic Jews, quite often indistinguishable in their dress, partaking in reveries of socializing, drinking, and music performance. At the end of the series there is a children's playground equipped with a wooden (obviously temporary) merry-go-round wheel that is well attended by adults. Hovering across from the playground can be seen the villas of the Jerusalem aristocracy— the Husseini, Jaralla, and Nashashibi families—who have already expanded into the northern hills of Sheikh Jarrah.

This moment of concordance was to disappear very soon with the Great Arab Revolt of 1936, and before that with the communal strife of 1929, just two years after the photos were taken, in what Hillil Cohen called "year Zero of the Arab-Israeli conflict."[26] Only one of these photographs appeared in the original article by Edward Keith-Roach, in which the intensity of the interaction between the revelers is not seen. Rather, we have here an idyllic picnic scene reinforcing the rubric of "a city of three faiths, that is still the holy city for all."[27] The description here is of three communities co-existing, *but each in its separate domain.* Under the heading "Pageantry of Religious Festivals," Keith-Roach writes: "The religious festivals bring their own pageantry o the city. There are Moslems with all their adherents from Northern Africa, India ...; Christians of all denominations ...; the Jews divided into Ashkenazim, Sephardim, Karaites, Yemenites, etc."[28] Maynard Williams contributed the photographic illustrations, including a single image of Simon the Just that shows the enclave of the tomb, but not the revelry that appeared in the archival collection. The caption here introduces the notion of a mosaic society elevated several decades later by Jerusalem mayor Teddy Kollek.[29] The historian Meron Benvenisti writes:

> Here is the reference to the festival of Simon the Just in the original Keith-Roach article: "Christians and Moslems, as well as Jews, come every spring to this festival at the north end of Jerusalem. Simon, a Jewish scribe, was one of a line who passed on the oral law given to Moses, but not recorded in the Penta-teuch."[30] The image that accompanies the article recognizes Simon the Just as the only festival involving the three religious communities, but their interaction is muted here. Obviously, it was Maynard Williams and not Keith-Roach who

had recorded the syncretic features of the event. In his words "Jews, Moslems and Christians get together … for an air smelling picnic." The images that he recorded, I suggest, show not only "Arabs and Jews" celebrating and intermingling in the occasion but a moment of de-ethnicized communal gathering. The olfactory moment ("air smelling") has united the crowds, and—at least momentarily—has created a shared experience of public euphoria.

Maynard Williams also captured a significant moment in which the communitarian character of the event was turning into a secular outing, but without losing its religious aura (see Figure 8.3). But Williams was not particularly concerned with the ethnic character of the Jerusalem ceremonials. His main objective, as he clearly confessed, was the destructive character that modernity engendered, in his view, in the disappearing world of Palestinian traditionalism.[31] Like Tawfiq Canaan before him, he wanted to record an ethnography of Palestine before the onset of modernity, by preserving what he thought was the "immutable East" in which this moment of religious communalism is frozen for ever in his photographs. "Here was a city, sacred to Moslem, Jew and Christian"—he wrote, "losing the character for which it had been distinguished for centuries. I longed to record something of it before it was too late."[32] But observers of the urban ceremonial scene contemporary to him, such as Khalil Sakakini and Jawhariyyeh, were not saddled with either the biblical themes or exoticism of the event, and did not particularly see it as a "mosaic

Figure 8.3 Detail from "Arab Jews," one of Maynard Williams' unpublished photographs of the Simon the Just Festival, Jerusalem, 1927. *National Geographic* Archive.

of coexistence." Rather, they experienced these events as a common ground for the urban population whose religious affiliation, though distinct, was not the defining arbiter of the event. They participated in the event as compatriots sharing the same common space of the city. They shared the music, food, and language of the city. The religious iconography is there, but it is lurking in the background and has been replaced by public "secular" reveries.

Neg.#43261-A-Photo by Maynard Owen Williams

PALESTINE -- JERUSALEM

The Feast of Simon the Just, remarkable because at this time Jews, Moslems, and Christians get together near the beginning of the Nablus Road at the extreme north edge of the city outside the walls for an "air-smelling" sort of picnic and county fair. Jerusalem, Palestine.

ELP.July.1927 INDEXED APR
Rec'd 1927

Figure 8.4 A selection of Maynard Williams' unpublished photographs with a description of the Simon the Just Festival, Jerusalem, 1927. *National Geographic* Archive.

The unpublished images taken by Williams vividly reveal this shared communal moment of "air smelling." I have chosen several of those images which have rarely been published (see Figure 8.4). In the first, the large number of celebrants are filling the area outside the tomb area, almost oblivious to any religious ritual taking

place there. In the second, a closer look at the revelers reflects the carefree picnic nature of the event. The dress code shows substantial hybridity with *franji* jackets and European skirts, dresses competing with *tarabeesh* (fezes) and some *qanabeez* (traditional robes) for men. What is striking here is the intermingling of men and women in the open space—a phenomenon that does not occur in other *mawasim* like Nebi Musa. In the latter mawsim, probably the largest and most *national* of the spring festivals in Palestine, the viewers and participants alike were engulfed in the militarized atmosphere that accompanied the revelers, as well as with the conspicuous presence of the state through its gendarmes and public officials, as we can see in Figure 8.5.

Figure 8.5 "Smelling the Air with the Ishmaelites," a second set of Maynard Williams' unpublished images of the Simon the Just Festival, Jerusalem, 1927. *National Geographic* Archive.

Another feature of these images is the apparent spontaneity and tranquil atmosphere they convey. This contrasts clearly with images of the crowds in formal and state-sponsored events such as the procession of Nebi Musa, which took place at the same time of the year. Michael Talbot, discussing the reaction of the Jerusalem crowds to celebrations by Ottoman musical bands, contrasted to the more spontaneous reaction of the local celebrants of Nebi Musa, and noted the "awkward, static and wooden stances" of the gatherings in these events:

The formal, static, wooden stances and carefully composed diversity of the Jerusalemite crowd mirror those of the official photographs and the newspapers' panegyrics and laudatory narratives. Just as the joy spread by the band in the accounts of *Havatzelet* [newspaper] was formulaic and repetitive, so too are the images of a populace awkwardly represented by endless posed images of silent, straight-faced gatherings under arches and outside public buildings.[33]

In his detailed analysis of the photographic images of the musical performances, Talbot punctures the notion that these events were "joyous public celebrations" or, in official parlance, "Sparks of Happenstance." He writes of the public reaction to the performance of military bands:

> The stereoscopic photograph of the performance of the military band in Jerusalem ... tells us something important about the relationship between state and subject in that one moment, from which broader ideas can be explored. Although the scene has not been staged for the camera, it shares an aesthetic with the wider corpus of posed Hamidian images. The band conveys an image of professionalism, but the reaction of the crowd gives a hint at the quality of their performance. The diversity of the crowd is itself illusory, a temporary gathering that would soon dissolve back into its constituent parts.[34]

One reason for these wooden stances was most likely the paused nature of the photographs arranged during the musical event, but the fact that those state-sponsored gendarmerie ensuring law and order were a distinguishing feature helps explains the relaxed and spontaneous character of the reverie at Simon the Just. In this regard, one should compare it not with the Nebi Musa celebrations, but with the Nebi Rubeen festival on the southern shores of Jaffa. In Nebi Rubeen, as in the case of Simon the Just, we notice the absence of the state and its gendarmes regulating the event, with the celebrants expressing a spontaneity and engagement with the event (see Figure 8.6).

Figure 8.6 Nebi Rubin celebration, 1935. G. Eric and Edith Matson Photograph Collection, Library of Congress, Prints & Photographs Division, Washington, DC.

CONCLUSION: THE LIMITS OF COMMUNAL BOUNDARIES

In this essay I have attempted to show how ethnography and historical photography can illuminate a submerged "air smelling" event—a lost world of communal shared space. The shrine of Simon the Just in Sheikh Jarrah has been at the epicenter of new confrontations at the confluence of religion and territorial Zionism. Simon the Just was a sage, a messenger, and a saint in the Jewish tradition, as well as in Orthodox and Catholic traditions. His burial place has been contested within the Jewish community between Jerusalem and Tiberius, and among Christians between Constantinople, Croatia, and Venice. Jerusalem Muslims shared the celebrations of the al-Yahudiyyeh maqam as a local deity even though he does not appear in the Qur'an or any Muslim tradition. Unlike Moses (Musa), Jacob (Ya'coub), Reuven (Rubeen), Simon the Just has not been Islamicized.

The discovery made in 1871 by Charles Ganneau of epigrams inside the shrine indicated that the tomb belonged to a Roman matron called Julia Sabin, and not to the putative rabbi, Shimon ha-Tsiddiq, whose name later became associated with the site. Ganneau's discovery did not deter followers from their annual spring visitation, but it may have "Arabized" the site since the bulk of its pilgrims at the turn of the nineteenth century appear to have been Yemeni and Moroccan Jews, as well as local Muslim and Christian revelers. At least this is the evidence that we can obtain from local sources. Wasif Jawhariyyeh gives a vivid description of the syncretic celebration by Jews, Muslims, and local Christians of the spring festival of al-Yahudiyyeh. The term *yahudiyyeh* is significant since it distinguishes the site's Jewish origins without necessarily establishing it as an exclusively Jewish festival. This should be contrasted to Nebi Musa, Nebi Rubeen, and Nebi Ayyub festivals—all festivals in honor of Old Testament prophets, but whose patronage was mainly among Muslims, but in which Jews and Christians actively participated. The synergy of these religious ceremonies consisted not only of formal attestations of co-existence between the three communities, but I would argue that *they were shared communal events*. The Jewish performers in the event honoring Simon the Just were also Jawhariyyeh's partners in his own "secular" musical band that celebrated weddings in Jerusalem's Old City.[35] The word "secular" here is problematic since these events were ritually religious in character, but were neither denominational nor sectarian. They also involved festivities that referred to the religious identity of the shrine, but not the ritual or musical content of the event. Celebrations of the Shimon ha-Tsiddiq mawsim in the nineteenth century did involve the various Jerusalemite communities, but from contemporary accounts it seems to have been a primarily Jewish affair. Even though the site itself was under Arab ownership, the actual celebrations, according to Ben Arieh, were performed by Jews and included "candle lighting, dancing, prayers, haircuts for children, and monetary donations."[36] Even then, many European observers who visited the site in the middle of the century noted the participation of Christian and Muslims. Pinhas Grayevsky noted that

Muslims would always be present and that "wives of the Ishmaelites would also come and stake a permanent place on the hill facing the square."[37]

Two major transformations impacted the veneration of Simon the Just, along with most other popular saints and prophets whose "seasons" were an essential feature of popular ceremonials in Palestine. The first was the process of secularization mentioned above which essentially reconfigured the ceremonies into a social event almost bereft of its religious origins. This is the case that we witness also with the celebrations of Nebi Rubeen[38] in Jaffa. The second was a process of nationalization of the ceremony in favor of a nationalist interpretation of the event. This is what happened to the mawsim of Nebi Musa in the 1930s, ostensibly a return to its original purpose as established by Salah al-Din al-Ayyubi in the twelfth century as preemptive deterrence against the possibility of Christian pilgrimage. During the Great Arab Revolt of 1936, Nebi Musa became a rallying cry for Palestinian mobilization against Zionist immigration and the Balfour Declaration.[39] Simon the Just's tomb, however, remained dormant throughout the British Mandate period and did not attract attention from Israelis until the 1990s. This is more or less also what occurred to the Nebi Rubeen site in southern Jaffa.[40]

In the discussion above we gain a glimpse of a bygone syncretic religious practice that was common in the late nineteenth century and first half of the twentieth century. It allowed for shared veneration of saints whose origins belonged to one, and sometimes two, religious communities. In the case of Simon the Just, there was a common adoption by Muslims and Christian of a popular Jewish scribe whose mawsim became synonymous with the spring rites for the people of North Jerusalem. This moment of communal celebration was caught in the ethnographic account of Wasif Jawhariyyeh in what he termed as *Shat-hat al-Yahudiyyeh* (the Jewish picnic), and later in the mid-1920s by Maynard Williams, who captured a moment of unique intermingling of dress codes and genders that was *not* common in other mawasim, such as Nebi Musa (see Figure 8.7 overleaf). At the same time, these joint celebrations should not blind us to the communal boundaries which separated the various religious communities in urban neighborhoods. Although religious quarters were never insular either in habitat, social visitations, or ritual, they were nevertheless demarcated by distancing mechanisms that were rooted in the language of difference. Festivals were often clearly identified as Christian (*Sabt an-Nur*, Good Friday, Ghtass), Muslim (*Lailat al-Qader* during Ramadan) or Jewish (*Lag be Omer, Purim*), even when co-religionists participated in the gathering of the other.

In 2010 the Sheikh Jarrah neighborhood of Jerusalem, where the shrine of Simon the Just is located, became a battleground between Jewish settlers and Palestinians over expanded Jewish settlement in East Jerusalem. The appropriation of Simon's shrine as an exclusively Jewish site of worship marks a progression of national-religious claims over several sites that used to be shared (as well as celebrated) between the various religious communities of the region. Those include Rachel's

Figure 8.7 The ambiguous ethnicity of the Simon the Just Festival celebrants. Detail from Maynard Williams' unpublished photographs of the Simon the Just Festival, Jerusalem, 1927. *National Geographic* Archive.

tomb, Nebi Samuel, and Nebi Rubeen. The latter was, by most accounts, one of the most important shrines whose festivals brought revelers from the central and southern townships of Palestine during the month of August. It is noteworthy, however, that no similar Jewish claims were made over the site of Nebi Musa or his spring festival. This is most likely due to the Jewish traditional narrative in which the burial place of Moses is in Mt. Nebo in Jordan. Nebi Musa is also distinguished as a rallying ground for mobilization against European encroachment during the Crusades, and later in the 1930s against Zionist activities during the British Mandate period. The progression of Jewish claims over shared shrines did not take place until two decades after the Israeli occupation beginning in 1967. These claims accompanied the ascendency of nationalist ideological hegemony of religious parties in Israel, such as Degel ha-Torah, Shas, and other Mizrahi movements. The eviction of Palestinian families from the area around the Shimon ha-Tsiddiq shrine—the Karm al-Mufti, and Um Haroun neighborhoods—began in earnest in 1985 and was accelerated in 2008, 2010, and 2022.[41] Protests against the evictions succeeded in the administrative halting some of these evictions, as well as legal recognition of Palestinian rights in some of these properties. At issue here was the putative Jewish ownership of these lands that existed before 1948, and new purchases that were made by the American Jewish investor Irving Moskovitch.[42] The properties around Shimon ha-Tsiddiq later came to house a number of Palestinian refugees from the Haifa and Jaffa regions who were expelled in 1948 and were housed by the United

Nations Relief and Works Agency for Palestine Refugees in the Near East and the Jordanian government in the area.[43]

A survey by Reiter and Lehrs considers the dimensions and implications for the future of Palestinian residents and Jewish settlers. One of the crucial conclusions of that study was that the forceful imposition of Israeli legal ownership over these properties, whether based on actual deeds or putative ones, opens a Pandora's box over the much larger Arab claims for restitution of lost refugee properties inside Israel, including substantial property claims in West Jerusalem, in now Jewish areas like Talbieh, Katamon, Musrara, Baqʿa, etc.[44] This explains the initial hesitancy of the government as well as Israeli courts in proceeding with these evictions. The question of settling the area of the shrine by religious (and non-religious) Zionists became the overriding factor in the contestation of land, and relegated all possibilities of shared space, as well as shared communal celebrations, to the distant past. Even though Simon the Just is a minor religious shrine, its fate was emblematic of similar encroachments at the national level, of which Nebi Samuel, Rachel's tomb, and Nebi Rubeen are the most recent examples.

One of the main victims of these claims and impositions in the case of Simon the Just, however, is the demise of a historical practice in Palestine where the communal sharing of shrines and their seasonal ceremonials had heralded the promise of an overlapping shared identity in society at large, in which neighborhood, social difference and one's religious identity did not come in conflict with one other, but reinforced a communal urban space that was renewed every spring.

NOTES

1. Nazmi Jubeh, "Sheikh Jarrah Neighborhood and the Battle of Survival," *Majallat al-Dirasat al-Filastiniyyah*, 127 (2021): 36–41.
2. Yitzhak Reiter and Lior Lehrs, *The Sheikh Jarrah Affair* (Jerusalem, Israel: Jerusalem Institute for Israeli Studies, 2010), https://jerusaleminstitute.org.il/wp-content/uploads/2019/06/PUB_sheikhjarrah_eng.pdf.
3. Andrew Petersen, *Bones of Contention: Muslim Shrines in Palestine* (Singapore: Palgrave Macmillan, 2018).
4. Tawfiq Canaan, *Mohammedan Saints and Sanctuaries in Palestine* (London: Luzac, 1927). See also Marcela A. Garcia Probert, "Exploring the Life of Amulets in Palestine from Healing and Protective Remedies to the Tawfik Canaan Collection of Palestinian Amulets," unpublished PhD dissertation (Leiden, the Netherlands: Leiden University, 2021).
5. Wilhelm Bacher and Schulim Ochser, "Simeon the Just," *Jewish Encyclopedia*, www.jewishencyclopedia.com/articles/13745-simeon-the-just.
6. Yosef Eisen, "Shimon Hatzadik (Simeon the Righteous)," *Chabad History*, www.chabad.org/library/article_cdo/aid/2833935/jewish/Shimon-Hatzadik-Simeon-the-Just.htm.
7. Bacher and Ochser, "Simeon the Just."
8. Charles Seymour explained the duality of tombs belonging to St. Simeon as a case of calculated reasoning on the part of the Venetians. "The hypothesis most satisfactorily explaining the presence in Venice of parts of two different shrines of Saint Simeon," he

stated, "is simply that the Venetians, for good reasons of their own doubtless connected with trade and pilgrimage, decided to leave the holy remains intact in Zadar. They then erected a monument in their own church dedicated to the saint—in strict definition not a tomb but a cenotaph." Charles Seymour, Jr., "The Tomb of Saint Simeon the Prophet, in San Simeone Grande, Venice," *Gesta*, 15(1/2) (1976): 193–200.

9. Eisen, "Shimon Hatzadik (Simeon the Just)"; Bacher and Ochser, "Simeon the Just."

10. Simon Sebag Montefiore, *Jerusalem: The Biography* (New York: Vintage, 2012); Dan Bahat, *Illustrated Atlas of Jerusalem* (New York: Simon & Schuster, 1990), p. 67.

11. Wasif Jawhariyyeh, *The Storyteller of Jerusalem* (Northampton, MA: Interlink, 2013), p. 58; Edward Keith-Roach, "The Pageant of Jerusalem," *National Geographic*, 52(6) (1927): 635–681.

12. Wasif Jawhariyyeh, *al-Quds al-intidabiyyah fil-mudhak-kirat al-Jawhariyyeh: al-Kitab al-thani min al-musiqi Wasif Jawhariyyeh 1918–1948*, ed. Salim Tamari and Issam Nassar (Beirut, Lebanon: Mu'assasah al-dirasat al-Filasteeniyah, 2005).

13. Maynard Owen Williams, Negative #43261, *National Geographic* Archive, 1927, indexed 1942. I am grateful to Yazan Kopty for making this collection available to me.

14. Keith-Roach, "The Pageant of Jerusalem"; Maynard Owen Williams, "Color Records From the Changing Life of the Holy City," *National Geographic* 52(6) (1927): 682.

15. Jawhariyyeh, *al-Quds al-intidabiyyah fil-mudhak-kirat al-Jawhariyyeh*, pp. 60–63.

16. Ibid., quoted in English in Jawhariyyeh, *The Storyteller of Jerusalem*, pp. 61–62.

17. Joshua Ben-Arieh, *A City in the Reflection of an Era: Jerusalem in the 19th Century* (Jerusalem, Israel: Yad Yitzhak Ben-Zvi, 1977), pp. 39–41; Pinhas Ben Zvi Grayevsky, *The Book of the Yishuve* (Jerusalem, Israel: Solomon Press, 1938–39). Both quoted in Reiter and Lehrs, *The Sheikh Jarrah Affair*, p. 16.

18. Michael Talbot, "Sparks of Happenstance: Photographs, Public Celebrations, and the Ottoman Military Band of Jerusalem," *Journal of the Ottoman and Turkish Studies Association*, 5(1) (2018): 45.

19. Ben-Arieh, *A City in the Reflection of an Era*, pp. 39–41; Grayevsky, *The Book of the Yishuve*. Both quoted in Reiter and Lehrs, *The Sheikh Jarrah Affair*, p. 16.

20. Talbot, "Sparks of Happenstance," p. 47.

21. Robert Lachmann, *Cantillation and Song in the Isle of Djerba* (Jerusalem, Israel: Archives of Oriental Music, The Hebrew University, 1940). See also Robert Lachmann, *The Oriental Music Broadcasts, 1936–1937: A Musical Ethnography of Mandatory Palestine*, ed. Ruth F. Davis (Middleton, WI: A-R Editions, 2013).

22. Ruth Davis, "Ethnomusicology and Political Ideology in Mandatory Palestine: Robert Lachmann's 'Oriental Music' Projects," *Music and Politics*, IV(2) (2010). Apparently Lachmann's main language was German. According to a contemporary affidavit, he spoke Arabic but not Hebrew while he was in Jerusalem.

23. Elisa Adami, "Exhibition Review: Jumana Manna, Chisenhale," *Art Monthly*, 391 (2015), www.academia.edu/36638640/Exhibition_Review_Jumana_Manna_Chisenhale.

24. Rebecca John, "Giving a Voice to Gaps and Cracks: Archival Critique in Jumana Manna's *A Magical Substance Flows into Me*," *Roots Routes*, 33 (2020).

25. Maynard Owen Williams, *National Geographic* Archive, 1927, indexed 1942.

26. Hillel Cohen, *Year Zero of the Arab–Israeli Conflict, 1929* (Waltham, MA: Brandeis University Press, 2015).

27. Keith-Roach, "The Pageant of Jerusalem."

28. Ibid., p. 667.

29. Meron Benvenisti, *Teddy Kollek: The Last Optimist, Eretz-Israel: Archaeological, Historical and Geographical Studies*, vol. 28 (Jerusalem, Israel: Israel Exploration Society, 2007), pp. xi–xiv.
30. Keith-Roach, "The Pageant of Jerusalem," p. 668.
31. Maynard Owen Williams, "Color Records From the Changing Life of the Holy City," *National Geographic*, 52(6) (1927): 681.
32. Ibid., p. 682.
33. Talbot, "Sparks of Happenstance," p. 65.
34. Ibid., p. 66.
35. See Jawhariyyeh, *al-Quds al-intidabiyyah fil-mudhak-kirat al-Jawhariyyeh*, p. 193.
36. Reiter and Lehrs, *The Sheikh Jarrah Affair*, p.16.
37. Ibid., pp. 16–17.
38. Mahmoud Yazbak, "The Muslim Festival of Nabi Rubin in Palestine: From Religious Festival to Summer Resort," *Holy Land Studies*, 10(2) (2011): 169–198.
39. Awad Halabi, *Palestinian Rituals of Identity: The Prophet Moses Festival in Jerusalem, 1850–1948* (Austin, TX: University of Texas Press, 2023).
40. Reiter and Lehrs, *The Sheikh Jarrah Affair*, p. 19.
41. Jubeh, "Sheikh Jarrah Neighborhood and the Battle of Survival," p. 54.
42. Ibid., p. 56.
43. Reiter and Lehrs, *The Sheikh Jarrah Affair*, p. 93.
44. Ibid., pp. 65–69.

9
The Ahmadiyya of the Carmel[*]
Amir Odeh

*Dedicated to Abdullah bin As'ad bin Sa'id bin Abdul-Hay Odeh—Abu Khaled
(1930–2024)*

OUR ROOTS ARE IN NI'LIN

The village of Kababir is home to Palestine's Ahmadiyya Muslims. The origins of the village, which has been swallowed by today's Haifa, lie at a remove of time and distance from the southern Levantine coast. Odeh, the founder of the village, was born in the middle of the nineteenth century in the Hebron Mountains in the village of Ni'lin, which lies northwest of Ramallah, near the Shuqba cave. The history of Odeh's family remains obscure to us, but they are still present in Ni'lin today. As the Zionist project seeks to erase Palestinian memory by displacing communities and bending them to Zionist interests, I feel that it is essential to document the history of places like Kababir because they testify to the religious and cultural diversity that is characteristic of Palestine society despite concerted efforts to erase and subjugate it.

Some aspects of Odeh's biography are still poorly understood. We know that he was born in Ni'lin and that he lived in al-Tira (what the Israelis today call "Tirat Carmel"), one of the largest villages on the Palestinian coast—indeed, one of the largest villages in all of Palestine. His descendants in Kababir do not know very much about his life. Some rupture has left them knowing very little about their family history. What is known is that Odeh grew up in al-Mazra'a al-Qibliya (also known as Mazra'at Chriteh) to the north of Ni'lin, where he was raised by his father's sister Nada after losing both his parents in a short period of time. His brother Yusuf died, too, not long after that. It is interesting that while Odeh's father's name has been lost to history, his father's father's name, Nada's father in other words, was most likely called Abd al-Hayy. I draw this conclusion on the basis of an enduring cultural tradition that has families naming their oldest sons after their grandfathers on their father's side. Odeh was named Odeh al-Nada for the aunt who raised him and later his wife, Safiyya, who was also born in Ni'lin, and their nine children (six boys and three girls) would be as well.

[*] Translated from the Arabic by Adam Talib.

We do not know why Odeh left Ni'lin in search of a new home. Some connect his departure to the bloody Qays–Yaman rivalry in the region around Jerusalem in the nineteenth century, which caused many deaths among Ni'lin's residents.[1] Odeh, who hailed from Qays, was accused of killing four Yamani opponents. As part of the effort to re-establish peace and order in the region, whether for the benefit of the population or their Ottoman overlords, Odeh al-Nada was exiled from his village. Others argue that he left the village in order to keep his sons out of the Ottoman army, but his scheme was unsuccessful. The only thing we know for certain is that, around the middle of the nineteenth century, Odeh al-Nada, his wife, their six sons, and three daughters left Ni'lin, taking their livestock with them, in search of a new home in the Galilee.

The likeliest assumption is that Odeh was hoping to live among his relatives in al-Tira, either in order to escape the Ottoman army or to take refuge as a *tanib* from inter-communal violence in Ni'lin.[2] Before reaching al-Tira, the family settled in the village of Far'un, south of Tulkarem, and people say that the family had good relations with their neighbors. It is also said that the leader of the Qaysi faction in Ni'lin would visit Odeh and his family there to see how they were getting along. After a few months, Odeh and his family resumed their journey northward to al-Tira, south of Haifa, known to Palestinians as Tirat al-Louz ("Tira of the Almonds") or Tira of Mount Carmel, where his maternal uncles lived. On his mother's side, Odeh was a descendant of the Bash family who trace their arrival in Palestine to Saladin's reconquest. When they arrived in Tirat al-Louz, Odeh and his family found accommodation with the head of the Bash family, Ahmad al-Jarbu', known as Abu Radwan, and they remained there for two years, during which time they lost a son.

Although Odeh was living among his relatives in al-Tira, repeated conflicts among the various families in the village caused him to look for another home for his family that would be calmer and farther removed. Odeh and his sons' search for a place to settle led them to an area at the foot of Mount Carmel overlooking the sea, which had easy access to two flowing springs and a cave and also featured the ruins of a historical village dating back to the Crusader period. The village had once been dominated by a fort, some remains of which can still be seen today in Ayn Umm al-Faraj in the Siyah valley below the village, and that apparently signaled to Odeh that that spot would be a suitable permanent home for his uprooted family. The village leader, Ahmad al-Jarbu', or Abu Radwan, drew up an official agreement signed by the heads of the four families in al-Tira granting Odeh and his sons the area at the foot of Mount Carmel known as Kababir in exchange for one bull per family.

AS HOUSES TURNED TO RUIN, OTHER HOUSES SPRUNG UP

Today Kababir is part of the Haifa metropolitan area, but the situation before 1934 was very different. Back then it was one of several hillside villages on Mount

Carmel. Populated by Odeh's children and grandchildren, it was administered by al-Tira, which fell in June 1948.

Kababir was a small and modest village whose nearest neighbor was Tirat al-Louz.[3] At the time, Odeh and his family were the only people living west of Mount Carmel, across from Farsh Iskander (Karmeliya today), in isolation from the rest of society. The only buildings on that side of the mountain back then belonged to the Monastery of Mar Elias. The only neighbors they had were the monks living in the monastery of Mar Elias and wild animals, including jackals and panthers.

Odeh, Safiyya, their children, and their animals all lived in the cave when they first settled in Kababir. Odeh and Safiyya's children later embarked on building projects in the village after their parents' death, and it has been said that they repurposed stones from Crusader-era buildings in the first phase of construction. They began by building vaulted houses for themselves near the cave where they had grown up, and a small shrine known as a *zawiya*. Each house had two doors, one leading downstairs where the cows and other livestock were kept, and a second which opened onto the kitchen and the lavatory, if there was one. A small staircase of four to five steps connected the kitchen to the upper room, which was used to receive guests during the day and served as a bedroom overnight. The houses did not contain beds, rather bedrolls were spread out at night, and during the day they were folded up to provide seating. The shrine consisted of a simple four-walled structure divided into a space for worship and a reception room.

FROM MOSQUE TO MISSION

Religion has always been fundamental to the lives of people in Kababir. Abu As'ad, an academic, poet, and translator in his eighties (who is also a descendant of Odeh), says, "They're very religious. Ever since God made them, they've been pious."[4] Alongside the first houses, the family built a small shrine to announce and host prayers, and it is still there to this day at the foot of Mount Carmel. Abu As'ad tells a story about Odeh's sons, Abd al-Hayy and Abd al-Qadir. Abd al-Hayy used to wait on the eastern side of the mountain to catch the sun rising so he could announce the dawn prayer, but his brother Abd al-Qadir would wait to hear his brother returning from the east before running to make the call to prayer. The two brothers were always arguing about which one of them deserved to perform the service.

The piety of Odeh's descendants helped them build relations with neighboring communities as well. It also led them to join three Sufi orders before finally embracing the Ahmadiyya movement. His five surviving sons were first drawn to the Khorasani Sufi order, which was led by a sheikh who gave spiritual lessons in nearby al-Tira. He also visited Kababir from time to time to give lessons in the shrine there. One of Odeh's sons, 'Abd Allah, was particularly devoted to the sheikh and wrote poems praising him.

Odeh's grandsons, on the other hand, shifted their loyalties to the Naqsh-bandi Sufi order under the tutelage of a sheikh called Abu al-'Azayim.[5] The *dhikr* ("prayer") sessions they convened in the shrine gained them a reputation for zeal. In the 1920s, during the British Mandate, some of Odeh's descendants were introduced to the Shadhili Sufi order by their friends from the al-Qazaq family of Haifa.[6] The order's main lodge was located in Akka, but there was also an important lodge in Haifa, where Odeh's descendants often attended dhikr sessions.

In addition to their prayers at the local shrine, members of the Odeh family also traveled to Haifa on Fridays to attend noon prayers at the Istiqlal Mosque, which were led by 'Izz al-Din al-Qassam, who had been born in Jableh near Latakia.[7] For many years, the Kababiris went into Haifa primarily to worship, to sell quicklime, which was produced in the village, and to acquire provisions. All that began to change in 1927, however, when the Odehs began returning to Kababir from Haifa with more than just new possessions. They'd been introduced to the Ahmadiyya movement.

During their trips to Haifa, they heard people talk about a visiting spiritual leader called Jalal al-Din Shams (1901–1966), who had come from the area around Qadian in India's Punjab region to proselytize for the Ahmadiyya Movement.[8] Curiosity got the better of the Odehs, so they attended some of the leader's lessons. Alongside others in a room in Wadi Salib, which was populated with the former peasants who formed Haifa's new working class, they heard the visitor speak about a new Islamic sect.[9] The Odehs liked what they heard, so they continued to attend the spiritual leader's lessons and would eventually invite him to visit the village of Kababir. It was there that he encountered "A receptive and pure-hearted audience," as Abu As'ad puts it, and planted the seed of Ahmadi Islam, which continues to thrive nearly a century later.

Their declaration of allegiance to the Ahmadiyya Movement was a turning point in the history of Kababir and its residents. Having embraced the movement, they offered the missionary Jalal al-Din Shams a single modest room by way of accommodation in the village, which he gladly accepted. Jalal al-Din Shams lived in Kababir for so many years that it became difficult to imagine the village without him, and the residents showed their esteem for him by calling him—and the missionaries who came after him—"Ustaz" ("teacher"). Although he had moved out of Wadi Salib, he did not confine his missionary activity to Kababir, continuing to meet with other Muslim leaders in Haifa and elsewhere for debates, which the people of Kababir remember him as having won. Abu As'ad recalls a debate during which residents of Kababir in the audience got very impassioned on behalf of their leader. When the opposing sheikh made a comment about their fanaticism, Jalal al-Din Shams responded by saying, "The cubs mew when the lion roars."

In addition to ritual and spiritual developments, the adoption of the Ahmadiyya Movement had an architectural impact on the village of Kababir as well. The people of the village had been praying in the small shrine for years, but Jalal al-Din Shams

Figure 9.1 The people of Kababir, including Jalal al-Din Qamar, the Ahmadi community's third missionary. Ahmadiyya Archive in Kababir.

encouraged them to build a larger, congregational mosque to serve the poor, rural population and he laid the cornerstone of the mosque himself on Friday April 3, 1931.[10] The men and women of Kababir worked together to build the new mosque, with the women carrying water from the Siyah valley on their heads and men collecting sand from the shore and using donkeys to transport stones. The first missionary, Jalal al-Din Shams, did not get to see the new mosque completed because the Ahmadi caliph recalled him to India and replaced him with a new missionary, which was customary for Ahmadi missionaries.[11] His replacement, Abul Ata Jalandhri (1904–1977), arrived in Kababir in time to see the new mosque open in 1932.[12]

Beginning in the 1930s after the construction of the mosque, Kababir took on its identity as an Ahmadi village. The people of Kababir invested what resources they could into building the mosque and neighboring school, but it began as a modest space. Over time, as the village of Kababir grew, they added a center for Ahmadiyya *tabligh* ("missionary work"), which includes accommodation for out-of-town visitors.

Kababir has become an important center of Ahmadi missionary work in Palestine and the Arab World over the past century. With the completion of the new mosque and the arrival of Jalandhri, Kababir's second missionary, the village began propagating Ahmadi teachings through books and a magazine called *al-Bishara* ("The Prophecy"), first published in 1932. The magazine was a community effort,

and it was by no means an easy task. People gave up their time and money and also put themselves at risk. The most dangerous episode took place when the magazine was distributed in Akka during the British occupation. Some young men had been goaded into attacking the Ahmadi missionaries (among which was my grandfather, Muhammad Ali Muhammad Odeh) by hurling stones at them. If it hadn't been for a non-Ahmadi carpenter who let them take shelter in his workshop, the attack would have been far bloodier.

Getting the magazine printed was no easier than distributing it. Abul Ata Jalandhri used to write to printers in Haifa, but the protests against the new missionary movements meant that they continuously had to change printers. Different issues of the magazine were printed in Haifa at Zaytuni Press in Jaffa Street, al-Muluk Press in Muhammad Ali Street, al-Islah Press in Muhammad Ali Street, al-Nafir Press, and Suruji Press in Akka.

The magazine's name, *al-Bishara*, had a Christian ring to it, which caused a great deal of controversy since it was associated with a movement that proselytized to Muslims, so it was changed to *al-Bushra* ("The Good News") in 1935, and it endures under that title to this day, having been first licensed during the British Mandate.

The people of Kababir purchased a printing press, also in 1935, so that they could produce their publications themselves. The purchase was financed in collaboration with the Ahmadi community in Egypt, whom Abul Ata Jalandhri visited as well. The printing press was the aspiration of the whole community, so the men and women of Kababir and other areas in Palestine donated to the cause, as did Ahmadi communities in Syria, Egypt, Iran, Iraq, the United Kingdom, and Kenya. The campaign raised a total of 9,062 qurush and dutifully recorded the names of everyone who made a donation in the first issue of the magazine to be printed in Kababir, the second issue of *al-Bushra* in 1935, in thanks. The printing press came from Cairo through Gaza, Jaffa, and 'Asqalan on its way to Haifa, where it made its final trip, arriving in a small room beneath the old mosque of Kababir. Abu Salih, one of the village residents, was in charge of the primitive device, and he made a concerted effort to train the younger residents in typesetting and printing. After the printing was completed, the sheets were taken to Jaffa Street, in what would later be known as Haifa's Lower City, for trimming and binding before being distributed for sale across Palestine. Within Palestine, each issue cost 20 qurush, but the price went up an additional 5 qurush for customers outside Palestine.

Despite opposition from some segments of the Muslim community, there were some open-minded Muslims in Palestine who were accepting of the Ahmadiyya movement. They were close to the community, and they worked together to build the al-Salam Mosque in Nazareth in 1963.[13] After 1967, when Palestinians living "on the inside" were re-connected with Palestinians living in the West Bank, such as those in Ni'lin, the community's hometown, the relationship between the Ahmadi community and other Muslims in Palestine became more complicated, according to Abu As'ad, who identifies the rising influence of the people he calls "sheikhs."

THE VILLAGE OF KILNS

Despite being somewhat isolated in regard to their location and religious beliefs, the people of Kababir were integrated in the region around them. During the British Mandate, a new port and petroleum refineries were constructed, in addition to other facilities, as part of a project to link Mosul in Iraq to the Haifa Bay. This provided many more job opportunities for the people of Haifa, especially erstwhile farmers who had to give up their land because they could not afford the exorbitant taxes imposed on them by the British occupation. The British wanted Haifa to surpass Akka, and they succeeded in attracting people from villages near and far, as well as workers from the rest of the Levant, Egypt, and Sudan. When the agricultural lands near the coast in al-Tira were confiscated to build a British military base, the people of Kababir had no choice but to join the wage laborers of Haifa.

Like other Palestinians, Odeh and his descendants had settled on a hill near Mount Carmel nearly a century before the British arrived and enlisted them into their colonial economy, building the facilities they would later work in. The people of Kababir lived off the natural blessings provided by Mount Carmel, the Siyah valley below, and the nearby plain. Odeh's descendants divided the work between them, some focusing on food production, while others worked to build relationships with neighboring communities and organize the village's earthly and spiritual affairs. They eventually built a school for the village children as well.

Because the village was located in a remote area on the hillside, Odeh's sons decided that one of them should be present at the small mosque throughout the day to look after the women and children and receive guests, as was customary in the region. People traveling between al-Tira, Haifa, and other places would pass by the village, and 'Abd al-Hayy, the oldest of Odeh's sons, was the ideal person to greet these guests because he played the pike-fiddle and composed poetry, both skills he had learned from his father. Even now, Odeh al-Nada's grandchildren recall two verses by him that 'Abd al-Hayy often recited, which may express his feelings about having to leave Ni'lin:

> You seized my heart
> and stole my sleep
> But still I'm strung along.
> Either love me or let me go.

Three of the brothers were responsible for food production: Muhammad looked after the livestock (goats, sheep, and cows), while 'Abd al-Qadir and Yusuf were responsible for the farmland. The older residents of Kababir remember the important role women played in village agriculture as well, carrying water from the Siyah valley and harvesting the fields in the al-Tira plain before the food was distributed equally among the village's inhabitants. The fifth brother, 'Abd Allah, had gone to

study at al-Azhar in Cairo, and upon returning to the village established a school where he taught the children and led prayers.

Mount Carmel offered the villagers more than just fertile land for crops, however, as even the uncultivated land provided excellent pasturing for livestock. The villagers also used the mountain's limestone to build kilns for producing quicklime.[14] The kilns took the form of a round hole 3 meters deep and 5 meters in diameter, lined with igneous rocks and topped by a dome built of limestone 2 meters tall buried under an additional 0.5 meters of pebbles. These kilns are known as *kabara* (plural *kababir*), and people say that is how the village got its name. The kilns have a small windward opening through which wood is added to feed the fire, which would blaze for two or three days at a time. The villagers took turns watching the kiln until they could see the fire poking out, which was a sign that the quicklime was ready. At that point, they would remove the dome to let the quicklime cool before packing the building material into bags for sale around Haifa and the Mount Carmel area.

The people of Kababir produced quicklime from the end of the nineteenth century until the First World War disrupted life in the village, as it did in most other places. The chaos that overcame the country led to an increase in thefts, and two of ʿAbd al-Hayy's five sons, who'd been pressed into service in the Ottoman army, did not return home. The death by drowning of another son only added to ʿAbd al-Hayy's grief. His two surviving sons were Saʿid, Abu Asʿad's grandfather, and al-Hajj Tayyib, who went on to have well-known progeny of his own.

* * *

This is the story of Kababir, a Palestinian village with a certain particularity but overall not exceptional in its historical development and political economy. These days, the Israeli state often celebrates the existence of an Ahmadiyya village in an attempt to co-opt and mobilize Palestinian identity for its own intentions. The people of Kababir and their Ahmadi Muslim beliefs are used to divide the Palestinian community, sometimes with a touch of colonial subtlety. Israel often hails Kababir as an example of "coexistence;" a word that, whenever one looks closely, obscures layers of conflict. In the face of these attempts to co-opt the Ahmadi community and divide them from the rest of the Palestinian community, perhaps another possibility can be offered. Perhaps when Odeh al-Nada left his home in the countryside in search of peace and tranquility by the coast a century and a half ago, as the story goes, he set an example for his descendants who today gather together with visitors from Tulkarem, India, Jordan, Benin, Syria, Cameroon, Canada, and London on Mount Carmel. This was to work toward universal peace in a land in which peace has been tragically interrupted

The author would like to thank Khaled Furani for contributing to this essay.

NOTES

1. The Qays–Yaman rivalry was a historic rivalry between the northern Qays tribe and the southern Yaman tribe in pre-Islamic Arabia.

2. In Palestinian society, a *tanib* is someone who seeks the protection of a notable man who has a reputation for good morals, credibility, and defending the weak. Fearing for his life, the tanib lives next door to his protector, but the only thing he expects to receive is protection, because he continues to provide for himself. Requests for protection are always honored unless they come from someone with a dubious reputation.

3. On the eve of the Nakba, the population of al-Tira was 5,800 individuals living in an area of 45,000 dunams. Families in the village included: Abu Rashid, al-Salman, al-Qusini, Dirbas, Bastuni, Zeidan, al-Batal, Ghannam, Hajir, Abu 'Isa, al-Bash, al-Hindi, al-'Asal, Shablaq, al-Naji, Bakir, Bahlul, al-Hamuli, al-Shayib, al-Rabbani, 'Ammurah, al-Sa'di, Shallah, al-Abtah, Abu Jamus, Dalul, Abu Tayie, 'Asqul, al-Hasan, 'Uways, al-Tayyim, Badran, Qizli, al-Hamidi, and others.

4. This text is primarily based on an interview we conducted with Abu As'ad on September 7, 2022. We have also benefited from the book by 'Abd Allāh As'ad Odeh ('Awdah), *al-Kabābīr: baladī—lamḥa 'an tārīkh al-qarya mundhu ta'sīsihā wa-ḥattā nihāyat al-intidāb al-biriṭānī* (Shafā 'Amr, Israel: Dār al-Mashriq, 1980).

5. 'Uthman al-Bukhari introduced the Naqshbandi Sufi order to Palestine in the early seventeenth century.

6. A Sufi order named for Abu al-Hasan 'Ali b. 'Abd Allah b. 'Abd al-Jabbar al-Shadhili (1196–1258), which became very popular in Egypt under Ottoman rule. Beginning in 1880, this order attracted many followers and was practiced widely.

7. 'Izz al-Din al-Qassam was active in the Wadi Salib neighborhood of Haifa, where he worked to teach residents, most of whom were peasants who had been dispossessed of their lands by the Jewish National Fund. He worked to promote literacy through night classes and frequent visits to the area, where he became very popular. He also worked to organize opposition to British imperialism and Zionist appropriation. He was martyred on November 20, 1935, when he was killed in an altercation with British imperial forces.

8. Jalal al-Din Shams (or Jalaluddin Shams) was the first emissary of the Ahmadiyya Movement to the Arab World, having been sent by the second Ahmadi caliph in 1925. He was instrumental in establishing Ahmadi communities in Damascus, Kababir, and Cairo. In 1930, he established the first Ahmadi mosque and school in Palestine. The founder of the Ahmadiyya Movement took special interest in the Arab peoples and was keen to spread the Ahmadi message to the Levant. One of his works was addressed specifically to the Arab peoples, whom he described as "The people of the land of prophethood and the neighbors of God's exalted house ... [t]he greatest of all Islamic nations and God's most fervent supporters."

9. Wadi Salib was established near the old city walls in 1761 shortly after Zahir al-Umar founded the modern city of Haifa. The town was populated by Palestinian Muslims and Christians until the middle of the nineteenth century, when Haifa's urban expansion engulfed it. The area saw an influx of Palestinians who worked in the railways and port, and later in the industrial zone designated by the British Mandate.

10. The Ahmadiyya Movement depends on a corps of missionaries who study in Ahmadi universities before embarking on missions around the world.

11. Jalal al-Din Shams was recalled by Mirza Basheer-ud-Din Mahmood Ahmad, the second caliph of the Ahmadiyya Movement.

12. Having arrived in Palestine in 1931 to replace Jalal al-Din Shams, Jalandhri remained there until 1936, during which time the Mosque of Sayyidina Mahmud in Kababir was completed.
13. The al-Salam Mosque (also known as the "New Mosque") lies east of the Old City of Nazareth. The mosque was constructed in the early 1960s and was opened to the public on November 22, 1963, as an inscription over the main door records. It is one of the largest mosques in the city and is the most centrally located.
14. The Arabic name for the kilns used to produce lime is *atun*, deriving from a Mesopotamian word for "smoke." A small kiln is called *kabarah*, the plural of which, *kababir*, gave the village its name.

PART III

Topographies

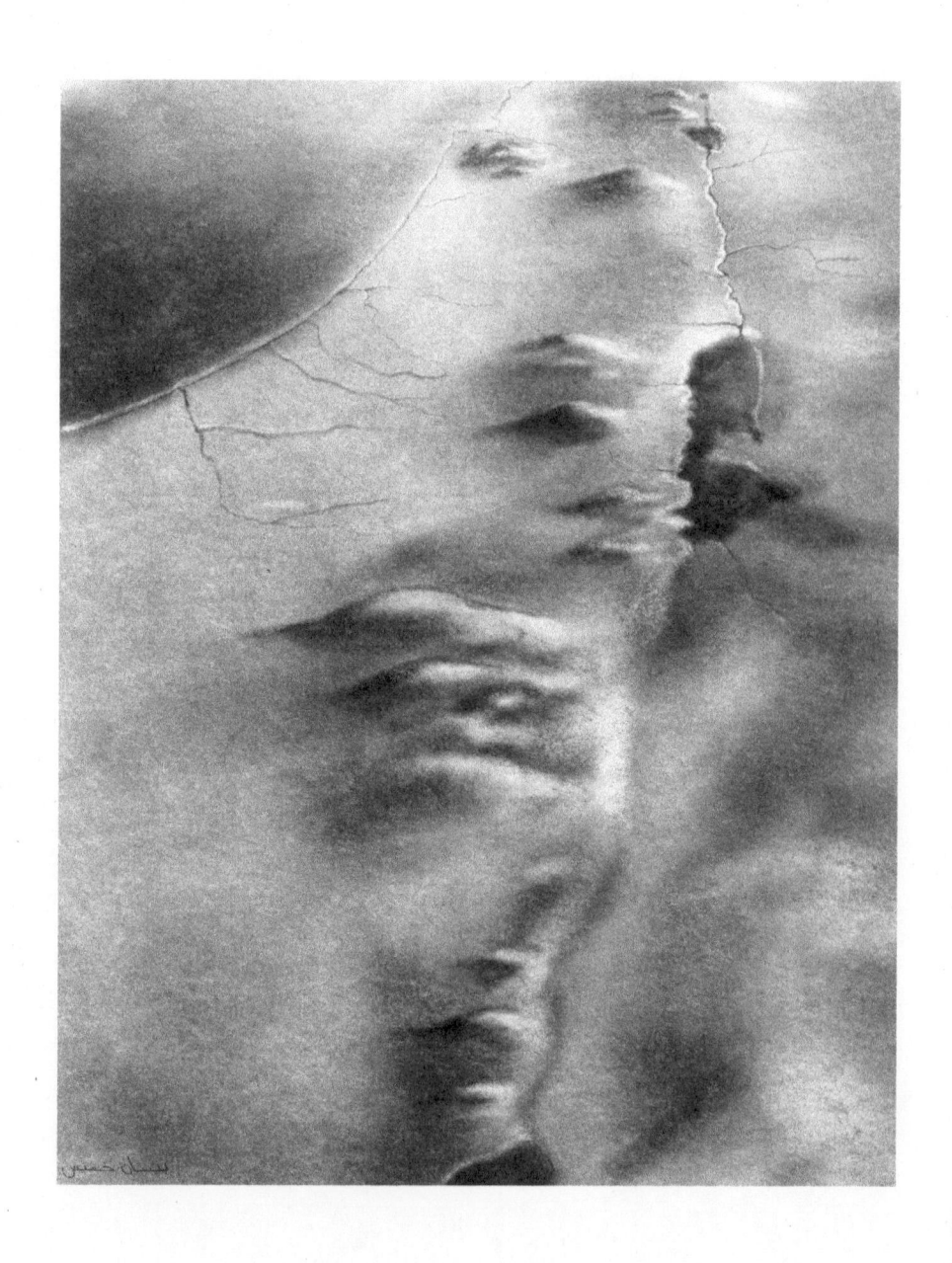

10
Géographie Ethnologique du Djolan: Adib Souleiman Bagh, the Golan's Last Geographer[1]

Readers of this essay might wonder why a text about the life of a Syrian geographer from the Golan Heights appears among other essays that explore the Palestinian "local." My answer is rather simple. There lies in that very mode of questioning an assumption of a Palestine that is already clearly defined. Both spatially and temporally, such an assumption imagines Palestine as a place with strict and sealed boundaries, beginnings, and endings; a confined territory with defined centers and peripheries; a land about which tenacious claims of an inside and outside have already been settled. The following essay aims at disrupting these enclosed and enclosing assumptions, by attending to moments of dissonance within them. It aims to destabilize what counts as "local" by highlighting particular scenes of a former way of life in the Golan Heights, a landscape that often figures as both a reminder and remainder of a Syrian presence in Palestine, and more precisely, of Palestine as part of Greater Syria. Put differently, I am writing this essay with a certain imagination of the Golan as a local site from which to grasp simultaneously Palestine and Syria, and to recognize in them what otherwise could be seen, and has often been treated, as isolated and discontinuous.

But what is it like to write from this site of ruins? In this essay, I write from the present-day occupied Golan Heights to recall a social world that has unfolded in the entangled local realities of empires and colonies. My focus will be the writings of the geographer Adib Souleiman Bagh, who was born in 1928 in the Syrian village of al-Juwwayza in the Golan, and who later, in the late 1950s, defended his doctoral thesis in Geography at the Sorbonne University in Paris. His doctoral thesis, titled *La région de Djolan: étude de géographie régionale*, was supervised by French geographer and geomorphologist Jean Dresch, and it investigates, as I wish to demonstrate, aspects of multiethnic, multilinguistic, and multireligious worlds in the Golan deemed unthinkable today. In other words, this essay recalls residual pasts in the present in an attempt to draw a sense of futures lost.

I chose Bagh specifically because his life trajectory can help us make sense of the radical historical and demographic transformations that took place in the Golan, a place often considered small and peripheral. Growing up in the Golan, squarely

between Haifa and Damascus, Bagh lived through some of the early twentieth century's canonical historical events: he was born shortly after the Great Syrian Revolt (1925–27), went to school and lived through the French mandate while witnessing the rise of Arab nationalism, and received his high school diploma in 1947, shortly after Syria's independence in 1946. Like many of his contemporaries, Bagh repeatedly reoriented his life as he navigated through these historical shifts and their grand ideological narratives. Coming of age in the Golan Heights of post-colonial Syria, he closely witnessed the colonial unmaking of neighboring Palestine as the Nakba unfolded together with the establishment of the Jewish state. Remarkably, even at these moments of political and geographical unmaking, Bagh saw Palestine seeping out beyond the newly imposed borders as hundreds of Palestinian families and individuals found refuge in the Golan. Sadly, Bagh passed away in 1964 at the age of 36, only three years before the Israeli occupation of the Golan.

To read these transformative events as they were locally experienced and to appreciate their significance in Bagh's life, requires a note about scale. In his study of the spatial layeredness of the past during the late Ottoman and modern Middle East, historian Cyrus Schayegh argues that "the local areas were *the* place in Bilad al-Sham where people lived and experienced the great economic and political changes."[2] In that sense, it was on the local and translocal scale more than on the regional that broad changes were experienced most intensely. Politically and economically, Schayegh writes, core cities of the hinterland such as Aleppo, Damascus, and Nablus extended the range of their respective local area to counterbalance their incorporation into the world market. Focusing particularly on the Golan, Schayegh argues that beginning in the late nineteenth century, "Damascene merchants [not only] started pushing into the Golan which ultimately came under greater central state control from Damascus, but Damascus and up-and-coming Haifa became more strongly connected as the Golan was situated on their way."[3] Locally speaking, individuals and groups living and working anywhere in the Golan Heights are geographically closer to merchants in Palestinian cities like Safad or Tiberias than these Palestinian merchants are to anywhere else in the rest of Palestine. Therefore, exploring a local scene from the Golan, at least in this essay, means weaving these geographical proximities together instead of imagining them as parts of separate, bounded national realities. It is my view that while many lives and histories could unfold in Palestine, Palestine itself could unfold as part of another story or stories, not beholden to statist visions. In other words, if we insist on imagining Palestine (or Syria, for that matter) as a sociopolitical and cultural container, then this container is approached here as inherently leaky.[4]

Envisioning the landscapes that Adib Bagh lived in and moved through, the people he saw, and the ideas he grappled with is not an easy task today. While Arabs constituted the majority of the population in the Golan during Bagh's time, the local landscape was undeniably a multireligious, multiethnic, and multilinguistic one, with overlapping and often competing modes of being and belonging. Bagh

himself was born to a Circassian family, who, fleeing the Russian occupation of the Caucasus in the mid- to late nineteenth century, had been forcibly settled by the Ottomans in various parts of their empire, including the Golan.[5] That the newly incoming Circassians were not Arabs, and caused discontent and sometimes hostile reactions among the native population at the time, a subject that appeared more than once in Bagh's work.[6] But Turkmens also lived there, as well as Kurds and Armenians. Maghrebis inhabited the Golan too, they were "the Arabs and Berbers who arrived with Amir 'Abd al-Qadir, driven from Algeria in the nineteenth century after the uprising he led against the French colonization."[7] The Golan was also home to several thousands of Palestinian refugees and Bedouin tribes, most of whom had come from Palestine in the aftermath of 1948.

How do we approach this plurality in the Golan through a geographer's own work and biography? As historians and anthropologists of the modern Middle East have shown, complex modes of belonging and identifications are historical designations whose meanings have changed and whose salience has ebbed and flowed.[8] While communal identities in the Golan, like elsewhere in the Levant in this era, were not etched uniformly into the fabric of the past and present, they nevertheless "were not recovered from some container of the past that preserves an unadulterated sense of self and other."[9] It should be noted that Bagh was writing during the height of post-colonial nationalism, where Syrian politics from independence through the late 1960s was marked by upheaval and political instability, and where local identities and the multiplicity they offered were produced over and over again, and sometimes were exploited, to justify different nationalist and anti-colonial modes of governance.

In what follows, I present some of the historical dimensions of identity formation, not necessarily to provide answers, but to suggest ways to reflect on them from within their own historical moment. To do so, I draw on Bagh's doctoral thesis, *La région de Djolan: étude de géographie régionale*, published in French at the Sorbonne in 1958.[10] His 600-page manuscript consists of four sections, and studies the natural and demographic characteristics of the Golan: its climate, hydrology, human geography, modes of social and economic activities, and other aspects of life. Here, I offer an original English translation of excerpts from the second chapter of the second section, titled "The Ethnological Geography of the Golan" ("Géographie ethnologique du Djolan"). I chose this chapter in particular because it starts with the author addressing what he calls *le problème ethnique*, or the ethnic question, in the Golan, and in Syria more broadly, by grappling with a set of European theories of race. In the opening of his chapter, Bagh presents the different ways in which geographers have approached the question of race and ethnic difference in the region, offering a brief outline of *his* history of geographical knowledge in modern Syria. However, he refutes completely the notion of a "Syrian race," and instead circles the question of Arab identity and Arabization as a way to explain the anthropological character of the various native and immigrant populations in

the Golan. He examines the Golan's different local populations (such as Turkmens, Kurds, Armenians, and others) through their adaptability to and absorption into Arab culture since, as Bagh writes, "the Arab majority in the Golan was able to impose its language, popular traditions, and customs on the immigrant minority."[11] The chapter ends with an ethnological elaboration of all the "racial types" that constituted the human landscape in the Golan, with detailed descriptions of their lifestyles, as well as the social and political changes they have gone through.

It would be true to say that Bagh's doctoral thesis, and the Golan as its core subject, were part of a broader story of the rise of social science on the margins of a post-colonial condition. As he addresses the vexed relationship of French colonialism and Syrian and Arab nationalism with discourses of race and identity, readers will notice that Bagh bases his analysis less on the assumption of "colonial difference" between the European and the native in the Golan, and more on the premise of the uniqueness of the collective Syrian national subject.[12] By tracing and measuring the multiple local ethnic realities in the Golan, Bagh, one could say, drew conclusions about what he saw as the unique characteristics of the Syrian and Arab national collective. Bagh's reasoning spoke to the social sciences of his time. He was preoccupied with questions about the ethnic homogeneity and heterogeneity of the Syrian nation, but he was significantly curious about processes of cultural and national assimilation. While embracing the ethnic difference in the Golan Heights, Bagh believed in the power of the modern state to blur, through assimilation, the different racial categories and their designated ethnic origins. Curiously, he cared about race only to tell us that race itself and racial difference can disappear through cultural and national assimilation, and in relation to the physical material environment.

Bagh's highly informative study remained untranslated for almost 25 years following its original appearance in French. It was only in 1983, in the midst of a global condemnation of the Israeli annexation of the Golan, that Bagh's doctoral thesis was fully translated into Arabic and became accessible for the first time to the Arabic-speaking reader. Below, I present an original English translation of the ethnological section as a way of contributing to the local social history of the region, hoping that this translation will offer an opportunity for interested scholars to engage with its content, and to read along and against its arguments and assumptions. Before I do so, and in order to situate the significance of Bagh's work, a quick summary of his biography is in order, albeit a very selective one.

CIRCASSIAN BEGINNINGS AND FRENCH WORLDS

Thousands of Circassian families,[13] including Bagh's, settled in the Golan Heights following the Russo–Turkish War of 1877–78, during which as many as two million Muslims were expelled from Russia and the Balkans to Ottoman lands.[14] Among these refugees were the Circassians and Chechens who had earlier been settled in

Rumelia during the nineteenth century. "Claiming that they were creating transborder problems and disturbances," historian Resat Kasaba writes, "Russia insisted that the Ottoman government remove these communities from the Balkans. As a consequence, the Circassians wandered out of Bulgaria (Eastern Rumelia at the time), and in the spring of 1878, in a starving and pitiful condition, they reached Acre, Palestine."[15] Judging the Circassians to be "tough warriors,"[16] Istanbul resettled many of them in the Asian regions it wished to control better, including in Western Palestine, Jerash, and the Golan.

The arrival of tens of thousands of Circassians and Chechens "aroused deep resentment among the local groups, who were unhappy with the support the refugees received from the central government and saw them as little more than agents of the Porte."[17] However, like many other communities that were instrumental in the empire's policy of settlement and sedentarization, "Circassians presented a more varied and complex picture. Many of them resented their new places and claimed that the land and resources given to them were insufficient. In time, some of them became famous for their fierce independence and banditry, generating a strong reaction from the central government."[18] In the Golan, Circassians soon attained a certain amount of prosperity through hard work and solid perseverance. "They built villages," Bagh writes in his study, "cultivated their fields, bred cattle, and dried grass for the winter."[19] They also drove Bedouins out of their neighborhoods, Bagh continues, "so that today Circassians inhabit the twelve large flourishing villages in the Golan's district of Quneitra."[20] One of these villages was called al-Juwwayza, where Bagh's family lived and where Bagh himself was born in 1928.

Very little is known about the intimate dynamics and family settings into which Bagh was born and grew up. From a short biography attached to the Arabic translation of his doctoral thesis, we know that in 1936, Bagh attended elementary school in his village in the Golan, later moving to Homs in western Syria to receive his elementary degree in 1941.[21] He was then accepted to the Jawdat al-Hashemi school in Damascus, the first official high school in Syria (established 1933), from which the first generation of graduates would go on to take important administrative, political, and military positions in the post-colonial Syrian state, and where the seeds of many political movements were formed, foremost of which was the idea of the Ba'ath Party. After graduation from high school in 1947, Bagh specialized in geography, received his diploma in education in 1951, and began his career as a geography teacher.

One can imagine the politicized and national life that Bagh lived and witnessed in Damascus, and Syria more broadly, a time when the military was becoming a powerful tool in shaping political and civil life. For instance, in the course of one year, in 1949, Bagh lived through the overthrow of Syria's national government by a military coup d'état led by Hussni al-Zaim, and then Zaim himself was overthrown by his colleague Sami al-Hinnawi, who in turn was overthrown by Colonel Adib al-Shishakli. Shishakli would rule the country until 1954, until growing public

opposition forced him to resign and leave the country. It was at around that time that Bagh saw an opportunity to pursue higher education and decided to travel abroad.

In 1954, around the age of 26, and exactly a decade before his untimely death, Bagh arrived in Paris to work on and write his doctoral thesis in geography. Entangled with a long legacy of empire and colonial expansion, French academic geography at the time enjoyed international renown as it both supported scholars working beyond French territories and appointed professors and advisors who had acquired prolonged experience beyond France.[22] Among the geography professors at the Sorbonne was French geographer Jean Dresch, who attracted the largest cluster of non-French researchers coming from the former French colonies, and whose professional patronage Bagh, unsurprisingly, sought out. When Bagh arrived in Paris, however, he was no longer a French colonial subject, but a post-colonial Syrian citizen studying and writing in French about his Syrian homeland.

Dresch was known for his political voice and criticism of French colonialism. His early career unfolded in Morocco as a result of a chance invitation by a Sorbonne professor to undertake some contract research that had come his way.[23] During the 1930s, Dresch taught in a Muslim middle school and then in a lycée while researching his thesis on the geomorphology of the High Atlas Mountains. In a detailed article about the professorial patronage and the formation of French geographical knowledge, geographer Hugh Clout recounts that as soon as Dresch landed in Casablanca for the first time, he had been struck by the poverty that surrounded him: "The contrast between the wealth of most Europeans and the misery of most indigenous people, directed his politics toward communism and his geography toward development issues, as well as geomorphology."[24] His identification with the plight of the poor "separated him from other geographers in Morocco whose enquiries provided information for the French administration and military."[25]

Although Dresch was expelled from Morocco in January 1941 because of his critique of French colonialism and his communist persuasion,[26] he had to return to France in 1939 to serve in the military during the Second World War. The war brought a long delay in the publication of his research, and "despite his doctorate having been examined successfully, his political persuasion contributed to a delay in acquiring a university chair."[27] After several temporary faculty positions, and lecturing in French cities like Caen and Strasbourg, in 1948 Dresch was appointed to a chair at the Sorbonne, where he would serve as an advisor to a cluster of doctoral students working in North Africa, the Eastern Mediterranean, and even parts of tropical Africa and South America. When Adib Bagh arrived in Paris in 1954, he joined a cohort of students coming from countries in North Africa as well as Latin America, the Near East, and tropical Africa, most of whom were preparing major monographs in physical geography. He was not the only Syrian under Dresch's patronage. Abdul Rahman Hamidé would also write about their home country, Syria.[28] It is through these multiple layers, backgrounds, and regions that Bagh's social, political, and intellectual life in and about the Golan came to be.

AN ASYNCHRONOUS INTERVIEW

One set of questions remains unaddressed: What does it mean to read Bagh's biography and work today, from a Golan Heights that is near-empty of its pre-1967 populations? What is it like, once again, to write from this site of ruins? How do I, the author of this essay, who grew up in a radically different Golan than Bagh's, reflect on that historical past? In answering these questions, I find myself exploring a speculative relationship with Bagh, without necessarily imposing a definition on it. The Golan that I was born in and now study is not only a space that was almost emptied out of its people in 1967, but is also a space that was carefully and selectively repopulated shortly after. I grew up in a Druze family in the occupied Golan Heights, in a small Syrian community that no longer lives under Syrian sovereignty, but instead navigates life under the machine of occupation and the Zionist project of Jewish settlement. It is a Golan that is today exclusively inhabited by a community of nearly 25,000 Druze who were able to remain after the occupation of 1967, but it is also a Golan that is increasingly and intensively becoming home for Israeli Jewish settlers whose numbers amount to nearly 20,000 today. One could say that the ethnic multiplicity Bagh will describe to us below has been replaced by an ethnic exclusivity, one that was colonially crafted and carefully designed. In a sense, *my* Golan is not just another different space and time from that of Bagh's, but precisely the inverse of his multilinguist, multiethnic world.

In attempting to write this introduction, I kept in mind the gap—that is, both the continuity and discontinuity—between Bagh's time and mine. I hoped to bring a "generational apprehension," to borrow from anthropologist David Scott, in an effort to give a concrete autobiographical specificity to where from and how I come to encounter the past in question.[29] In following key moments in Bagh's life, as well as presenting sections of his work, I imagined myself "interviewing" him. Interviews, writes Scott, "neither presuppose nor encourage symmetry or reciprocity between." On the contrary, interviews "underline rather than dissolve certain dimensions of social difference, specifically generational ones."[30] To be sure, Bagh's work undeniably operated within a specifically strict Arab nationalistic discourse. For instance, he dedicates the publication of his study to the "nation's officers, soldiers, and martyrs who fell in Syria's wars."[31] My aim in interviewing Bagh is neither consensus nor critique, but clarification. In doing so, "I am listening," as Scott would put it in the context of his interview with the distinguished Jamaican intellectual and choreographer Rex Nettleford (1933–2010).[32] I am challenging myself to hear something about a past in the Golan Heights that somehow also belongs to me.

To me, Bagh was not only a post-colonial subject who inhabited an Arab nationalist present and mustered its language, but also a native resident whose family's arrival in the Golan was intimately enabled by a violent Russian as well as Ottoman project of displacement and resettlement. Remarkably, Bagh was also a student and an intellectual who lived in the Golan and wrote from and about a pre-

Israeli settler-colonial present, without the knowledge that his family, community, and all aspects of cultural life as he knew them would soon cease to exist as a result of the Israeli occupation. There is a haunting quality to Bagh's writing, in that it captured the historical specificity of this era just before it ended. And so, in offering my translation below, it is my attempt to emphasize the organic connection as well as the dissonance between two intertwined worlds: the Golan of post-colonial Syria, and that of the settler-colonial Israel. On this brief journey with Adib Bagh in section two of his dissertation, the reader bears witness to a certain plurality in the Golan, a plurality that now exists only in the past. It is my hope that this glimpse into the past will invite us to reflect on the Golan's purified colonial present.

Part II, Chapter II

Adib Bagh

The Ethnological Geography of the Golan

The ethnic question (*le problème ethnique*) in Syria, and particularly in the Golan, is a very controversial question, which authors have not always approached objectively and impartially. Syria's population is often approached as a people with no race (*peuple sans race*), or else as very heterogeneous; the expression, the Syrian ethnic mosaic (*mosaique ethnique syrienne*), has also been claimed and exaggeratedly so.

Those who support the thesis that Syria is a "mix of races" (*conglomérat de races*) are numerous. For them, this region is a melting-pot into which many people were continuously blended. According to this thesis, today's Syrians are but the descendants of the remnants of all the invasions that have afflicted this country during its long history.

What makes the ethnic question relevant here is the Arabophone majority (*la majorité arabophone*). But can we consider language as a criterion for determining people's race? In other words, would it be right to categorize all those who speak Arabic as part of a race called the Arab race? If not, then what would be their race? Can we speak of a Syrian race (*race syrienne*)?

While some authors have looked at the people of Syria as an ethnic mosaic, others, including [historian and Jesuit] Henri Lammens have, on the contrary, and quite unfortunately for a purpose that is far from scientific, seen in this same people a race they call the "Syrian race."[33]

In 1939, [French geographer] Jacques Weulersse strongly opposed Henri Lammens' thesis, saying that "the Near East had long passed the stage of pure races."[34] Seven years later, Weulersse blatantly contradicted his prior thesis by arguing that the rural population of Syria, that is to say, the great majority, belongs to one race that was unaffected by the successive invasions that had previously struck the country. In the region today, rural peasantries, Weul-

ersse writes, should be traced back to their origins for the multiple invasions this region had suffered from were only superficial. In other words, the Hittites, Aramaeans, Assyrians, Sea Peoples, Egyptians, and the Persians, were only fleeting invasions; they caused changes to capital cities, sometimes modified languages and customs, but they hardly affected the rural population that was already strongly attached to the land.[35] With that said, Weulersse refrains from telling us the true origins of today's peasants in Syria.

It was [the Syrian geographer] Izzat Nouss who explained to us the origins of the Syrian people, claiming that "Syria's ancient Semitic Mediterranean background was only sporadically and superficially affected by the invasions."[36] According to him, the people of Syria are of an "Arab Syrian race, in other words, nothing other than a Mediterranean-Semitic group; a group whose ethnic origin is similar to that of the Aramaeans and the Hebrews (*Hébreux*)."

However, our professor, Jean Dresch, sees things differently. "One certain fact," he writes, "is that contrary to common belief, there is no such thing as a 'race' or 'type', neither Semitic, nor Arab, nor Jew. The Bedouins are mostly Mediterranean. But the Armenians, Canaanites, Phoenicians, and Arameans who could have been on the margins of the desert were Bedouinized, and later after the expansion of Islam they were Arabized. The Jews would be the Armenoid (*arménoïdes*) nomads who came from the North sometime during the second millennium BC; however, there are tall, fair-haired (*grands et blonds*) Jews of the Nordic type, and Jews of the Iranian type."[37]

This brief account of the ethnic situation and the radically opposed ideas show us how difficult it is to resolve such a question.

The ethnic question also becomes critical in the Golan, and on a regional scale this matter seems to be more complicated than in the rest of Syria. However, the history of the population in the region can shed light on a number of fundamental facts:

- The great majority of the population is of the same race. They are, in fact, the native population in the region who arrived here since the third century BC. Today, this predominant majority is represented by individuals who have the same physical features, the same language, and the same traditions. They are Arabs, either nomadic or sedentary. Indeed, this majority must be considered as representing what could be called an Arab race for the following reasons:
 1. Historically, it is certain that Arabia is their country of origin, as the tribes of the Ghassanids, the al-Azd, and the Lakhmids had come from Yemen and settled our region before Islam. Other tribes, such as that of the Tayy, settled this region after the Muslim conquest.

 According to the genealogists of the al-Fadl tribe, currently living in the northwest-Golan, their origin can be traced to Fadl ibn Abbas, one of the Prophet's cousins.

2. The different tribes who live in the Golan today, from south to north, speak pure Arabic, each with a particular accent, but with no foreign influence.

3. The Arabs in the Golan did not mix with other foreign (*exotiques*) groups who for various reasons tend to live a secluded life.

4. The Arabs of the Golan are indistinguishable from those who still live in Arabia, neither by physical features and language, nor by customs.

However, the non-native populations who came to live beside the Arabs were not hermetic; the common interest of these coexisting human groups brought them closer together.

The natural conditions of the environment imposed, more and more, diverse but well-defined forms of life; thus, the ethnic mosaic is replaced by a social mosaic.

Finally, two essential facts should be noted:

a. The Arab majority in the Golan was able to impose its language, its folklore, and its customs on the immigrant minorities.

For instance, the Eski-Turkmens living in the Golan only speak a very broken Turkish; and the words used in their daily life are mostly Arabic. The new generations of Circassians and Yuruks in the Golan speak Arabic alongside their mother tongues. As brief as it has been, the period of [Syrian national] independence has played an important role in the Arabization of foreign elements; and in that respect, teaching was the most effective means of doing so.

Folk costumes (*les vêtements folkloriques*) have completely disappeared; today, rural peasants, whatever their origins may be, almost all dress in the same way.

b. The natural environment also plays a considerable role in shaping people's physical features [...]. A Turkman in the Golan is no longer distinguishable from a semi-sedentary Arab; their physical features, the language, the clothes, and the ways of life are almost the same.

Similarly, the natural traits that [ethnologist Marcelle] Proux had once attributed to the Golan's Circassians population are becoming less and less evident.

However, we are unlikely to find the same physical features, even among individuals of a single ethnic community. Let us recall, in this respect, what [French geographer] [Paul] Vidal de la Blache had written: "when one draws on anthropological indexes, even on those reputed to be the most coherent, to distinguish the elements that constitute a population, not only that of a large country but also in small communities, we note, with few exceptions, that the absence of homogeneity is the rule."[38]

The Arabs of the Golan (Les Arabes du Djolan)

We cannot specify the exact date of the first Arab arrival (*infiltrations Arabes*) in the Golan. Historians who found Arab traces in Syria dating back to around 2000 BC consider the Palmyrenes and the Nabataeans to be of Arab origin (*souche*). Indeed, the Nabataean kings ruled over the Golan and Hauran before the Roman conquest [...]. However, we don't have decisive proof of the Nabataean people's Arab origins. Even if we cannot specify the exact date of the Arabs arrival, and even if the origin of the Nabataeans is not proven, one thing remains indisputable: the Golan was already Arabized at the time of the Muslim conquest.

Thus, the new sovereigns (*maitres*) of the Golan, the Muslims, differed from the former ones, the Ghassanids, only in religion. The Ghassanids had embraced Christianity even before their Roman allies did and had built some churches in Hauran and the Druze Mountain, but they easily converted to the new religion. Also, shortly after the Muslim conquest, the population of the Golan had been very homogeneous: same anthropological characteristics, same language, and same religion.

From within this homogeneous population emerged a diversified social order: some groups remained strongly attached to the fertile land, especially in the southwest. It is there that one finds the Golan's typical fellah today. Others, on the contrary, remained attached to the original Arab way of life; that is, nomadism, although we still find other forms that are in a state of transition: either semi-sedentary, or semi-nomadic.

The Arabs of the Golan, however, can be genealogically linked to four major tribes: al-Fadl, al-Na'ime, Al-Wayziyya, and al-Rifa'aiya.

Druze (Les Druzes)

One of the most controversial questions of Syria's social makeup is the origin of the Druze; in this regard, bizarre and contradictory explanations have been given. We will take up this question again, and clarify it, for the Druze still live in large numbers around Mount Hermon and across the region of our study.

Is it a Druze race or a sect (*De quoi s'agit-il, d'une race Druze ou d'une secte*)? Western authors often speak of a Druze race that is distinct from the Arab race. For instance, [officer and writer Narcisse] Bouron, speaks of a "Druze race, non-Arab, but strongly influenced by Bedouin traditions and customs even though the core of the race itself has all the characteristics of the purest Indo-European."[39]

Bouron traces the Druze's origins to the Gauls (*Gaulois*): "It is said that when one has lived among the Druze, one is tempted to agree, and to think that this race with light skin, moderate eyes, a red and drooping mustache, and copper-colored hair, may well be the descendants of the Gallic tribes." Some

historians trace Druze origins to the Hittites because for them the Druze are those crusaders who straggled behind, and thus they owe their name to the crusader: Dreux, whereas other historians trace the Druze back to an Iranian origin as the founder of their sect, Nashtakin ad-Darazi, is Persian [...]. Indeed, all these explanations seem to be very far from the truth.

Instead, it is very likely that the Druze are the descendants of the Arab Yemeni tribes who settled in the natural fortresses of Lebanon, the high valleys of the Wadi al-Taym.

[...]

Persecuted and accused of heterodoxy by the Sunni majority, all the followers of the [Druze] religious sect took refuge in the mountains. Isolated for religious reasons, the ethnic characteristics of the Druze remain more or less unsullied (*intacts*), while the Sunnis have perpetually mixed with other non-Arab Sunnis.

In 1293, the Mamluks, Sultans of Egypt and Syria, sent an army to Lebanon to fight the Druze rebels, but this army was partly wiped out (*exterminée*). The Sultan, in 1304, was finally done fighting the Mongols, and was able to organize a punitive expedition against [the Druze]: invading, destroying their dwellings, and uprooting their vines and mulberry trees. [Druze] rebels who could not flee were either massacred or forcibly incorporated into the Egyptian militia. It was after this year that the Druze emigrated from Wadi al-Taym towards the southern and south-eastern slopes of the Hermon, and towards the Jabal Hauran (the Druze Mountain).

Today, the Druze of the Golan base themselves in villages with defensive sites, living with the Christians and Syriacs. According to state registers, about 11,000 Druze live in the mountain villages of Hermon. But these statistics are more official than real for there are people who are not registered, and others who emigrated a long time ago but whose names are still on the registers.

Circassians (les Tcherkesses)

The Circassians are Indo-Europeans who arrived in Syria, either directly or indirectly, from the Caucasus. Dating back to the time of the Mamluks, the descendants of the oldest wave of Circassian immigration to Syria have been completely Arabized; the Circassians of the Golan arrived in Syria during the second half of the nineteenth century and the beginning of the twentieth century. Coming from different Islamic backgrounds, Circassians have always been easily assimilable into the Arab majority.

It is worth noting that the Circassian Sultans (Mamluks) who ruled Egypt and Syria for more than two centuries always intended to link themselves with an Arab genealogy. In this way, the last Mamluk Sultan Qansuh al-Ghuri (*Kansaou al-Ghouri*) declared that the Circassians descended from the Ghassanid Prince Jabala ibn al-Ayham who embraced Islam, but then converted to Christianity and took refuge in Constantinople.[40]

[Caucasian scientist and politician, Professor] Aytek Namitok claims that Circassians, Albanians, and Kurds are three branches originating from three brother princes of Arabia.[41] What is even more curious is that the (Arabian) tribes of Anizah, who came to the Golan during the drought years, claim that the Circassians and the Anizah descend from two brothers: Anaz, the grandfather of the Anizah, and Ma'az, the grandfather of the Circassians. Even if all of these genealogical explanations are unlikely to be accepted by anthropologists, they have the virtue of showing us the psychological relations between Circassians and Arabs. "It is almost certain that Circassians are Indo-Europeans, descended from the Hittites who ruled over northern Syria and Anatolia for quite a long time."[42]

"Circassians are renowned for the beauty of their race: tall stature, slim waist, clear forehead, straight nose, purely modeled features, clear complexion, soft or slightly wavy hair, brown or blue eyes which place them unquestionably among the Indo-Europeans"

However, these physical features are becoming less and less distinct, which is the result of the severe natural conditions of the environment, but also their current diet. Those wealthy Circassians who were meat-eaters in the Caucasus, feed themselves less well today. They are often poor and make do with a diet that is little varied and often mediocre, often consuming dairy products, tea, cheese, and a lot of bread. It is certain that in the Golan [Heights], where winters are very cold, the diet should strongly include a carnivorous diet. Elderly Circassians are still averse to vegetables, considering them "goods for animals," as they say. Their remarkable longevity is a proof of the role nutrition plays on their bodies, and the consequences it has had on their race.

The Circassians of the Golan, who today number about 13,500 people, did not come directly from Caucasia to the Golan. Driven out by the Tsars, Circassians were welcomed by the (Ottoman) Porte and were then resettled in Eastern Rumelia, in the northwest of Kurdistan, and in Anatolia. The Ottoman government hoped to group Circassians into military colonies which would put down the subversive movements of the empire's Christian subjects. Indeed, Circassians were sent to Rumelia, and then cruelly massacred Yugoslav and Bulgarian insurgents.

During the Russo–Turkish war of 1875 to 1877, Circassian troops proved so relentless that the Russians demanded the insertion of a special clause in the Treaty of Berlin (1878), which prohibited Circassians from residing in Bulgaria and the Balkan countries.

Consequently, those Circassian deportees who settled in Rumelia since 1764 had to flee once again. Pushed back to Asia Minor, where they found a large number of their compatriots who had remained in the Caucasus, but who, dissatisfied with the new regime, had sought salvation in flight.

The Ottoman government, facing threatened borders and troubled regions at the time, distributed the [Circassian] immigrants across the Syrian territory

along the Empire's border, between the Euphrates and the Transjordan. When they arrived in Syria, the majority of the immigrants were steered to the Golan. The Turks' guiding principle in settling Circassians in the Golan was to make them guardians of order in this continually unstable region.

The newly arriving Circassians had to deal with the expansion of the Druze of [Mount] Hermon who control the passage between the Hauran and the Golan as well as the nomadic Ruweilah (Anizah tribe) who used to graze their camels in the Golan for centuries. The settling of the Circassians in the Golan was received with a certain ill will. The following decades saw an increasing number of incidents between the Circassians and those who considered themselves the legitimate owners of the land by virtue of inhabiting it first.

Circassian immigrants grouped themselves into villages and neighborhoods according to their main tribes: Dagestan, Chechen, Abaza, Abazah, Kabarday, Bzedoughs, Kouchha, and others. Their first main settlement was in the town of Quneitra, and their other villages were established around that town, especially toward the south of the Golan.

These small urban centers were established during a number of different eras. Incoming waves of Circassians continued to migrate to the Golan from 1878 until 1947. The first and main wave arrived in the Golan between 1878 and 1887, followed by another one in 1897; its people are those who inhabit the town of Khushniyyah today. Then in 1912, the inhabitants of Faham today, and later in 1922, those of Hamidiyé. In 1930, eight families arrived in Quneitra from the USSR, and finally in 1917 about 50 other men arrived in the Golan.

These urban areas appeared in the middle of the Arab population as ethnic, linguistic, and folkloric islands. But the Circassians, more or less, quickly assimilated:

1. Their national costume has completely disappeared, even the Kalpak, the distinctive sign of their nationality, has been replaced by the Arab keffiyeh and the Ugal. The disappearance of this costume can be explained by several reasons:

 a. First, it is expensive.
 b. It is worn tight against the body, and therefore inconvenient for work in the fields. It is a cavalier's costume after all.
 c. It had been the official uniform of the Circassian units that were established by the former (French) mandate authority, this costume became the symbol of unpleasant memories dating to the Syrian Revolt of 1925.

2. The Circassian language, very different from Arabic, was initially abstruse. Direct relations with the Arabs, especially through education have had considerable consequences. Today, the Circassians of the Golan speak Arabic fluently.

3. Islam was, in fact, an essential factor in their assimilation. All Muslims are brothers, as it is said in the Quran. Furthermore, the prayers, the call, and the reading of the Quran, all require knowledge in Arabic.
4. Even in the Caucasus, the Arabs enjoyed a great reputation for nobility and chivalrous generosity. Arabs and Circassians have somewhat similar conceptions of honor, hospitality, warrior courage, revenge, and the right to refuge.
5. At the time when the French authorities in the Golan were pushing for the preservation of Circassian customs, folklore, and even the Circassian language [1920–41], a large number of this community openly supported Syrian nationalism and declared acceptance of the principle of Arab assimilation as an ineluctable necessity.

The clash that took place in [the town of] Quneitra on September 9, 1936, between the pro-Arab Circassians and pro-French Circassians caused a decisive change in the political orientation of this community. Since then, Arab nationalism gained ground and the Circassians accepted Arabization willingly.

Turks

When it comes to the inhabitants of Turkish origin, it is necessary to distinguish between two different communities who live in the Golan today: Eski-Turkmens and Yuruk.

The Eski-Turkmens: We cannot specify the exact date of their arrival in the Golan; however, we can confidently say that they have been in this region for at least 400 years. If we are sure that they are of the Turanian race (*la race touranienne*), we are less sure of their history. Where did these Eski-Turkmens live before their immigration to the Golan, and why did they come here? There are three hypotheses:

1. They descended from the famous tribes in Muslim history, the Seljuks. They lived, for a certain period of time in Palestine, in the Plain of Esdraelon [Valley of Jezreel, today's Emeq Yizre'el] and then emigrated to the Golan for unknown reasons.
2. The Eski-Turkmens claim that they are Ottomans, and that they were brought from Turkey (400 families of the Turkish aristocracy) on a mission to civilize the Bedouins of this region.
3. A third origin is possible: they are the remnants of nomadic tribes from the Tamerlane era. This last hypothesis seems more likely than the others because the Eski-Turkmens now live in a semi-sedentary way. Their language is very broken and mixed with a large percentage of Arabic words. The Turkmens have become good Arabic speakers. Their villages are scattered on either side of the Quneitra and Jisr Banat Ya'aqob road. The Turkmens of the Golan currently number about 4,000 people, of whom only 2,650 are officially registered in the state records.

In their small villages, Turkmens often live alongside a number of Bedouins. Only one large Turkman family resides in [the town of] Quneitra, a very rich family who came from Damascus for trade.

Yuruks: Their origins are not different from Eski-Turkmens, but their society remains quite intact and little evolved. They came from Turkey where they lived as nomadic tribes: summering near Eskişehir and wintering near Smyrna. Serious disputes between the different Yuruk tribes forced a number of them to migrate in 1870. They arrived in the Golan after camping in Adana, Antioch, Homs, Damascus, and Palestine in the Ghor where they lost their herds of goats and two-humped camels to a catastrophic flood. They then left the Ghor to come to the Golan.

As true nomads, they travel to Ghor, where they spend the winter each year, and return to their villages at the beginning of April. Due to the abundance of wood in Ghor, they collect and chop wood, and then sell it in the Golan, where it is also used as reeds for rooftops.

Following the First World War, the Yuruks returned to Turkey. However, the Kemalist regime was not favorable to them, so they returned to the Golan. Before they left for Turkey, the Yuruks sold most of their land, and upon their return to the Golan, they were able to recover their hovels, but their fields were all gone. Today, they are obliged, for the most part, to work on lands belonging to Circassians or Arabs.

Their main dwelling center is Ain Aiché, inhabited only by Turkmen, numbering 740 people. This more or less primitive society is still little Arabized but very much attached to Islam.

Other Minorities

Other minorities live in the Golan today, but they number very few: Armenians, Kurds, North Africans, Tellawiya, and Blacks.

Armenians: There are 419 individuals who live in the town of Quneitra only. They monopolize a certain number of jobs, crafts, and liberal professions. In the Golan, all photographers, watchmakers, goldsmiths, dentists, and pharmacists are Armenian.

Armenian society is unassimilable; they have their national school, and their church. Only the Armenian language is taught in their schools, and it is also the liturgical language of the church. Thus, Armenians, even the youngest, do not speak Arabic satisfactorily; and they are recognizable by their particular accent.

Kurds: They are also very few in number; however, within the Golan's Kurdish community, a distinction must be made between:

1. Kurds who are completely assimilated: They only speak Arabic. They live a nomadic way of life and resemble the Arab nomads. Recognized as "agha" by the Arab Bedouins, this is all that remains of their origin and their past.

2. The urban or village Kurds: In Quneitra there are about 50 people who trade and maintain good relations with the Bedouins. In a number of villages, the Kurds work as shopkeepers or butchers.
3. The large Kurdish landowners: They own lands that are indirectly managed through sharecroppers. These landowners reside in Damascus. Indeed, the Kurds are the largest landowners in the Golan. Only three families possess 452,925 dunams there.

The North Africans (*Les Nord-Africains*): They are grouped in two villages in the extreme south of the Golan: Abdine and Ma'arraya. They are referred to as Magharbé, and came to the Golan from Algeria following the French colonial conquest of their country. They own lands, and Prince Said al Jazairi (a descendant of Abdel-Kader) is one of the important landowners in the Golan; however, he resides in Damascus.

Tellawiya: These are Arabic-speaking tribes who live in the small plain of al-Butayha on the northeastern shore of Lake Tiberias. The Tellawiyas' physical features are similar to those of the Black Africans (*des noirs de l'Afrique*), but they are less dark. They have lived on these fertile alluvial terrains for generations; however, they are no longer landowners. They are, indeed, the most unfortunate of all the inhabitants of the Golan. The land that belonged to them was passed, in a very mysterious way, into the hands of a Kurdish Pasha.

The Tellawiyas in the Golan number about 8,000 people, of whom only one-third are recorded in the civil registry. Their name is derived from the Tell Aa'war region where their ancient ancestors once lived. After their numbers increased, they occupied the whole plain. The origin of the Tellawiyas, foreigners (*exotiques*) in the region, are unknown, and they were always harassed by the Arab Bedouins, so they asked for the help of a Kurdish Pasha (Abdul-Rahman Pasha) who was supported by the [Sublime] Porte. The Pasha was able to register their land in his own name, in an illegal and very mysterious way, and since then the Tellawiyas became sharecroppers.

Blacks (*Les Noirs*): a certain number of individuals of the black race live in the Golan. They are Arabic-speaking, but the Arabs refer to them as A'abeed (*esclaves*), even those who are freed. The latter are grouped in the small village of Rafid. Other Black people are still enslaved and belong to the Bedouin Emirs, especially Emir Faaour, a leader and former deputy of the al-Fadl tribes. We cannot determine their number or origin in a satisfactory way.

CODA

Sociologist Salim Tamari reminds us of past times when the term "Southern Syria" had been synonymous with Palestine.[43] He points out that while Ottoman Palestine corresponded more or less to the political frontiers established by the British Mandate after the First World War, identity and borders did not follow neatly, and

people in Palestine continued to identify themselves as Syrians, southern Syrians, Shamis (that is, people of the Levant), or by their religious affiliations, depending on the context.[44] Even more than personal and collective identification, the expression "Southern Syria" itself gained an added political significance in the years immediately after the First World War, as historian Rashid Khalidi shows, when "the first new newspaper to be established in Palestine was *Suriyya al-Janubiyya* [Southern Syria], published in Jerusalem beginning in September 1919 by the lawyer Muhammad Hassan al-Budayri, and edited by ʿArif al-ʿArif."[45] And although the idea of "Southern Syrian" was mainly espoused by fervent Arab nationalists,[46] it also came to signal the unity of Jerusalem with Damascus more broadly. What geographer Adib Souleiman Bagh offers us in his ethnological account, I contend, is a unique glimpse into a local site that was central to the making of the social world of what was once known as "Southern Syria." Simultaneously, his account is also a unique description of a cosmopolitan landscape that would later be violently unmade with the Israeli occupation of the Golan Heights in 1967.

By the late 1950s, a population of 153,000 lived in the Golan Heights across 163 villages and 108 large agricultural farms.[47] The social fabric of that world, as described by Bagh, was multiethnic, multireligious, and multilinguistic. To seek to present this multiplicity in the here and now is, however, but a preliminary step, and only partially compelling. What were the potentialities of such diverse social fabric? What was its magic? Reciprocally, what problematics, troubles, tensions, and challenges did it pose to everyday life, and how did individuals and collectives go about solving, or alternatively, living with them? Given its geographical location, we are also prompted to ask how this multiplicity both shaped and itself was shaped by neighboring societies and landscapes. These questions simply resist a straightforward answer but are themselves a source of haunting. The world of the Golan Heights that is described by Bagh once used to be the organic extension with which people in northern Palestine interacted. His account therefore implicitly offers us a portrayal of an ethnically diverse and thriving landscape through which to envision Palestine's edge as a productive site of interaction. In this vein, my choice in presenting a historical document from the Golan Heights in this collection is an invitation to engage with an idea of a Palestine that "radiates outwards," one that "exudes and seeps beyond the defined political borders of a given political entity."[48]

As we read through sections of Bagh's doctoral thesis, we realize that it not only troubles the static image of the colonial present in the Golan Heights, but also, and equally importantly, complicates its layered past. As the preceding sections outlined, the argument behind his narrative illustrates an ideal according to which the national, with its cultural and environmental conditions, can and ought to transcend the ethnic multiplicity and local difference. Bagh describes to us a multiethnic landscape that slowly lent itself to a process of national and cultural assimilation, regardless of how far this form of assimilation went in tolerating local differences. In fact, we must pay attention to the various moments in Bagh's account when local

groups are presented as they were pushing and negotiating the boundaries of the categories of "Arab" and "Syrian," through language, costume, habit, diet, profession, among others. While contemporary accounts tend to frame the present-day Golan Heights as a place mainly devoted to resisting the Zionist project of annexation and to refusing its colonial citizenship, Bagh's account reminds us of another past suggesting more stratified readings of this geography, including one of national assimilation in the context of the modern Arab Syrian state. In a colonial present that seamlessly recast this past into a single, exclusive, and confined space and time, that which historically used to be multiple, and complex finds itself abstract; that which used to be malleable cartographically is now deemed limited and bounded. Challenging such presentist perceptions, however, are our written, oral, and sensorial forms of history, which constantly remind us of a potential otherwise.

NOTES

1. I am thankful to Noura Salahaldeen, Arpan Roy, and Khaled Furani for the invitation to contribute to this volume, and I am grateful for their comments and feedback throughout the writing process. I wish to also thank Margaux Fitoussi for proofreading the English translation and for her critical input. Special thanks to Adrien Zakar, who read and discussed earlier versions of this essay and helped formulate its narrative.
2. Cyrus Schayegh, "On Scale and Spaces: Reading in Schumacher's *The Jaulan* (1888)," in Liat Kozma, Cyrus Schayegh and Avner Wishnitzer (eds.), *A Global Middle East: Mobility, Materiality and Culture in the Modern Age, 1880–1940* (London: I.B. Tauris, 2014), pp. 19–54, at p. 29. See also Cyrus Schayegh, *The Middle East and the Making of the Modern World* (Cambridge, MA: Harvard University Press, 2017).
3. Schayegh, "On Scale and Spaces."
4. I am particularly inspired here by the work of anthropologist Franck Billé on what he calls "auratic geographies." See Franck Billé, "Auratic Geographies: Buffers, Backyards, Entanglements," *Geopolitics*, 29(3) (2021): 1004–1026.
5. Sakr Abu Fakhr, "Voices from the Golan," *Journal of Palestine Studies*, 29(4) (2000): 5–36.
6. Resat Kasaba, *A Moveable Empire: Ottoman Nomads, Migrants, and Refugees* (Seattle, WA: University of Washington Press, 2009), p. 111.
7. Abu Fakhr, "Voices from the Golan," p. 6.
8. Ussama Makdisi, *Age of Coexistence: The Ecumenical Frame and the Making of the Modern Arab World* (Berkeley, CA: University of California Press, 2019).
9. Ibid., p. 4.
10. Adib Bagh, *La région de Djolan* (Paris, France: Sorbonne University, 1958).
11. Ibid., p. 319.
12. I draw here on the insightful work by historian Omnia El Shakry, especially her distinction between a colonial mode and an indigenous mode of knowledge production in the anthropology of the late nineteenth- and twentieth-century Egypt. See Omnia El Shakry, *The Great Social Laboratory: Subjects of Knowledge in Colonial and Postcolonial Egypt* (Redwood City, CA: Stanford University Press, 2007).
13. Anthropologist Seteney Shami notes that "the term Circassian and its variants (e.g., Sharkass, Tcherkess, Çerkez, Jarkass), were used by outsiders (Arab, Turk, Russian, and European), whether travelers or conquerors. In general, the term designated the Adyge

but was sometimes used in a more inclusive sense to group, with the Adyge, other related groups of the Northwest Caucasus, such as the Abkhaz and the Ubykh. The origin of the word itself is unclear and may have developed out of earlier self-designations of the peoples of the region. In the communities outside the Caucasus today, the two words, Adyge and Circassian (Sharkass in Arabic, Çerkez in Turkish), are used interchangeably; however it was not always so." See Seteney Shami, "Displacement, Historical Memory, and Identity: The Circassians in Jordan," *Center for Migration Studies Special Issues*, 11(4) (1994): 189–201.

14. Kasaba, *A Moveable Empire*, p. 117. For an extensive account of how the Ottoman and Russian empires managed migration, especially an account of the Ottoman resettlement of North Caucasians in the Balkans, the Levant, and Anatolia, see Vladimir Hamed-Troyansky, *Empire of Refugees: North Caucasian Muslims and the Late Ottoman State* (Redwood City, CA: Stanford University Press, 2024).

15. Ibid., pp. 117–118. See also: Norman Lewis, *Nomads and Settlers in Syria and Jordan* (Cambridge, UK: Cambridge University Press, 1987), p. 99; Eugene Rogan, *Frontiers of the State in the Late Ottoman Empire* (Cambridge, UK: Cambridge University Press, 1999), p. 73.

16. Ryan Scott Gingeras, *Imperial Killing Fields: Revolution, Ethnicity, and Islam in Western Anatolia, 1913–1938*, doctoral dissertation (Toronto, Canada: University of Toronto, 2006), p. 24.

17. Kasaba, *A Moveable Empire*, p. 118.

18. Ibid.

19. Bagh, *La région de Djolan*, pp. 324–331.

20. Ibid.

21. Adib Bagh, *Al-Jawlan: Dirasa fi al-Jughrafiya al-Iqlimiyyah*, trans. Yousef Khoury, Abdul Rahman Hamidé, Muhammad Harb Farzat, and Mahmoud Ramzi (Damascus, Syria: Manshurat Ittihad al-Kuttab al-Arab, 1983), p. 3.

22. This was a period (roughly between the early 1890s and the late 1960s) extending from the peak of colonialism to the immediate post-colonial era and pre-dating major conceptual innovations and trends in French geography. See Hugh Clout, "Professorial Patronage and the Formation of French Geographical Knowledge: A Bio-bibliographical Exploration of One Hundred Nonmetropolitan Regional Monographs, 1893–1969," *Cybergeo: European Journal of Geography*, Epistémologie, Histoire de la Géographie, Didactique, document 549, http://journals.openedition.org/cybergeo/24203.

23. Ibid., p. 12.

24. Ibid.

25. Ibid.

26. Dresch was expelled by order of the Resident General, Charles Noguès; see ibid.

27. Ibid., pp. 12–13.

28. Ibid., p. 15.

29. David Scott, "The Temporality of Generations: Dialogue, Tradition, Criticism," *New Literary History*, 45(2) (2014): 157–181.

30. Ibid., p. 160.

31. Bagh, "Preface," in *La région de Djolan*, p.1.

32. Scott, "The Temporality of Generations," p. 160.

33. Henri Lammens Le Père, *La Syrie: précis historique* (Beirut, Lebanon: Imprimerie Catholique Beyrouth, 1921), p. 5.

34. Jacques Weulersse, *Le Pays des Alaouites* (Damascus, Syria: Institut français de Damas, 1940), p. 45.

35. Jacques Weulersse, *Paysan de Syrie et du Proche-Orient* (Paris, France: Editions Gallimard, 1946), p. 56.
36. Izzat Nouss, *La population de la Syrie, étude démographique* (Paris, France: Sorbonne University, 1951), p. 268.
37. Pierre Birot and Jean Dresch, *La Méditerranée et le Moyen-Orient, tomb second: La Méditerranée orientale et le Moyen Orient* (Paris, France: Presses universitaires de France, 1956), p. 299.
38. Vidal de la Blache, *Principes de géographie humaine* (Paris, France: Librairie Armand Colin, 1922), p. 11.
39. Narcisse Bouron, *Les Druzes: Histoire du Liban et de la montagne haouranaise* (Paris, France: Berger-Levrault, 1930), p. 47.
40. Ibn Iyās, *Historiographe Egyptien de l'époque Mamelouke* (London: Royal Asiatic Society, 1921).
41. Aytek Namitok, *Les origines des Circassiens* (Paris, France: Geuthner, 1939), pp. 28–29.
42. Youssef Izzat Pacha, *Histoire de la Caucasie* (published in French, Istanbul, 1912; Arabic translation, Cairo, Egypt: Issa al-Babi al-Halabi and Partners Press, 1933).
43. Salim Tamari, *The Great War and the Remaking of Palestine* (Berkeley, CA: University of California Press), p. 3.
44. Ibid., p. 13.
45. Rashid Khalidi, *Palestinian Identity: The Construction of Modern National Consciousness* (New York: Columbia University Press), p. 162.
46. Ibid., pp. 170–171.
47. Abu Fakhr, "Voices from the Golan."
48. Billé, "Auratic Geographies," p. 1014.

11
Similar but Not the Same:
The Heritage Question in Palestine

Khaldun Bshara

Here lie all sorts of people that ever walked the earth.[1] فيها كلُّ من وطئَ الثَّرى

Beyond that aim, we differ in all.[2] ومن بعده نحن مختلفون على كل شيء

Multiple layers make up Palestine's cultural landscape. "Here lie all sorts of people that ever walked the earth," as the poet Tamim Al-Barghouti suggests, and still, one sees the coexistence of forms, adoption of earlier forms, and the absorbing of traditions into new construction regimes. The Hebrews adopted the Canaanites' cults, who most likely borrowed from the Egyptians, Hittites, Mitannis, and Assyrians—all converging or overlapping over the Eastern Mediterranean. The Romans adopted Hellenistic forms, the Byzantines took over and added to them, Muslims emulated the Christian structures and modified them to suit the new faith, and the Mamluks and the Ottomans adopted local techniques, bringing with them new ones to enrich the local architectural industry. The latter—the Ottomans—trying to modernize their empire, incorporated neoclassical European styles and technologies into the bodies of their cities such that one notices no gaps between late Ottoman and the British colonial architectural forms. I discuss in this essay the legacies of these traditions of building in Palestine, and what they might tell us about the present and future of the people who inhabit this still-surviving built environment.

During my over 25 years of work at Riwaq—a Ramallah-based leading heritage nongovernmental organization (NGO)—in protecting, restoring, and developing built heritage in Palestine, owners and residents of historic towns and buildings were *almost always* reluctant to value built heritage restoration works. Some see restoration costs as neither feasible nor affordable. Others believe that historic buildings are not suitable for contemporary lifestyles. Others, suffering from deterioration, dampness, and the lack of facilities and infrastructure, see heritage as a curse rather than a blessing.

Heritage experts and practitioners also have their own doubts; heritage value has not been recognized as an opportunity; restoration techniques and traditional know-how vanished with the modernization of the construction industry, making restoration a hard profession; the Palestinian National Authority (PNA) did not prioritize human or financial resources for restoration. As a matter of fact, the budgets

of the Ministry of Culture and the Ministry of Antiquities and Tourism combined constitute less than 1 percent of the PNA annual budget. Furthermore, the Palestinian legal framework and protection bylaws are not sufficient to cope with increasing threats, especially after the Oslo Accord (1993) and its disadvantageous consequences for Palestinian territorial reach. Oslo created tremendous urbanization pressure on areas under Palestinian control. As a result, heritage sites and historic centers have been continuously destroyed to make room for high-rise buildings.

Working on the restoration of historic centers and buildings throughout Palestine, I observed a prevailing stigma surrounding historical edifices and heritage sites, particularly in rural Palestine, wherein a significant portion of the nation's architectural legacy is located, manifest through diverse mechanisms. Historic towns and buildings have, regrettably, become the dwellings of economically disadvantaged populations. Inhabitants of these areas aspire to escape what is colloquially referred to as "deteriorating slums" and to relocate to more esteemed and contemporary neighborhoods, often denominated as *al-jadida* ("the new") or *al-foqa* ("the upper neighborhood"). This nomenclature underscores a deliberate temporal and spatial disassociation from the connotations of *al-qadima* ("the old") or *al-tahta* ("the lower neighborhood").

After renovation, I observed that owners and residents of historic buildings and towns *always* see the rehabilitation results as compelling; the restored structures "are even better than they used to be when they lived in it." At such moments, ordinary people come to value heritage because of the renewed meanings of their vernacular architecture. After all, it is not an unfortunate event to inherit a rubbish dump that can be turned, with reasonable efforts, into an economic asset. In such a moment, the stigma of the "backwardness and primitiveness" of the historic buildings and towns instilled by colonial value systems and modern aesthetics vanishes, and the owner's pride gets a boost.

Because of its dialectical relation to memory and identity, heritage in Palestine has been undeniably entangled in politics. Claims and counterclaims have been shaping the contemporary history of Palestine. The centerpiece of these claims is the archeological remains that approve or disapprove of political narratives. This is not surprising in a settler-colonial context that considers Palestine *the promised land for the chosen people*. While Palestinians have been busy coping with the colonial everyday brutal measures, the enduring consequences of Nakba, and the continuing loss of the remaining territories of the homeland since 1967, Israelis have made archeology into a "national hobby"—the bible in one hand and the shovel in the other digging for it.

The battle over the material relics of the past has been asymmetrical. As Palestinians, we have not developed an archeological relation to our land the way our adversary has; instead, we have lived and practiced our territory and space, altering it in ways that help us survive and form communal and social life. In so doing, we push back further and defamiliarize archeology itself! To be able to stand the hard-

ships we faced, both the artificial ones such as colonization and land expropriation, and the natural ones such as famine and drought, we developed a very solid moral and ethical value system such as *oneh* ("interdependency") or *faz'a* ("solidarity") to cope with everyday difficulties. Further, to solidify these ethico-moral systems we anchored them in space such as the *saha* ("plaza"), *madhafeh* ("guest room"), the spring, the mosque, the church, and shrines[3] For us, the static past of Palestine is neither magic nor a treasure that one needs to cherish. Our lack of interest in archeology does not say anything about our interest in our past, space, or territory. Rather, it says something about our reluctant engagement with archeology—the field that subordinates us, as Nadia Abu El-Haj[4] has persuasively argued.

On the other hand, Israel, governmental and nongovernmental bodies alike, has deployed all means at hand to ensure a continuous quest for material relics that approve the founding legends of the state. As such, archeology in Palestine, as a discipline, has been turned into an ideological state apparatus that marginalized the Palestinians and their contributions to their territory and space.

However, we need to look into modes of resistance amid power influxes to show the Palestinians as active agents in a colonial struggle rather than perceiving us as ill-equipped victims. In light of the power asymmetry between Palestinians and the colonial regime, how might we use our material past to reclaim our present? Are there any (re)conciliatory aspects that archeological or historic sites may acquire in colonial/postcolonial situations?

There are no straightforward answers to any of the above questions. Mahmoud Darwish put it bluntly: "I studied archeology without finding identity in the stones. Am I really me?"[5] Indeed, Palestine has been the subject of intensive archeological investigations and expeditions as early as the nineteenth century with the onslaught of the project of Western modernity. Most, if not all, of these excursions aimed at "searching for God and country," as coined by Neil Silberman. In archeological digs, the Palestinian laborers served as porters and had little or no contribution to knowledge production about Palestine's material past.

A century forward, during the late Ottoman and British eras, Palestinian intellectuals such as archeologist Dimitri Baramki, folklorist Tawfiq Canaan,[6] musician Wasif Jawhariyyeh,[7] and others had started contributing a great deal to the study of Palestinian history and society. These contributions brought to light intimate stories of vibrant intellectual life that cut across ethnic, religious, and territorial lines, rendering Palestinian architects, planners, archeologists, and bureaucrats as active agents in their homeland.

The Nakba changed the Palestinian relation to landscape. The relationship to built environment that Palestinians had long cultivated through socio-spatial practices was utterly altered, shifting such a relation from concrete lived practices to symbolic ones. The new colonial regime considered Palestine, in spite of these long-existing practices, as frozen in the past, or as a tabula rasa that needed intervention and rejuvenation.

In recent decades, particularly after the Oslo Agreement, Palestinian heritage activists (mainly NGOs), as well as governmental bodies (mainly the Ministry of Tourism and Antiquities), have aspired and searched in heritage for relations and continuity with the past—rich with diverse forms of life—rather than accept the discontinuity and historical gaps by which Western scholars and colonial administrators have narrated the Palestinian story. For instance, "Israeli" history is usually narrated as an anachronistic story beginning with the biblical Bronze Age and then jumping over all the peoples and civilizations that inhabited Palestine afterward, and then beginning again with the Zionist triumph. For this new generation of Palestinian activists and intellectuals, heritage is a medium for reclaiming space and rewriting history, while also acknowledging the structures and fractures that hinder development in Palestine. We have also become aware of the heavy colonial legacy that still informs and shapes post-colonial discourses as they pertain to heritage.

In post-Oslo Palestine, restoration, the establishment of museums, laws and bylaws, charters, and conventions emerged as new paradigms that acknowledge historic towns and buildings as sites of memory. These sites are crucial pillars in heritage consciousness, identity formation, and nation-building processes. A humanist approach to heritage calls for reconsidering heritage as a medium to search for common history and relations among humankind.

Much has been said concerning the role of heritage in state-building processes, including in Palestine, where heritage NGOs virtually enacted the state through their creative and pragmatic takes in the field that is usually monopolized by state power.[8] In Palestine, a strong civil society has been using heritage as a medium for nation-building despite its colonial context—a project at the center of which is an imagination of alternative history and geography that fosters a sense of community and social cohesion. Instead of considering social cohesion as an abstract concept, it comes to life through concrete action on the ground. Through rehabilitation initiatives and restoration programs, a lost Palestine is reclaimed and the hitherto discontinued national narrative is renewed. Palestinian heritage activists have also started to consider heritage as a representation of social relations rather than a representation of construction technology. Homes, for us, are units in which social relations are produced. Moreover, homes are located within extended family courtyards in which no one is left alone. Residential courtyards are located within neighborhoods that are located within the village or town according to familial ties, status, and wealth. As such, heritage discourse encompasses discourse of society as a total social fact, and evolves into a critique of contemporary spatial and architectural practices in Palestine; those which have become both alien and alienating. Knowledge about heritage in particular evolves into a call for new society and social existence, about a community that cares, about the commons and the shared rather than about the private, the individual, and the neoliberal.

For us, those who work in the heritage sector, this is not a nostalgic call for a return to vernacular spatial practices and architectural forms of bygone eras. Rather,

it is a call for understanding the meanings of these practices that were devalued in the last century or so, especially after the Nakba. A profound understanding also shows that Palestinians managed to use new technologies at their convenience to "modernize" their space without losing the sense of community. We absorbed into our culture new architectural and spatial forms and left an unmistakable imprint on the bodies of Palestinian villages, towns, and cities.

To make my point clear, I will discuss two of the most popular typologies of residential buildings in Palestine: the peasant home and the *liwan* ("central hall") house. A peasant home (*al-beit fellahi*) is a socio-economic unit, a home that is the peasant's castle and treasury, a home that contains the family, their belongings, and their domesticated animals in a compact rationally-designed duplex. Riwaq's *Registry of Historic Buildings in Palestine* (published in 2006) contains information about thousands of peasant homes dispersed in more than 400 villages and towns throughout Palestine. Visiting hundreds of these and documenting tens of them, I never came across an identical design of such a simple home—that is to say, I never encountered replicas of the same blueprint. Weaving together diverse architectural expressions into a single Naseej, peasant homes look similar, but are never the same. Every owner/mason/stone carver improvised to produce a novel architectural shape while preserving the basic elements of the duplex (Figure 11.1). Seventeen such peasant houses were documented, for instance, in Lifta—the well-known depopulated village in West Jerusalem (Figure 11.2).[9] These houses amount to almost 25 percent of the still-standing houses in Lifta. Although they have similar structures and materials (i.e., limestone), and all belong to the late Ottoman era (i.e., nineteenth and early twentieth centuries), none of these are identical in shape, orientation, and architectural details. Since the construction industry in Palestine was also a familial enterprise transferred along kinship lineages, I can safely say that the same masons and builders (and their successors) had constructed all the variations of the peasant houses in Lifta. *Why did the owners and builders not replicate the model they believed suitable to their lifestyle and social relations?* I do not have an answer to this intriguing question.

Similarly, there are thousands of liwan houses. I visited hundreds, and documented tens of them. The liwan is a central hall around which rooms and spaces of different functions are organized. The liwan can be considered a complex modern Palestinian house. The liwan style developed in Palestinian urban centers toward the end of the Ottoman era, and became very popular during the British Mandate, stretching to most towns and villages. With an elaborate and complex design, the liwan house evolved into a structure in which infinite small differences made all the difference. Sixteen urban houses were documented to be illustrated in Riwaq's publication *Palestinian Urban Mansions* (published in 2001).[10] Each town and city, from Akka and Nazareth in the north to Hebron and Gaza in the south, was represented with at least one special mansion that reflects the rich social history of the family behind the construction. Reviewing the 16 plans shows that although they

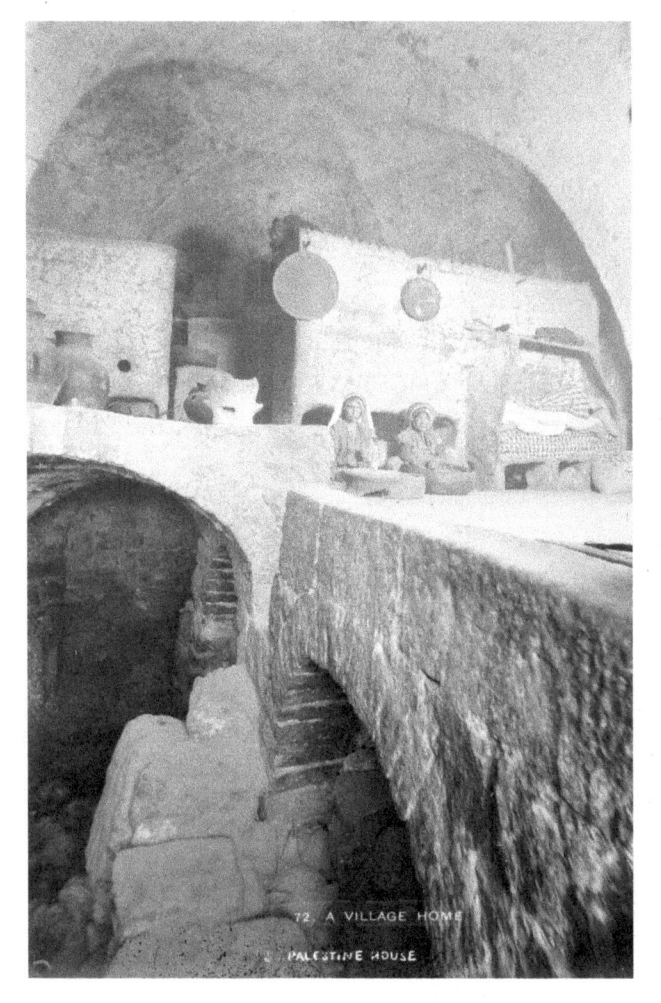

Figure 11.1 Peasant house interior. Library of Congress, Prints & Photographs Division, Washington, DC.

all revolve around the central hall/liwan, none of these mansions was identical to another. Of course, the different localities that come with different materials and masons, and perhaps the different construction periods that witnessed technological development and engineering, or the variation of class (self-made working class, or petite-bourgeois/middle-class, or well-off quasi-aristocratic families) manifest in the choice of materials and schemes.

To complicate the situation, I examined houses in Ramallah, the city I have written about extensively (Figure 11.3). In the decade between 1920 and 1930, 176 houses were constructed in what was then a small town. The vast majority of these houses were liwan houses. Ramallah's economy was booming at the time as a result of the remittance transfers from a North America-based diaspora that sought to

Figure 11.2 Lifta village, early twentieth century. Library of Congress, Prints & Photographs Division, Washington, DC.

express their newly acquired wealth via the construction of mansions in their homeland. Needless to say, I never encountered an identical copy of any of these houses even if it was constructed for the same family, or even in the same year. The house of Dar Salem Jaber, north of Ramallah's Old Town, that of Dar Mikhael Sarafandi, on a hilltop overlooking the Old Town from the east, or those of Dar Rashid Foteh and Dar Shehadeh al-Bateh, in the southern expansion of the Old Town, are only separated by a street and were all constructed in 1922.[11] And yet each has its own shape and details that make each one very different from the other mansions. I can also imagine that the al Saa' family were the masons of most of the houses constructed in the town. However, the houses cannot in any way be considered identical. Each liwan house was made special by a unique selection of elements, such as types of stones and textures (Figure 11.4), decorative tiles and their color combination, types of doors and metal, wood and glass works, internal mural paintings, and exterior ceramic decorations. Again, all liwan houses are similar, but no two are the same.

Figure 11.3 Ramallah, early twentieth century. Library of Congress, Prints & Photographs Division, Washington, DC.

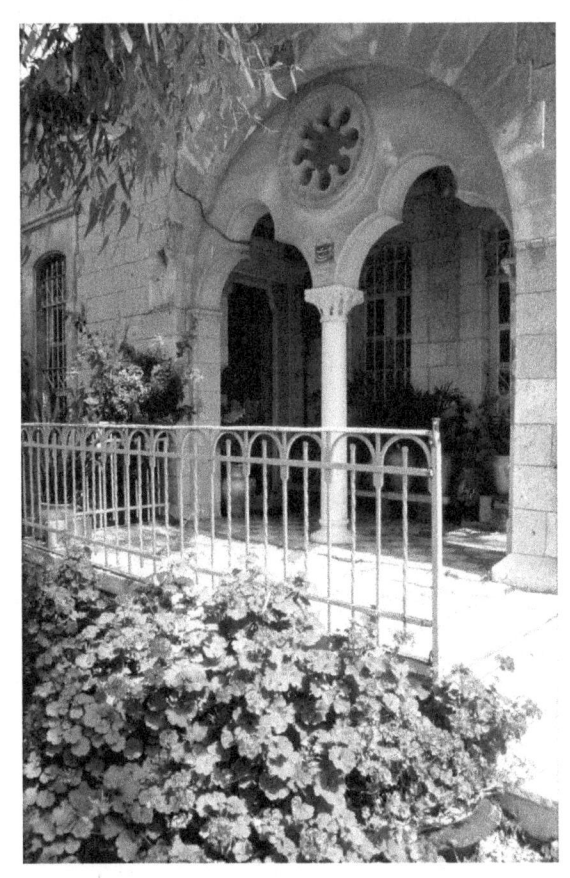

Figure 11.4 A Jerusalem urban mansion with elaborate entry hall of a liwan house. Riwaq Photo Archive.

The story had it that a heavy-drinking stone carver named Yaqoub Rabba'a from the town of Beit Jala was nagging Yaqoub Shahwan to sculpt another piece for the mansion Yaqoub and Jeries Shahwan were constructing between 1913 and 1917. Financially depleted and emotionally not in the mood, Shahwan kicked Rabba'a out, telling him "Go carve me a monkey," meaning "go to hell," or *kerd yes'ha-bak*, meaning "may a monkey pull you from my sight." A few days later, the drunk Yaqoub brought in a sculpture of a beautiful monkey for Yaqoub, the owner, and asked him to compensate him for sculpting such a masterpiece.[12] Even if the story cannot be validated, it shows how the uniqueness of each liwan house came to be through the social relations between owners, builders, masons, and—in this case— a drunk artist.

Peasant homes and liwan houses can be seen as interconnected siblings with a shared lineage. The peasant home, whether a standalone unit or situated within a *hosh* (a residential courtyard), is a product of a social and spatial structure revolving around the extended family. Within this arrangement, successive peasant homes are constructed to accommodate the needs of a newly wedded son or brother, result-ing in the gradual closure of open spaces from neighboring courtyards. The peasant homes open directly to the Hosh, forming a castle-like structure with a single alley or a gate, fostering familial interdependency in daily domestic activities.

As modernization and reduced reliance on agriculture and cattle altered familial ties, the spatial order evolved. The peasant homes and courtyards gave way to the emergence of liwan houses. In constructing these more contemporary residences, the concept of Hosh was incorporated into the new spatial order. Similar to hosh units surrounding an open inner space, the liwan house features a central covered space. While the open courtyard was central to the Hosh, the liwan takes prece-dence in the liwan house, serving as the focal point around which various rooms are arranged.

The significance of the liwan as a gathering space is comparable to the hosh's role in peasant homes. Attention to grandeur and details, such as doors, windows, mural paintings, and floorings, emphasizes the importance of this spacious area for family gatherings. In the traditional context, close kin were welcomed in the courtyard while foreign-to-the-kin guests were welcomed in the *madhafeh* or *illeyeh* ("guest room") (see Figure 11.5), but in the liwan house, close kin or friends were welcomed in the liwan while foreign-to-the-kin guests were accommodated in their separate *diwan* ("guest room") with a separate entrance.

Beyond their physical structures, the socio-spatial order of peasant homes and liwan houses is intertwined with belief systems and symbolic meanings. Architec-tonically speaking, the hosh or liwan bears resemblance to the schemes of mosques or churches, with parallels between the courtyards (*sahin*) of mosques or cloisters of churches and peasant courtyards. The significance of the central aisle (*riwaq*) in churches or mosques is mirrored in the liwan house, underscoring its importance. Consequently, both peasant homes and liwan houses carry metaphysical meanings

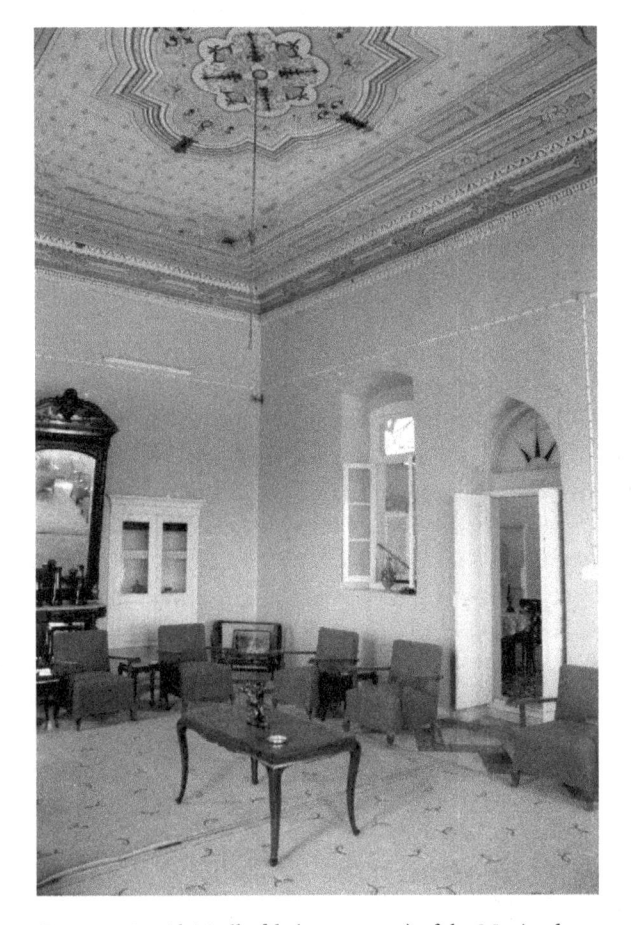

Figure 11.5 Al-Madhafeh (guest room) of the Mas'oud
Palace in the village of Burqa, north of Nablus. Riwaq Photo
Archive.

consciously or unconsciously embedded in their spatial structures of domestic
spaces or vice versa. This observation shows that sacred and secular terrains are
intertwined and coexist in practice. This interplay between structure and agency,
between language and parole could explain the attachment to structures that accept
improvisations/nuances within the accepted long-lived norms/structures/forms/
language.

Similar arguments can be made concerning shrines, mosques, churches, serais,
souks, hammams, fountains, and caravanserais. Palestine's built environment shows
how the land's inhabitants managed to find multiple voices and identities in the
spaces we inherited from previous civilizations, inhabited, and built. The overall
harmony is achieved from the use of local materials (mainly stone) and local tech-
niques that span this generational and dynastic inheritance. When zooming out
and looking from afar, one may not observe the differences and typologies; rather,

one may only see harmony and similarity. The exceptions here are the monumental holy sites with their domes, minarets, and towers—symbols of power and politics. Zooming into the more mundane, everyday architecture, however, differences in types and styles begin to appear. Zooming in even further, we see the subtle differences that furnish each structure with a completely different and unique identity. This is a naseej.

To consider the archeological layering of Palestine at the level of civilization, and also the more everyday examples of the peasant home and the liwan house, is to bring about an alternative paradigm to planning discourses of standardization and unity; discourses that are then projected onto the presumed tabula rasa myth as popularized by colonial regimes. Because the tabula rasa myth does not recognize Palestine's rich, layered architectural heritage, planners are given a carte blanche for an "anything goes" kind of development. Here I have argued for a much different picture. Building with domestic materials and local knowledge, heritage in Palestine generated many varieties of architectural styles or typologies. This diversity in style tells us how a free Palestinian nation in the future may echo its architecture and spatial practices, and how it may relate to the peoples and civilizations that have inhabited our homeland for millennia, from the Canaanites and Romans of antiquity to the peasants and wealthy elites of recent centuries. In this sense, architectural heritage democratizes structures and allows every part of a built environment to express identity, agency and aspirations, forming a fluid or hybrid self for those dwelling among these structures. If we are to learn a political lesson from heritage it would be the acceptance of difference while being similar, but never the same.

NOTES

1. Tamim Al-Barghouti, "In Jerusalem," trans. Houssem Ben Lazreg, *Transference*, 5(1) (2017): Article 13, https://scholarworks.wmich.edu/transference/vol5/iss1/13.
2. Mahmoud Darwish, "A State of Siege" (2002), trans. Ramsis Amun. NADWA for poetry in translation, www.arabicnadwah.com/arabicpoetry/darwish-siege.htm.
3. Riwaq - Palestine, "Architecture of Repair," Symposium *Architecture of Repair: Decolonization, Architectural Conservation and Healing in the Colonized Landscape of Rural Jerusalem*, Kafr Aqab, Al-Jib, Qalandiya, and Beit Hanina, July 25–26, 2023, YouTube, www.youtube.com/watch?v=9GZ_UQXEgCQ&t=585s.
4. Nadia Abu El-Haj, *Facts on the Ground: Archaeological Practice and Territorial Self-Fashioning in Israeli Society* (Chicago, IL: University of Chicago Press, 2002).
5. "A college student says: Nor does anything please me. I studied archaeology but didn't find identity in stone. Am I really me?" Mahmoud Darwish (2008) "Nothing Pleases Me," https://arabamericannews.com/2014/06/13/Poetry-corner-Nothing-pleases-me/.
6. Tawfiq Canaan, "The Palestinian Arab House, Its Architecture and Folklore, Part 1," *Journal of Palestine Oriental Society*, 12 (1932): 223–247; Tawfiq Canaan, "The Palestinian Arab House, Its Architecture and Folklore, Part 2," *Journal of Palestine Oriental Society*, 13 (1933): 1–83.
7. Salim Tamari and Issam Nassar (eds.), *The Storyteller of Jerusalem: The Life and Times of Wasif Jawhariyyeh, 1904-1948* (Northampton, MA: Olive Branch Press, 2014).

8. Chiara De Cesari (2010) "Creative Heritage: Palestinian Heritage NGOs and Defiant Arts of Government," *American Anthropologist*, 112(4): 625–637.

9. Khaldun Bshara, "ʿālālī ʿālā wādī al-šāmī" [Attics Overlooking the Valley of al-Shami: An Analytical Perspective on All That Remains from the Depopulated Village of Lifta], in Nazmi al Jubeh et al., *Lifta: Sijjil Shaʿb* (Ramallah, Palestine: IPS, 2020), pp. 227–275.

10. Diala Khasawneh, *The Palestinian Urban Mansions* (Ramallah, Palestine: Riwaq, 2001).

11. Nasmi Al Jubeh and Khaldun Bshara, *rām al-lh: ʿmārī ūtārīḫ* [Ramallah: Architecture and History] (Ramallah, Palestine: IPS and Riwaq, 2002).

12. Diala Khasawneh, *The Palestinian Urban Mansions* (Ramallah, Palestine: Riwaq, 2001).

12
The Herzegovinian Muslim Colony in Caesarea, Palestine*

Nina Seferović

After the Austro-Hungarian occupation of Bosnia-Herzegovina in 1878, a group of Herzegovinian Muslims emigrated to the Turkish Empire. The Ottoman authorities of the time settled this group in Caesarea (Qaysariyya), on the Palestinian coast of the Mediterranean Sea.

This essay will examine the emigration of this group of Herzegovinian Muslims, the establishment of their colony in Palestine, and how they preserved their ethnic identity while adapting to the new environment.

The data presented in this study stem primarily from interviews conducted between 1977 and 1979 in Amman, Beirut, Damascus, Belgrade, Sarajevo, and Mostar with individuals who were born and lived in Palestine before the 1948–49 Arab–Israeli War and whose ancestors migrated from Herzegovina to Caesarea.[1] Interviews were also held with women born in Yugoslavia between the two world wars and married to the descendants of such emigrants, their families having already been neighbors in generations past; some of those individuals were from families that later returned to Yugoslavia. Other informants included those with close relatives who emigrated but did not cut ties with family back in the "old country." Furthermore, conversations were held with various scholars, historians, sociologists, and economists, including experts on Judaism from the Middle East and our country who studied, among other subjects, the settlement of these areas since

* This essay was originally published as Nina Seferović, "Kolonija Hercego-vačkih Muslimana u Kajzeriju u Palestini," *Zbornik radova Etnografskog instituta*, 12 (1981): pp. 47–64, by the Institute of Ethnography of the Serbian Academy of Sciences and Arts in what was then the Socialist Federal Republic of Yugoslavia. The English translation reproduced here was completed in 2015 by Darryl Li and published with the kind permission of the Institute of Ethnography of the Serbian Academy of Sciences and Arts in the *Journal of Palestine Studies*, 45(1) (2015): 76–83. It was the first scholarly study of "Bushnaqs"— Palestinians whose ancestors hail from the territory of the present-day republic of Bosnia-Herzegovina (hereafter: Bosnia). The author, Yugoslav anthropologist Nina Seferović (1947–1991), who worked at the Ethnographic Museum and later at the Museum of African Art, both in Belgrade, Serbia, describes the circumstances of the Bushnaqs' departure in the late nineteenth century, the distinct community they founded in the village of Caesarea, near Haifa on the Mediterranean coast in the early 1880s, and their assimilation into Palestinian society thereafter.

Ottoman times. Useful information was also provided by individual diplomatic, trade, and other representatives of the Socialist Federal Republic of Yugoslavia serving over the years in Israel and elsewhere in the Middle East who had personally met descendants of our emigrants from Herzegovina and became acquainted with their history and fate.[2]

MAJOR REASONS FOR THE EMIGRATION FROM BOSNIA-HERZEGOVINA AFTER 1978

The military and political decline of the Ottoman Empire entailed gradual diminution of its territory, as well as the withdrawal of both Turkish and locally "Islamized" populations to areas that remained under the Sultan's supreme authority.[3] In the Balkan Peninsula and elsewhere, each episode of Ottoman retreat was followed by waves of Muslim emigration.[4] This migratory wave, known as the "*muhajir* migrations,"[5] continued throughout the age of Turkish withdrawal.[6]

The withdrawal of Bosnia-Herzegovina's Muslim population occurred from these parts of our country even while still under Ottoman rule. These movements had a mostly individual character.[7] Migration to the Ottoman Empire after the Austro-Hungarian occupation, however, included quite significant numbers of Bosnia-Herzegovina's Muslims.[8] In typical areas of out-migration,[9] those dissatisfied with the overall situation and the difficulties and uncertainties of life-chances saw no option other than to leave.[10] Serbs, Muslims, Croats, and Jews[11] all migrated from Bosnia-Herzegovina, but Muslims were consistently the most numerous of those who departed.[12] Although Muslim emigration was a topic of perennial concern to Bosnia-Herzegovina's Austro-Hungarian rulers, such movements nevertheless continued and indeed intensified around incidents that reinforced the people's sense of uncertainty or even hopelessness about their already difficult circumstances.[13] Although authorities did not keep records on migration between 1878 and 1883,[14] it is assumed that the greatest number of Muslims left in these early years of the occupation.[15] An additional wave of migration was spurred on by the introduction of a new territorial defense law,[16] with the "Džabić movement" around the turn of the century,[17] as well as after the Austro-Hungarian annexation of Bosnia-Herzegovina in 1908.[18] According to some [reports], the latter was the broadest of all the migration waves from Bosnia-Herzegovina under Austro-Hungary.[19] Major migrations to the Ottoman Empire ground to a halt after the 1912–13 Balkan wars.[20] The next major wave came after 1919, with the emergence of the new historical and political situation in the Balkan Peninsula, when large numbers of Turks and Muslims speaking the Serbo-Croatian language[21] also departed from liberated territories that joined the newly created state of Yugoslavia.[22] Some of our population also migrated to Türkiye after the Second World War.[23]

EMIGRATION FROM HERZEGOVINA TO THE OTTOMAN EMPIRE AND THE MUHAJIR SETTLEMENT POLICY

Spurred by the Austro-Hungarian occupation, a group of about 100 Herzegovinian Muslim families, linked by ties of kinship and friendship, decided to emigrate to the Ottoman Empire. They were from both urban and rural backgrounds,[24] hailing mainly from Mostar and other places in Herzegovina such as Trebinje, Stolac, and Čapljina. The Ottoman authorities at the time settled this group near Haifa,[25] on the Palestinian coast of the Mediterranean Sea, where they built a village atop the site of the ancient town of Caesarea.[26] They lived there until the official proclamation of the state of Israel in 1948, when by force of circumstance they were displaced to the neighboring Arab countries and their village ceased to exist.[27] They comprise a sizeable population among our diaspora in the Middle East today. [For more on this diaspora, see "Balkan Migration to the Middle East" below.] But after a century of living in this part of the world, they no longer exhibit any distinctive traits[28] that would allow them to be defined as a separate ethnic group, as they are today totally blended within the Arab cultural milieu.

As this group set out, all they knew was to head to the Ottoman realms, without knowing where they would settle. Muhajirs lived in provinces throughout the empire,[29] and Muslims from Bosnia-Herzegovina in particular could be found on both its European and Asian flanks.[30] Although most were settled in the sparsely populated expanses of Anatolia (Asia Minor), a number of Bosniaks[31] set up in the Arab provinces of the Ottoman Empire.[32] This group of Herzegovinian Muslims also headed to the Middle East.

In general, it is difficult to discuss with certainty the influence of Ottoman policies on settlement of the muhajirs, as this issue has not been thoroughly clarified to date. One can only surmise on the basis of inference and analogy from other cases why this group of Herzegovinian Muslims was sent to the Middle Eastern areas of the Ottoman Empire.

The Turkish authorities determined where to send the muhajirs according to the ethnic, strategic, and economic aspects of their colonization policies,[33] regardless of the migrants' own will and aspirations.[34] First and foremost was the need to internally populate the empire[35] by using muhajirs to increase the numbers of Muslims,[36] which had been thinned out by frequent wars.[37] Muhajirs lived in all the Turkish provinces, but the resettlement process did not proceed in a uniform manner.[38] As the area of Palestine was sparsely populated throughout the nineteenth century,[39] one can assume that this was one reason for settling the Herzegovinian Muslims there. Meanwhile, the context of the second half of the nineteenth century was one in which "the Sick Man on the Bosporus" was afflicted in its dying throes[40] by uprisings in the Middle East due to the awakening of Arab nationalism and the broader movements of liberation from Turkish rule,[41] as well as economic and cultural penetration from the West,[42] which only intensified after the Congress of Berlin.[43] In light of these factors,

one can assume that the Turkish authorities engaged in a kind of "demographic interpolation," settling sparse, insecure, and hostile border areas of the empire with populations that would be loyal. Accordingly, Circassians—the traditional "watch-dogs" of the Turkish Sultan[44]—and Muslims from the Maghrib came to Palestine after 1878, in addition to the group of about 100 families from Herzegovina.[45]

THE EMIGRATION

On the eve of the occupation of Bosnia-Herzegovina, several prominent Mostar families—including the Stupac, Ćehajić, Hadžijahić, Rizvanbegović, Lakišić, and Drače clans—sent representatives to Constantinople tasked with seeking permission to move to Türkiye. Having been granted approval, representatives of the Lakišić, Rizvanbegović, and Ćehajić families spearheaded preparations for the journey.[46] These arrangements took about six months, during which time the muhajirs gathered together. The Austrian occupation authorities did not hinder or help the migrants.[47] Similarly, the Turkish authorities were involved only in providing immigration permits. Entire families set out together.[48] Fixed assets were sold for nothing; they carried only what was necessary, plus as much currency and gold as possible.

The first place they stopped was Constantinople,[49] then İzmir. Some families stayed in İzmir, while the others continued to Syria, specifically a village just outside Damascus.

Being relatively well-provisioned, the emigrants did not receive any special assistance from the Turkish authorities. They purchased land with their own funds and took up farming. From the outset, however, they faced hostility from the local population, "who received them as foreigners."[50] Believing that they would find greater religious purity while living in the ancient Islamic lands, the Bosniaks instead were confronted with ethnic intolerance, startling regional particularities that were strange to them, and religious "impurity" among the autochthonous population. They became acutely aware that the only thing tying them to this people was a common religion. This ethical and moral discomfort was accompanied by problems with acclimatization. Unable to adapt to the desolation and heat at the edges of the Syrian desert (to say nothing of their disappointing new neighbors), they decided to ask the Ottoman authorities to facilitate their resettlement, on condition that they could stay together. The government acceded to this request and accorded them the freedom to choose a new place of residence. They learned from a compatriot working in the Ottoman administration about Caesarea, a semi-ruined archaeological site near Haifa, on the Palestinian coast of the Mediterranean Sea. Only those who had the means to do so left; a small number remained in Syria, while some others returned to Anatolia and settled in Adana and Istanbul.

So, after about two years in Syria, the group set out for Palestine,[51] having lost ties to their homeland with no new arrivals from Bosnia-Herzegovina. There, they

settled in Caesarea while a smaller group—comprised of the Lakišić, Silić, Mićije-vić, and Mikišić[52] families—split off and went to Yanun, near Nablus.

THE BOSNIAK SETTLEMENT IN CAESAREA

Families Residing in Caesarea

From the 100 or so families that moved from Mostar, about 50 settled in Caesarea; only 32 of the families' names are known. In Caesarea, there were the Zubčević and Muratović families from Trebinje, the Mehićs who were in both Mostar and Trebinje, the Džampo family, originally from Stolac, the Šaldos hailing from Čapljina, the Čerkezovićs who were in Mostar but do not know their origins, the Rizvanbegovićs, a famous Stolac family that was equally distinguished in Mostar, the Rajkovićs from Blagaj, although also in Mostar, the well-known Fazlagić family from Čapljina (who must have also lived for a long time in Mostar, as evidenced by the existence of a "Fazlagić Street" in the city), as well as the Ulakšić, Borić, Mikišić, Vjetro (or Jetro), and Hadži Mula (or Hadžimulić) families, whose origins are unknown. All the other families that settled in Caesarea were from Mostar and could be considered large, respectable, and well-off. These were the Lakišić, Puzić, Hadžiselimović, Hasanagić, Ćehajić, Drače, Omeragić, Stupac, Demirović, Ramić, Kadijević, Hadžajlić, Brkić, Dizdar, Komad, Mičijević, Repak, and Repavac families.

At the time of immigrating to Caesarea, the Mostar muhajirs were the only people living in the village, but they soon paid *fellahin*[53] to cultivate their land. The Ottoman authorities later settled seven Circassian families, an "Islamized" Bulgarian one, and two Turkish families in Caesarea. The Bosniaks enjoyed cordial relations with them and with all of the neighboring communities; they had good ties and business relationships with the indigenous Jewish communities of Hadera and Zamarin.

There were virtually no new arrivals from Bosnia-Herzegovina unless we count the women who were brought over from the old country as wives starting in the 1930s. One exception was the Mehmedbegović family, who moved to Caesarea in the 1920s, at the invitation of their kin among the Hadžijahićs. Many of the immigrants fell ill in the early years of the settlement at Caesarea due to the difficult climate, which was compounded by the negative effects of the wetlands just outside the settlement. Malaria in particular took its toll, as did homesickness. In the first ten years in Palestine, there were many deaths, with entire families wiped out and no births, due to sterility.[54]

Municipal Autonomy

Bosniaks in Caesarea were organized into a municipality in accordance with Turkish regulations in force at that time.[55] The *mudir*[56] was Ahmad-beğ Katkhuda

and the *muezzin*[57] was a Bosniak from the Drače family. On their own initiative, the villagers built a mosque with a school that provided four years of religious education for children.[58] The Bosniaks hired an Arab teacher called Hajj Hasan, whom they also paid to act as imam.

Construction of the Settlement

The Herzegovinian muhajirs were attracted to the ancient site of Caesarea[59] for three reasons: (1) the site was empty, so it afforded them an opportunity to live on their own; (2) the presence of fertile land suitable for cultivation; and most importantly (3) the ancient town had its own harbor, which was very important since the lack of convenient land links to the outside world at the time made opening up access to the sea especially conducive to trade. Caesarea was not settled immediately, however; the emigrants lived in Haifa and other nearby areas for about two years while the village was being built, and only moved in after construction was finished. As with their initial arrival in the Middle East, the Turkish authorities did not provide any assistance to the muhajirs in building their village.[60] Instead, the community was left to solve its problems on its own, and it used its own resources to hire a German engineer.[61]

As with other muhajir settlements throughout Türkiye, the new Bosniak settlement in Caesarea stood out from nearby communities in its layout and architecture.[62] It was built within the walls of the ancient Roman and Byzantine settlements, but modeled on Herzegovinian villages near Mostar, as remembered by the immigrants. Along the wide streets were two-story stone houses with ceramic tile roofs and fenced-in gardens. This was a sharp contrast from the classic style of villages indigenous to this part of the world, which lacked windows, had interior courtyards onto which the rooms would open, and were surrounded by high walls.[63] The number of rooms varied between two and four, depending on the size of the family and its financial situation. Each house had a sitting room, bedroom, *mutbakh*,[64] and attic. These rooms were furnished in a typical Bosnian style, while the toilets were built in "the old style"—in the courtyard.

They also constructed public buildings in the village: an administrative office, a customs post for the Caesarea harbor, and a mosque with school and graveyard, all of which the Bosniaks built on their own.

Clothing

The older styles of clothing from the homeland remained in use among the Bosniaks of Caesarea until the second generation in Palestine, when they gave way to garments from the surrounding Arab population. This change was primarily due to the impact of the new environment, as well as through conscious adaptation to new living conditions. This happened to all of the villagers, without regard to their

social status. Men tended to be first in taking up local clothing, on account of their closer connections with the outside world; women, being tied by tradition to hearth and home, lagged behind. In this new place, women started by abandoning pantaloons (*dimije*, or *salwars*), which were not worn by Arab women.

Thus, the attire of the old country was abandoned relatively quickly, just as with the muhajirs in Türkiye,[65] who also adopted the clothing of the surrounding population.

Diet

Like our muhajirs in Türkiye,[66] Bosniaks took on the traditional food of their new surroundings while continuing to produce dishes typical of the old country, including specialties of Bosnian Muslim cuisine such as *pite* (savory filo dough pies), *gurabije* (shortbread biscuits), and *hurmašice* (cakes soaked in syrup).

Work, Labor, Trades

The Bosniaks' holdings lay about 3 kilometers outside the village. The land was good and fertile, and one of their primary occupations was exploiting the soil. For help in cultivating the land, they hired fellahin who worked as wage laborers on the Bosniaks' lands and also performed gardening tasks and other manual labor. Aside from agriculture, the most common and lucrative trades were in animal husbandry and handicrafts.[67]

Marriage and Family

After settling in Caesarea, large families lived together in shared households, which would include the families of fathers, married sons, and their own wives and children. Marriage was for the most part monogamous, with only one known case of bigamy among the Bosniaks.

Considerations of ethnicity and wealth status were major factors in marriage decisions, with a tendency toward maintaining ethnic endogamy. Spouses were chosen in situ: wives and husbands were found among the Bosniaks of Caesarea. Some went to Türkiye in search of wives from the Bosniak diaspora there. Such trips were common. To a lesser extent was the practice of seeking brides from the home country, starting in the mid-1930s.

At first, there were no marriages to Arabs. But this eventually changed, as many Bosniaks died from the harsh climate and women in particular could not conceive children in the first ten years. Gradually the villagers started to arrange marriages with the Arab population

Elements of Spiritual Culture

Since the Herzegovinian Muslim settlers and their Arab neighbors in Palestine shared a common religion, it is very difficult 100 years later to discern major cultural differences between the immigrants and indigenes. Moreover, it is important to note that it was precisely through their shared religion that the Herzegovinian muhajirs consciously assimilated into the surrounding Muslim Middle Eastern population.

However, the muhajirs still preserved their maternal language, thanks mostly to women in the domestic space who nurtured and passed it along to the younger generation. At first they deliberately maintained their mother tongue, but eventually the language came to be neglected. Serbo-Croatian was spoken intensively until the children started school, but as youths of the second generation began to pursue education elsewhere, the language was lost.[68]

After their arrival, they continued to pass down oral traditions from one generation to the next, including folk songs, stories, and proverbs—but these, too, were eventually lost with the passage of time.

EMIGRATION FROM CAESAREA

Reasons and Directions

Emigration from Caesarea began early. The hardship of adjusting to the new climate and feelings of insecurity from bedouin raids that were otherwise common in this part of the world[69] compelled some families such as the Ramićs and Rajkovićs to return home and others to move elsewhere in the Ottoman Empire, such as the Dizdars and others.

There was also a wave of families who departed when their children reached school age. Since Caesarea only had a four-year religious school, many families moved to bigger cities such as Haifa, Tulkarem, Nablus, Jaffa, and Jerusalem seeking education for their children. From there, youths could seek larger centers for study.

The infiltration of new foreign immigrants also encouraged the Bosniaks to increasingly abandon Caesarea. First came German colonists, who offered large sums of money to purchase Bosniak properties,[70] followed by Jews with their own amply attractive offers to buy land and houses. The influx of Jewish immigrants was particularly intense around 1920–22, when Bosniaks began to leave Caesarea in larger numbers.[71]

The mass exodus of the Herzegovinian muhajirs from Caesarea triggered faster and more significant changes in their lifestyles, accelerating their assimilation into the surrounding Arab population. In the censuses conducted by the British Mandate, Bosniaks were treated as Arab Muslims.[72] It was at this time that the ethnic label Bushnaq (Bošnjak) became a family name—aptly symbolizing their blending in.[73]

As construction began on Haifa's port[74] after the First World War, the harbor in Caesarea lost its importance; similarly, the opening of the coastal railway line south of Haifa[75] also diminished the village's importance and pushed the muhajirs to move to new places where they could continue to ply their trades. During this period, their movement was free and voluntary, without any interference from the Mandatory authorities. They moved to neighboring big cities, and some families returned to their homeland. At the time of the mass movement from Caesarea, economic reasons also spurred many families—including the Muratovićs, Lakišićs, Čerkezovićs, and Dizdars— to move to Türkiye, especially to Adana.

After the creation of the state of Israel in 1948, the Bosniaks moved out of Caesarea definitively and, like the rest of the Arab population of Palestine, were displaced to neighboring Arab countries such as Syria, Jordan, Kuwait, Lebanon, and Egypt.[76] With the departure of the Bosniaks, Caesarea ceased to exist as a village.[77] Since then, it has been only an archeological site of cultural and touristic importance.

THE SITUATION TODAY

Today, Bosniaks live in the occupied territories of Jordan [sic], in Tulkarem, Nablus, and Ramallah; in Amman there are about 60 families, who are mostly of a higher socioeconomic status. There are also large numbers of Bosniaks in Kuwait. In Lebanon, Bosniak families live in Beirut (Drače), Tyre (Repavac), and Tripoli (Džampo). In Syria, they live in Damascus and in Tartus, on the Mediterranean coast. They also live in Egypt [sic], particularly in the Gaza area. Some have even moved to Tunisia.[78] For a while, a Bosniak family lived in Bahrain, and later moved to Kuwait, and some Bosniaks settled for a while in Abu Dhabi. It also seems that there are Bosniaks in Saudi Arabia, in Riyadh, Mecca, and Jeddah.[79] Many have returned to Türkiye, while one family, that of Dr. Sulejman Kathuda, returned a few years ago to Yugoslavia, renewed its Yugoslav citizenship, and lives in Mostar.

The Bosniaks have to this day preserved a strong sense of particularity, along with some cultural and anthropological characteristics.[80] They still differ from the Arab cultural environment to some extent, having never fully accepted all the Middle Eastern, Islamic Arab customs. They still maintain ethnic endogamy, and accordingly have a noticeably lighter complexion. But the mother tongue slowly but surely faded out, and even the older generation today does not speak it particularly well. In the eyes of their new neighbors, they are today part of an Arab Middle Eastern people—the Palestinians.[81] One can say that 100 years after arriving in the region, the Herzegovinian muhajirs live in near complete assimilation with the Arab population of this part of the world.

NOTES

1. A note on terminology: Seferović refers to this community using various terms that all risk some degree of anachronism. She glosses them as "our" emigrants, the possessive

pertaining to Yugoslavia, a country that did not exist when this migration occurred. She calls them "Muslims" (*Muslimani*), a Slavic national group of Muslim confessional background recognized in the Yugoslav constitutional order in the 1970s, with Bosnia as its designated homeland (as opposed to the non-capitalized *muslimani*, a general term for adherents of the Muslim faith). She also refers to "Bosniaks" (*Bošnjaci*): since the 1990s, this term has displaced Muslimani as the preferred national name for Muslim Slavs from Bosnia, but in the period Seferović is writing about it also had geographic connotations pertaining to Bosnia as territorial space without necessarily implying Muslimness. To the extent the subjects of this article called themselves Muslims or Bosniaks, it is far from clear that they used those terms as national categories as they later came to be understood.

2. Among the descendants of these emigrants, the most comprehensive information was provided by: Abdurrahman Ali Bushnaq, a businessman from Amman; Abdullah Bushnaq, a retiree from Amman; Selma Bushnak, née Brkić, married before the Second World War to Abdullah Bushnaq, homemaker; Amina Bushnaq, homemaker from Beirut; Lamya El Khalil, née Bushnak, owner of an orange grove in southern Lebanon, Beirut; Dr. Sulejman Kathuda, a retired doctor from Amman, living today in Mostar; Umica Kathuda, née Ćišić, married in the late 1930s to Dr. Sulejman Kathuda; engineer Samir Kathuda, their son, living in Yugoslavia, as well as Aiša Džabić, homemaker from Mostar; Muhamed Mujić, a civil servant from Mostar; Narcisa Mujić, homemaker from Mostar; Ibrahim Đikić, civil servant from Sarajevo; Džemal Drače, retiree from Belgrade with close and distant relatives among the emigrants. Among the scholars and publicists who provided the most information were: Joseph Sfeir from Beirut and Eugen Werber, scholar of Judaism from Belgrade. Useful data were also provided by: Razia Brkić, who with her husband, the trade representative of the Socialist Federal Republic of Yugoslavia (SFRY), spent many years in the Middle East and met several of our emigrant families; Mithad Muratbegović, diplomatic representative of the SFRY and his wife Razija; Meho Rajković and his wife, Bahra; Nusret and Emilija Seferović; and Dr. Muhamed Ustavdić, a doctor in Srebrenik (near Tuzla) who spent several years working in the hospitals of the Palestinian liberation movement, whose patients included descendants of our emigrants and their Arab neighbors, from whom he heard and learned many details about the history, life, and fate of the colony of Herzegovinian Muslims in Caesarea, Palestine.

3. Salim Ćerić, *Muslimani srpskohrvatskog jezika* (Sarajevo, Bosnia and Herzegovina: Svjetlost, 1968), p. 114; D.E. Eremeev, *Etnogenez turok* (Moscow, Russia: Nauka, 1971), p. 171; Vojislav Radovanović, *Opšta antropogeografija*, vol. 1 (Belgrade, Serbia: Graćevinska knjiga, 1959), p. 174; L. Trnjegorski, *Jugoslovenske manjine u inostranstvu* (Belgrade, Serbia: Narod i država, 1938), p. 135.

4. Radovanović, *Opšta antropogeografija*, pp. 174–75; Ćerić, *Muslimani srpskohrvatskog jezika*, p. 115; Trnjegorski, *Jugoslovenske manjine u inostranstvu*, p. 135; *Bune i ustanci u Bosni i Hercegovni u XIX veku* (Belgrade, Serbia: Vojnoistoriski institut JNA, 1952), p. 16; Xavier de Planhol, *Les fondements géographiques de l'histoire de l'Islam* (Paris, France: Flammarion, 1968), p. 258; Kemal Karpat, *Turkey's Politics: The Transition to a Multi-Party System* (Princeton, NJ: Princeton University Press, 1959), p. 94; Jovan Cvijić, *Balkansko poluostrvo i južnoslovenske zemlje: Osnovi antropogeografije* (Belgrade, Serbia: Zavod za izdavanje udzbenika, 1966), pp. 141–42, 569; Milisav V. Lutovac, "Migracioni procesi stanovništva Jugoslavije," in Milisav V. Lutovac (ed.), *Cvijićev zbornik: U spomen 100 godišnjice njegovoj rođenja* (Belgrade, Serbia: Serbian Academy of Sciences and Arts, 1968), pp. 190–191; "Pogovor," in Milisav V. Lutovac (ed.), *Cvijićev zbornik: U spomen*

100 godišjice njegovoj rođenja (Belgrade, Serbia: Serbian Academy of Sciences and Arts, 1966), p. 569.

5. Cvijić, *Balkansko poluostrvo i južoslovenske zemlje*, p. 142; Alija Nametak, "Narodni osećaji bosansko-hercegovačkih muslimana iseljenih u Tursku," *Napredak* 3(4) (1933): 41. It was also known as the "muhajir movement," see Jovan Cvijić, "O iseljavanju bosanskih muhamedanaca," in Jovan Cvijić and Jovan Erdeljanović (eds.), *Cvijićeva knjiga* (Belgrade, Serbia: Sveti Sava, 1927), p. 82; the "muhadžirstvo," see Cedomil Mitrinović, *Naši muslimani: Studija za orientaciju pitanja bosansko-hercegovačkih muslimana* (Belgrade, Serbia: Drust'vo, 1926), p. 48; and the *hijra*, see Nametak, "Narodni osećaji bosansko-hercegovačkih muslimana iseljenih u Tursku," p. 41.

6. De Planhol, *Les fondements géographiques*, p. 258.

7. F.M. Vejzović, "Štampa o iseljavanju muslimana u periodu austro-ugarske okupacije Bosne i Hercegovine," *Bosna i Hercegovini: Iseljenički almanah* (1970), p. 108.

8. Vejzović, "Štampa o iseljavanju muslimana," p. 108; de Planhol, *Les fondements géographiques*, p. 257; Trnjegorski, *Jugoslovenske manjine u inostranstvu*, p. 135.

9. Ejub Sijerčić, *Migracije stanovništva Bosne i Hercegovine* (Sarajevo, Bosnia and Herzegovina: Republički zavod za statistiku SR BiH, 1976), p. 19.

10. On the reasons for the emigration of Bosnia-Herzegovina's Muslims during the Austrian occupation, see G. Gravier, "Emigracija muslimana iz Bosne i Hercegovine," *Pregled*, January 15, 1911, pp. 476–479; M.S. Filipović, "Bošnjaci u okolini Skoplja," *Pregled*, October–November 1931, p. 262; E. Bulbulović, "Nekoliko fragmenata iz naše bliske prošlosti," *Jugoslovenski list*, January 1, 1941, p. 11; Vojislav Bogićević, "Emigracija muslimana Bosne i Hercegovine u Tursku u doba austrougarske vladavine 1878–1918. godine," *Historijski zbornik*, III(1–4) (1950): 185–186; Abduselam Balagija, "Les musulmans yougoslaves" (Algiers, Algeria: University of Algiers, 1940), pp. 132–133; Cvijić, "O iseljavanju bosanskih muhamedanaca," pp. 84 and 89; Dragiša Lapčević, *O našim muslimanima* (Belgrade, Serbia: Knjizara Gece Kona, 1925), p. 47; Vejzović, "Štampa o iseljavanju muslimana u periodu austro-ugarske okupacije Bosne i Hercegovine," p. 108; Ćerić, *Muslimani srpskohrvatskog jezika*, p. 161; Hamdija Kapidžić, *Hercegovacki ustanak 1882. godine* (Sarajevo, Bosnia and Herzegovina: Veselin Maslesa, 1973[1958]), pp. 13, 67, and 74; *Bune i ustanci u Bosni i Hercegovni u XIX veku*, p. 29; Đorđe Pejanović, *Stanovništvo Bosne i Hercegovine* (Belgrade, Serbia: Serbian Academy of Sciences and Arts, 1955), pp. 42–45; Nametak, "Narodni osećaji bosansko-hercegovačkih muslimana iseljenih u Tursku," p. 41; A. Apostolov, "Kolonizacija na muhadžirite do Makedonija i rastrojstvo na čifčiskite odnosi od krajot na XIX vek do 1912. godina," *Glasnik na institutot na nacionalna istorija*, IV(1–2) (1960): 115; de Planhol, *Les fondements géographiques*, p. 259; F. Slipičević, *Bosna i Hercegovina od Berlinskog kongresa do kraja prvog svetskog rata (1878–1918)* (Zagreb, Croatia: Povijesno društvo NR Hrvatske, 1954), pp. 10, 14, and 18; Hamdija Kapidžić, "Bosanci i Hercegovci u Americi pred izbijanje prvog svetskog rata," *Bosna i Hercegovini: Iseljenički almanah* (1970), p. 181; Vladimir Stojančević, "Migracije iz Bosne i Hercegovine u Srbiju izazvane dogaćajima 1876–1878. godine," in Milorad Ekmečić (ed.), *Otpor austrougarskoj okupaciji 1878. godine u Bosni i Hercegovini* (Sarajevo, Bosnia and Herzegovina: Academy of Arts and Sciences of Bosnia-Herzegovina, 1979).

11. R. Zaplata, "Iseljavanje iz Bosne i Hercegovine," *Jugoslovenski list*, May 19, 1940, p. 11.

12. Ibid.

13. Bogićević, "Emigracija muslimana Bosne i Hercegovine u Tursku u doba austrougarske vladavine 1878–1918. godine," p. 181.

14. Ibid., p. 182.

15. Zaplata, "Iseljavanje iz Bosne i Hercegovine," p. 11; Mita Kostić, "Pregled bosansko-hercegovačkih muslimana po kosovskom vilajetu 1883. godine," *Istorijski časopis*, 1(1–2) (1948): 252; Muhamed Hadžijahić, "Uz prilog prof. Vojislava Bogićevića," *Historijski zbornik*, III(1–4) (1950): 191. Filipović, "Bošnjaci u okolini Skoplja," p. 262; Bogićević, "Emigracija muslimana Bosne i Hercegovine u Tursku u doba austrougarske vladavine 1878–1918. godine," p. 181.

16. Kostić, "Pregled bosansko-hercegovačkih muslimana," p. 252.

17. Slipičević, *Bosna i Hercegovina od Berlinskog kongresa do kraja prvog svetskog rata (1878–1918)*, p. 30; Alija Nametak, "Jedna anonimna propagandna pesma za iseljavanje bosanskih muslimana u Tursku," *Novi behar*, April 15, 1936, p. 279.

18. Bulbulović, "Nekoliko fragmenata iz naše bliske prošlosti," p. 10; Filipović, "Bošnjaci u okolini Skoplja," p. 262; Gravier, "Emigracija muslimana iz Bosne i Hercegovine," p. 477; Nametak, "Jedna anonimna propagandna pesma za iseljavanje bosanskih muslimana u Tursku," p. 279.

19. Cvijić, "O iseljavanju bosanskih muhamedanaca," p. 84.

20. Nametak, "Narodni osećaji bosansko-hercegovačkih muslimana iseljenih u Tursku," p. 42.

21. Lutovac, "Pogovor," p. 269.

22. Mirko Barjkatarović, "O etničkim grupama u Jugoslaviju," *Narodno stvaralaštvo-folklor*, VIII(29–32) (1969): 362; Mirko Barjkatarović, "O etničkoj strukturu balkanskog poluostrva," in Milisav V. Lutovac (ed.), *Cvijićev zbornik: U spomen 100 godisnjice njegovoj rođenja* (Belgrade, Serbia: Serbian Academy of Sciences and Arts, 1968), p. 236; E. Mušović, "Jugoslovensko useljeništvo u Turskoj," in Milisav V. Lutovac (ed.), *Cvijićev zbornik: U spomen 100 godisnjice njegovoj rođenja* (Belgrade, Serbia: Serbian Academy of Sciences and Arts, 1968).

23. Lutovac, "Pogovor," p. 269; Jovan Trifunoski, "O muhadžirima u Kočanskoj kotlini," *Etnološki pregled* 3 (1961): 150–151; Barjkatarović, "O etničkoj strukturu balkanskog poluostrva," p. 236; Sijercić, *Migracije stanovništva Bosne i Hercegovine*, p. 20.

24. Hadžijahić, "Uz prilog prof. Vojislava Bogićevića," p. 191; Zaplata, "Iseljavanje iz Bosne i Hercegovine," p. 11; Kostić, "Pregled bosansko-hercegovačkih muslimana," p. 252; Bulbulović, "Nekoliko fragmenata iz naše bliske prošlosti," p. 10; Vejzović, "Štampa o iseljavanju muslimana u periodu austro-ugarske okupacije Bosne i Hercegovine," p. 108; Gravier, "Emigracija muslimana iz Bosne i Hercegovine," p. 479; Bogićević, "Emigracija muslimana Bosne i Hercegovine u Tursku u doba austrougarske vladavine 1878–1918. godine," p. 18; Wayne S. Vucinich, *The Ottoman Empire: Its Record and Legacy* (Princeton, NJ: Princeton University Press, 1965), p. 117.

25. Qaysariyya is the Arabic form of the Latin name Caesarea. See "Caesarea," in Michael Avi-Yonah (ed.), *Encyclopedia of Archaeological Excavations in the Holy Land* (London: Oxford University Press, 1975), p. 271.

26. Ibid.

27. Ibid.

28. Barjkatarović, "O etničkim grupama u Jugoslaviju," p. 359.

29. Karpat, *Turkey's Politics*, p. 94, note 36; de Planhol, *Les fondements géographiques*, p. 257.

30. Cvijić, "O iseljavanju bosanskih muhamedanaca," p. 142; "O iseljavanju bosanskih muhamedanaca," p. 85; E. Čelebić, "Naši u Turskoj," *Svijest* (1935), p. 8; Gravier, "Emigracija muslimana iz Bosne i Hercegovine," p. 477.

31. On the ethnonym Bosniak, see Petar Vlahović, "Etnologija Jugoslavije," from outline for course in *Etnogeneza naroda Jugoslavije*, Belgrade University Philosophy Faculty, 1979, p. 193.

32. Mitrinović, *Našimuslimani*, p. 49.

33. Apostolov, "Kolonizacija na muhadžirite do Makedonija i rastrojstvo na čifčiskite odnosi od krajot na XIX vek do 1912. godina," p. 116.

34. Gravier, "Emigracija muslimana iz Bosne i Hercegovine," p. 480.

35. Ibid., p. 478; Bogićević, "Emigracija muslimana Bosne i Hercegovine u Tursku u doba austrougarske vladavine 1878-1918. godine," p. 178.

36. Gravier, "Emigracija muslimana iz Bosne i Hercegovine," p. 478.

37. Apostolov, "Kolonizacija na muhadžirite do Makedonija i rastrojstvo na čifčiskite odnosi od krajot na XIX vek do 1912. godina," p. 130.

38. De Planhol, *Les fondements géographiques*, p. 265. On the areas of muhajir settlement in general, see de Planhol, *Les fondements géographiques*, pp. 260–266.

39. Philip Hitti, *Istorija Arapa: Od najstarijih vremena do danas*, trans. Petar Pejčinović (Sarajevo, Bosnia and Herzegovina: Veselin Masleša, 1967 [1937]), p. 655; Marie Syrkin, "The Palestinian Refugees: Resettlement, Repatriation, or Restoration?," in Irving Howe and Carl Gershman (eds.), *Israel, the Arabs, and the Middle East* (New York: Quadrangle Books, 1972), p. 178.

40. Vucinich, *The Ottoman Empire*, pp. 78–96; Abdul Latif Tibawi, *A Modern History of Syria, Including Lebanon and Palestine* (Edinburgh, UK: Macmillan, 1969), pp. 179–206; Richard F. Peters, *Histoire des turcs, de l'empire à la démocratie* (Paris, France: Payot, 1966), pp. 68–91.

41. Tibawi, *A Modern History of Syria*, pp. 152–163; Emanuele Ghersi, *L'Espansione europea ed i movimenti nazionalistici nel mondo musulmano* (Florence, Italy: Bibilioteca di studi coloniali, 1943), pp. 84–90; Milutin Milenković, *Arapi između juče i sutra* (Belgrade, Serbia: Beogradski izdavacko-graficki zavod, 1974), pp. 51–55.

42. Tibawi, *A Modern History of Syria*, pp. 172–178 and 180–186; Pierre Jean-Daniel André, *L'Islam et les races*, vol. 1: *Les origines, le tronc et la greffe* (Paris, France: Paul Geuthner, 1922), pp. 236–278; Peter Mansfield, *The Ottoman Empire and Its Successors* (London: Palgrave Macmillan, 1973), pp. 22–23; Hitti, *Istorija Arapa*, pp. 670–179; Vucinich, *The Ottoman Empire*, pp. 177–178; Alexander Aaronsohn, *With the Turks in Palestine* (Boston, MA: Houghton Mifflin, 1916), pp. 1–20; Michel Chatelus, *Stratégies pour le Moyen-Orient* (Paris, France: Calmann-Lévy, 1974), p. 37.

43. Tibawi, *A Modern History of Syria*, p. 173. See also Chatelus, *Stratégies pour le Moyen-Orient*, p. 37; Raphael Patai, *The Kingdom of Jordan* (Princeton, NJ: Princeton University Press, 1958), p. 20.

44. Tibawi, *A Modern History of Syria*, p. 173.

45. As was customary, this group of muhajirs was led by elders. Gravier, "Emigracija muslimana iz Bosne i Hercegovine," p. 479.

46. Bogićević, "Emigracija muslimana Bosne i Hercegovine u Tursku u doba austrougarske vladavine 1878-1918. godine," pp. 183; Kostić, "Pregled bosansko-hercegovačkih muslimana," p. 252.

47. This was also the case with other muhajir groups. Gravier, "Emigracija muslimana iz Bosne i Hercegovine," p. 479; Vejzović, "Štampa o iseljavanju muslimana u periodu austro-ugarske okupacije Bosne i Hercegovine," p. 108.

48. At first the emigrants headed to the large towns, gathered in groups, and awaited decisions as to where they would be resettled. Gravier, "Emigracija muslimana iz Bosne i Hercegovine," p. 480.

49. The muhajirs aroused suspicion among the local people. Karpat, *Turkey's Politics*, p. 96.

50. "At the same time Muslim Bosnians (Bushnaq) were transferred to Syria upon the occupation by Austria of Bosnia and Herzegovina. They were settled in the half-ruined

Caesarea on the coast of Palestine ...”; Tibawi, *A Modern History of Syria*, p. 174. They founded a “small Bosniak village”; “Caesarea,” pp. 271–272.

51. To territory today occupied by Jordan [*sic*].

52. It is not confirmed that this family settled in Yanun.

53. Arab peasants; André Miquel, *L'Islam et sa civilisation: VIIe–XXe siècle* (Paris, France: A. Colin, 1968), p. 506.

54. During these first ten years, none of the women gave birth.

55. “The provincial administration laws promulgated by the Turkish authorities in 1864 and 1870 empowered religious associations (džemats) to establish and organize municipal administrations, with each municipality having an organization for each religious community. These džemats, which were primarily established on religious grounds, were not only organizations for worship but also had characteristics of municipal meetings, with the state leaving them to perform important services such as court jurisdiction in questions of marriage, and the running of educational and charitable institutions that the state did not wish to take on.” Georges Corm, *Prilog proučavanju multikonfesionalnih društava*, trans. Miroslava Popović-Vujisić (Sarajevo, Bosnia and Herzegovina: Svjetlost, 1977[1971]), pp. 220–221.

56. The term for local administrator in Ottoman times. Abdulah Škaljić, *Turcizmi u srpskohrvatskom-hrvatskosrpskom jeziku* (Sarajevo, Bosnia and Herzegovina: Svjetlost, 1973), p. 468.

57. A functionary working in the mosque. *Turcizmi u srpskohrvatskom-hrvatskosrpskom jeziku* (Sarajevo, Bosnia and Herzegovina: Svjetlost, 1973), p. 471.

58. As was the case in the old country. Balagija, “Les musulmans yougoslaves,” p. 94.

59. On the history and significance of Caesarea, see Simon Dubnow, *Kratka istorija jevrejskog naroda* (Belgrade, Serbia: Savez jevrejskih opstina Jugoslavije, 1962[1936]), pp. 76 and 78; see “Caesarea,” in particular the concise bibliography on this archaeological site on p. 28; Gaston Haelling, *Palestine israélienne* (Paris, France: Editions La Jeune Parque, 1952), pp. 33–34; Martin Noth, *Histoire d'Israël* (Paris, France: Payot, 1970[1960]), p. 412; Vidosava Nedomački, *Stara jevrejska umetnost u Palestini* (Belgrade, Serbia: Savez jevrejskih opština Jugoslavije, 1964), p. 63; Gérard Nahon, *Les Hébreux* (Paris, France: Éditions du Seuil, 1963), pp. 115, 153, and 186; Lee Levine, “Some Observations on the Coins of Caesarea Maritima,” *Israel Exploration Journal*, 22(2–3) (1972): 134.

60. It was only with the arrival of muhajirs from Crete in 1900 that the state began to build typical houses for immigrants; de Planhol, *Les fondements géographiques*, p. 268.

61. Germany's penetration of the Middle East was accompanied by the arrival of its experts; Aaronsohn, *With the Turks in Palestine*, p. 268.

62. It has been noted that one of the general characteristics of muhajir migration was their retention of their own particular style of housing, which they brought with them from the homeland. Rather than merely change the basic type of traditional housing in a certain area, they radically changed the use of building materials itself. In Türkiye today, even a century after settling, their houses differ from those of the autochthonous population. The nature of these immigrant villages has noticeably evolved from rural, to semi-urban, to urban types. De Planhol, *Les fondements géographiques*, pp. 268–269.

63. Tibawi, *A Modern History of Syria*, p. 177.

64. Arabic for kitchen; Škaljić, *Turcizmi u srpskohrvatskom-hrvatskosrpskom jeziku*, p. 480.

65. S. Smlatić, “U Kalabuku kod Izmira,” *Bosna i Hercegovina: Iseljnički almanah* (1972), p. 112.

66. Ibid.

67. Products from their estates were exported to Egypt, Türkiye, and several European countries.

68. This process was also typical among our emigrants in Türkiye; Smlatić, "U Kalabuku kod Izmira," pp. 112–113.

69. Tibawi, *A Modern History of Syria*, pp. 136–137.

70. Ibid., p. 189.

71. The Third Aliyah fell between 1919 and 1923.

72. See John Hope Simpson, *Palestine: Report on Immigration, Land Settlement, and Development* (London: His Majesty's Stationery Office, 1930).

73. Changing surnames appeared only in 1924, during the British Mandate. That was when all the Bosniak families took the surname Bushnaq. Only one took the name Kathkhuda, which was actually the original Persian version of their old family name, Ćehajić; Škaljić, *Turcizmi u srpskohrvatskom-hrvatskosrpskom jeziku*, pp. 186–187. All the Bosniaks today remember their old surnames and use them among themselves.

74. Edwin Samuel, *The Structure of Society in Israel* (New York: Random House, 1969), p. 11.

75. Ibid.

76. After the creation of the state of Israel in 1948, the Palestinian Arab population was displaced to the surrounding Arab countries. For more, see: Syrkin, "The Palestinian Refugees: Resettlement, Repatriation, or Restoration?", p. 209; Charles-Henri Favrod, *Les Arabes, Encyclopedie du monde actuel* (Paris, France: Edma, 1975), in particular the entries on Palestine on pp. 248–249, the West Bank on pp. 128–129, and Gaza on pp. 58–59; Milenković, *Arapi između juče i sutra*, pp. 193–194; Chatelus, *Stratégies pour le Moyen-Orient*, p. 20.

77. See "Caesarea," p. 271.

78. In Tunisia, there are the Mostarli and Bushnaq families, although it is not known for certain if they originate from the Bosniaks of Caesarea.

79. There is disagreement on this point among informants.

80. They say: "We are Slavs, not Turks. Still less are we Arabs."

81. "The Arabs of Palestine, the majority of the non-Arab immigrants from the East (Kurds, Caucasians, Armenians and Turks) and from the West (Greeks, a number of Italian, Yugoslav and Albanian families, and the remnants of the crusaders) together constituted one people with a unified culture"; Ibrahim al-Abid, *A Handbook to the Palestine Question*, vol. 17 (Beirut, Lebanon: Palestine Liberation Organization Research Centre, 1969), p. 57. In the identity documents of the Bosniaks, Palestine is indicated as their place of birth and they are treated accordingly by the officials of the countries in which they live today.

<p style="text-align:center">13</p>

On the Use and Misuse of Music: A Conversation about Jumana Manna's *A Magical Substance Flows into Me*

Jumana Manna and Saleem al-Bahloly

In 1936 and 1937, the Palestine Broadcasting Service aired twelve episodes of a radio show in which a German musicologist named Robert Lachmann sampled the different musical forms he found in the city of Jerusalem. Some of these traditions belonged to discrete communities, like the Samaritan and the Bedouin, or they were practiced over a wide geography beyond Palestine, like *maqam* and *mawwal*, but other traditions were brought to the city by Jewish migrants who had arrived from North Africa, Kurdistan, and Yemen. Lachmann had sought to promote "local" music, which he saw endangered by the growing dominance of the European musical tradition, but in that time of growing polarity among the population of Palestine, the show met with protest and attack.

Eighty years later, the artist Jumana Manna restaged Lachmann's project. In her 2016 film *A Magical Substance Flows into Me*, Manna surveyed some of the same musical traditions which, despite Lachmann's concerns, have survived into the present. She asked contemporary musicians to play the same pieces that Lachmann had recorded and broadcast, or pieces similar to them. Her purpose, however, was not to document the richness of local traditions, but rather to highlight the gaps between the communities that practice them, political and otherwise. Unlike the medium of radio, film pairs sound with image. In Manna's film, these gaps become visible as disjunctions between the sound of the music and the images of its performers, between what we hear and what we see.

In the context of this book's exploration of diversity in the Palestinian social fabric, this interview with Manna about making *A Magical Substance Flows into Me* explores how the sources we choose—and which sources we choose—to narrate the Palestinian story create other kinds of problems: disciplinary, curatorial, colonial, Orientalist. It leaves open the question of whether these problems can be resolved, or if we must find a way to live with the contradictions.

Saleem al-Bahloly (SA): Jumana, for some time now, contemporary artists have been turning to archives, particularly of the region's cultural life, in order to gain a

<p style="text-align:center">145</p>

critical angle on the present, but this is an unusual archive. How did you first learn about Robert Lachmann?

Jumana Manna (JM): I learned about Lachmann in the memoirs of Wasif Jawhari-yyeh, a Palestinian oud player from Jerusalem and chronicler who left behind a wonderful two-volume memoir called the *Mudhakkirat al-Jawhariyyeh*.[1] There is a moment in the second volume, which covers the period of the British Mandate, where Wasif talks about his encounters with a German-Jewish ethnomusicologist by the name of Robert Lachmann who had recently moved to the city and was giving lectures on Oriental music, recording with local musicians, and engaging in discussions about the impacts of modernity. It was their debate around the future of music that caught my attention. I felt this debate encapsulated wider questions around modernization, technology, transformations that were happening in Palestine, as well as Palestine's bifurcated relationship with Europe and the West. Lachmann was opposed to the use of Western notation systems and the influence of Western instruments on Oriental music. He argued that Arabic music was too "emotional," and also that it would be difficult to notate with Western notation because of the modal system, the quarter-tones. He believed that if change should come, it should emerge from the depths of Arabic music itself, not with the West as an ideal referential model. Jawhariyyeh disagreed: he thought that Arabic music was no more emotional than Western classical music, and that the only way to preserve the tunes that people weren't memorizing in the same way as before, was to write them down. He believed that notation could be adapted as both a tool for preservation and advancement of education.

These were some of the debates, which I found to be very valid—perhaps still valid—debates. How can a tradition allow for inspiration and influence from other ways of doing and knowing free from hierarchical relations of power?

I was initially doing research towards a film about the social life and nightlife of Jerusalem before the Nakba. In my mind, Wasif was going to be the inspiration for the main character of this film. So I went to the archive of Robert Lachmann, which is in the Israeli National Sound Archive, located at the Hebrew University's Givat Ram campus, looking for recordings Wasif made with Lachmann. Wasif writes in his memoirs that Lachmann recorded 17 wax discs of him playing, which I was very curious to find. But there was no record of Wasif Jawhariyyeh in the National Sound Archives. The archivists had never heard of him. Instead, I came across this radio program, the *Oriental Music Broadcasts*, a twelve-part radio program made for the Palestine Broadcasting Service between 1936 and 1937. I was excited to hear the sounds and voices of Jerusalemite musicians from eighty years ago, and found Lachmann's focus on Arab Jewish musics alongside Palestinian music to be compelling.

Lachmann was an Orientalist and had European listeners in mind: his motivation was to educate non-Arabic listeners about the diversity and richness of various

kinds of Oriental music (urban *maqam*, rural folk traditions of Palestine and the Levant, liturgical Christian and Samaritan music, and the Jewish traditions of the North Africa, Kurdistan and Yemen), how they were each distinct and historically entangled. What I found to be fundamentally political, even if unintentionally so, was his claim that you cannot study the musical traditions of the Arab Jews outside the context of the Arab and Islamic world. This was a moment when the Arab–Jew divide was already entrenched as a result of decades of colonial divide and rule policies, and gaining further traction with the growth of the Zionist movement. I was interested in how Lachmann's scholarly project challenged the constructed divisions of Orientalism and Zionism that rendered Arabs and Jews into distinct and opposite categories. These threads were the genesis of my project.

SA: In the film, you read a line from one of Lachmann's scripts: "Here as in no other city of the world, these people are gathered together but living according to their own particular traditions. For this reason, Jerusalem is best suited to the work of the archive. The Palestine Broadcasting Service provides the neutral background needed for both parties to collaborate."

Lachmann seems to be saying that a city can hold together different things, to make them present to each other, and an archive does the same thing: in the same location you can find multiple histories. You could say the same thing about film: like a city and an archive, film enables you to juxtapose different things that may even be antagonistic to one another. For instance, in the film, we see juxtaposed not only different song-forms, but also different forms of memory: alongside the different musical traditions you survey are scenes of your father writing a history of the expulsion of Palestinians, and of land surveyors mapping plots of land in the West Bank. How do you see these different forms of memory relating to one another—the songs that return your father's Iraqi friend to his roots, and that allows the Moroccan-Jewish woman to dissociate from Zionist myths, and the narrative-form of memory in which your father is engaged?

JM: The film is a kind of archiving in the making: musicians responding with contemporary versions of the recordings of their ancestors. The role of film as archive—a series of audio-visual field recordings—as an incomplete act of archival practice is present in the work.

A Magical Substance addresses history through the senses. It counters hegemonic historical narratives through muscle memory, through memory that is not necessarily written down or "archived" in the traditional dusty sense of archives, but something that is passed down affectively, through sound, rhythm and (musical) taste. In this case I'm talking mainly about the hegemony of Zionism, which at once ethnically cleansed Palestine of Palestinians, but also uprooted Arab Jews from the Arab world, actively trying to erase their heritage by prioritizing the new Israeli "melting pot" modeled on Ashkenazi ideals and sense of superiority.

The book my father is seen writing in the film, and that has since been published,[2] is a book that is based a lot on oral testimonies, precisely because of lack of archives from the Palestinian point of view of the Nakba in the years that followed. Such archives were either non-existent in the rural areas of Palestine, or destroyed/confiscated in the urban centers in the 1948 War. So in my father's book there is a reliance on orality that the film shares and explores, but obviously according to the methods of the academic discipline of history which are different from those of filmmaking. I am in a way echoing my father's project.

SA: You said that you understood the film as a form of field recording that is not just visual, but also auditory. Did you have a clear sense of what you wanted to capture visually? Because there are these moments in the film where the camera pauses: for instance, in the first scene, on the elevator button and the inscription of the company name Isralift. Personally, whenever I get into an elevator, I always notice the name of the manufacturer inscribed on the floor or on a panel. So I was struck by the inclusion of a shot like that, and in fact the film is full of shots like this, which makes it so rich. What was it that you were hoping to capture?

JM: It is nice that you bring up this detail! I was thinking of different things. I am also a sculptor and I like to focus on objects and details that have material relations and histories embedded in them. These shots in the film are related to how I think about sculpture: as an archiving from below or a taxonomy of things that fall outside conventional historical interest and preservation, yet are telling of material and social conditions. Such details also bring out the comedy of the everyday, be it the Isralift, shoes and slippers that keep popping up, conversations about taking out the trash: things that are the crass parts of daily life, the profane and mundane meeting the magical substance of music and grand historical matters—that for me is very much Jerusalem or Palestine at large. I like to bring those worlds and relations together both in film and sculpture.

I was thinking a lot about domestic spaces, because so much of coloniality takes place in and shapes the notion of home. Most of the musical scenes are shot in interiors. It is a deeply personal film in the sense that my parents are the chapter-markers between the different groups that are encountered. I was trying to find a language for the film that is inspired by ethnographic or observational film that is at once observing others, but also my own family home; a self-ethnography in turn. So I was looking at these spaces and thinking about how the music sounded in these interior spaces, which is where affect and memory get passed down. In the moment of shooting, these details are driven by a sense of humor and an attention to what they may reveal.

SA: One of those domestic spaces you visit is the home of a Samaritan cantor. You play for the cantor and his wife a recording Lachmann made of her father, who had

been a famous cantor. The husband has nothing but praise for his father-in-law, and he talks over his wife as she explains that her father had left her mother, that she did not know him, that she can hear his voice but his voice offers her no connection to him. She wishes she could dream of him but she cannot even do that. It raises a question about what music does *not* transmit.

JM: What music does not transmit is the political divide. It has been interesting to see how this film has circulated now that it has been out for eight years, and how differently it has been read and written about. I was looking at segregated memories/narratives in the space of a film, which is not commonly done in Palestinian cinema. Palestinians do not interview Israelis much. But learning about the history and music of Mizrahi Jews[3] is an important entry point to unpacking Eurocentric binaries of the Zionist project. We need to understand more carefully, as Palestinians and Arabs in general, what happened to the Arab Jews. Not in order to excuse their role in the settler-colonial project, but because the same historical process of dispossession that denied Arab Jews their rootedness in Arab countries is that which continues to ethnically cleanse Palestine from Palestinians. Arab reactionary regimes, dependent and controlled by imperial powers, played a role in this uprooting too. Consider how many great composers and musicians of the nineteenth- and early twentieth-century Arab world were Jewish. The dissociation of the Arab Jews from the Arab world was a great loss for the plurality of the region.

Music does not provide a shortcut to historical justice and reconciliation. This is why it was important for me that the musicians/families were filmed in their respective/segregated domestic spaces. The divide of Arab Jews and Palestinians, despite a shared history, culture and language, cannot be overcome under conditions of apartheid. What is tricky about music is that it can be misused or reduced to say, "Here we are coming together, we listen to the same kind of music, we must be able to come to an understanding." Music can and is sometimes used to flatten historical injustices. We see more and more examples of Israeli *hasbara* ("propaganda") using Mizrahi culture today to assimilate and "naturalize" itself in the Middle East, especially after the recent signing of peace treaties with the Gulf and Morocco. Arab Jews were culturally colonized by Zionism, but having assimilated into the colonial project, they are colonized and colonizers at once.

SA: What are the different ways that the film has been received?

JM: By some, it has been read as coexistence, which I reject under the present conditions of occupation and apartheid. For others, a hopeful film, a film about future possibilities of one state or bi-nationalism. Others have picked up on the anger in the film, seeing it as a film about loss—about the lost possible alliance between Arab Jews and Palestinians. I would say that it was an attempt to both reflect on history and the "roads not taken," and about futurity, repair, and return. In making the film,

I researched those brief moments of attempted alliance: meetings that took place at some point between the Mizrahi Black Panthers and the PLO. These were important but minor and inconsequential attempts. From the 1980s onwards, with the rise of the political party Shas, which represented the Mizrahi population, there was a major turn to the right and a total embrace of Israel and Israeli identity. Anyway, today the divide between Mizrahis and Ashkenazis is not as clear-cut as it was in previous generations because Israelis have mixed and intermarried.

I feel most uncomfortable when I come across synopsies or reviews of the film as this feast of people cooking and singing together, because that is not the film I made. Particularly Europeans, or people who are not familiar with these hisories and are insensitive to the signs of anger and violence pointed to in the edits. For instance, there is scene that cuts from the Kurdish Israeli real estate appraisers who are really the technocrats of the occupation and its expropriation of lands, playing and singing in the office, followed by a scene of my father talking about expulsions from the Galilee during the Nakba. The intention of these juxtapositions is not picked up by all audiences. That is fine. That is what film does—it is experienced differently by different groups. But the focus on it being a feast of cultural diversity is one of the narratives that unfortunately comes up which I have to regularly correct.

SA: The film opens with a recording of Lachmann reporting on the attacks and protests launched at his program, and his response is to issue a call for suggestions—"proposed changes to the program"— but he says that he cannot promise that he will follow any of the advice he receives. Was this film advice to change the programming?

JM; I did think of the film as a response to Lachmann's call for feedback. It was the future giving advice to the past, and vice versa.

Lachmann was an Orientalist, and with all his well-meaning scholarship on Oriental music, he was part of the colonizing mission. He was part of the Hebrew University and the building of institutions that laid the foundation for the establishment of the state. This is also my interest in the contradictions of the archive: how colonial inheritance can be "hijacked" in the sense that it can be counter-appropriated, borrowed from its original context in order to tell a different narrative, in this case my taking these historical materials outside of the Zionist archive and its intentions. This archive happens to be my inheritance as well as this is the colonized home I come from. Lachmann too was caught in all kinds of double-binds. He was suspicious of recording technologies; their impact on the taste of local music, either from the rapid influence of "pop-music" from Cairo being heard on the radio, or imported wax discs with European opera. He was reluctant about these recording technologies being disseminated among the natives, and yet those were the exact technologies he was using to make his own studies, which were then aired on the

radio. He insisted on not dividing the study of Arab and Arab Jewish music because they are not divisible musically speaking; but not necessarily because his project was a critique of Zionism.

He died young, before the establishment of the state, but still he was there on the payroll of a colonial institution. I think these are the kind of contradictions we face today as academics, cultural workers, artists, filmmakers, etc. It's the predicament of the kind of work that we do: we cannot accept the conditions in which we are invited to work or agree to the sources of the money we are given. And yet we often do, attempting to navigate the lesser evils of funding, in order to continue doing our work and saying the things we want to say. There might be no outside to the colonial and capitalist system today, but there is always a beyond, with unruly impacts and resonances. These questions come up all the time, and contradictions are constantly there, and there is an element of taking a historical look at these questions through Lachmann's project.

NOTES

1. Issam Nasser (ed.), *The Storyteller of Jerusalem: The Life and Times of Wasif Jawhariyyeh, 1904–1948* (London: Olive Branch Press, 2013).
2. Adel Manna, *Nakba and Survival: The Story of Palestinians Who Remained in Haifa and the Galilee, 1948–1956* (Berkeley, CA: University of California Press, 2022).
3. *Mizrahi*, meaning "eastern" in Hebrew, is the umbrella term used in Israel to describe Jews from the Arab and Islamic world.

PART IV

Familiar Places

14

Umm Kulthum's Intercessor*

Sheikha Hussein Helawy

This story takes place in an unrecognized Bedouin village located in northern Palestine, near Haifa. It was demolished in 1990, and its residents were displaced to neighboring villages.

"You shameless brat!"

I was 16 years old, and she was 61. It was the only time she'd ever slapped me on the cheek, and it rang in my ears for days. It was followed by a thunderous scream that hurt me as though she'd slapped me a second time:

"Now get out of my face!"

It was also the only time she'd kicked me out of her room. Even though I didn't bear her name and I wasn't the oldest of her eight grandchildren, I was her favorite granddaughter. From the time I was little and until that night, she'd been accustomed to calling me "Habiba," or "Beloved." When she called me from her room, she didn't need to mention my name. It was enough for her to say, "Come here, Habiba!" and everybody in the house would know I was the one intended. Everybody else in the big house had names she called them by, and sometimes the name would be followed by an identification of how they were related to her. It was as if, when she asked them for something, she wanted to remind them of her rights over them, and their duty toward her.

I came out of her room, my palm covering my humiliated cheek, and hid in my room before anyone in the house noticed my fall from grace. Once the incident was noted, it would beg the urgent, disapproving question: "What happened?" Then they would present a list of hypotheses for me to choose from, possibly with just a nod of the head. But none of that happened. She retreated for refuge into her prayers and pleas for God's forgiveness, and I, into my books and my silence.

However, there was another "Habiba" whose name was distinguished from mine by the two Arabic letters *alif* and *lam*, or the definite article "the." This other person was "*al*-Habiba," or "*The* Beloved," whereas I was just "Habiba."

Despite my youth and my ignorance of the rules that governed definite and indefinite articles and the weight that was carried by the former, I was terribly jealous of that other "Habiba." My childlike intuition told me I was the loser in an unnamed

* Translated from the Arabic by Nancy Roberts.

game whose outcome had been determined before I was born, and that any attempt on my part to reverse that outcome was bound to fail. After all, I was competing against a woman I knew nothing about except her name, her voice, and the times when she came on the radio or television—times which, to Grandma, were sacred. At some point in my life, I made peace with this defeat, reminding myself that among all those my grandmother loved, I enjoyed the singular honor of being second only to Umm Kulthum.

The voice of Umm Kulthum, the beloved Prima Donna and, as the people in our household referred to her, *habibat al-jadda*, or "grandma's beloved," would emanate from the eastern room at specific, known times of the day, around which we arranged our schedules and on the basis of which we could predict our grandmother's moods. It was a voice rivaled (albeit weakly) only by that of the reciter on the Qur'an radio station, which my grandmother would listen to for an hour every day after the dawn prayer. If, on a given day, she granted the reciter a more generous share of time than she did to The Beloved, the "imbalance" could be explained by the fact that our grandmother wanted to commemorate someone who had died, or she'd had a bad dream, or people had suffered some unforeseen disaster. In other cases, it might be on account of some inadvertent sin she'd committed, or an urgent request she needed to bring before her Creator and which called for a lengthy Qur'an recitation followed by a session of praise and pleas for forgiveness on her prayer beads.

Umm Kulthum's voice was one I didn't know how to classify or describe with my limited eight-year-old vocabulary. It wasn't pretty, and it wasn't ugly. It wasn't smooth, and it wasn't gravelly. It wasn't comforting, and it wasn't irritating. It was just Umm Kulthum's voice, as my grandmother would say. In my view, this placed it outside the realm of all classification, and in my grandmother's view, above all classification. As far as she was concerned, it was sui generis.

She would exclaim, "Isn't it a shame for a woman with a voice like that to be six feet under the ground? I swear, it's a crying shame!"

Then, with the fear of a believer who's just caught herself committing some terrible transgression, she would exclaim, "Lord, forgive me!"

Her children and grandchildren knew how to appease her if she was miffed or tap her generous side if she was feeling stingy. When we wanted something, we'd appeal either to her Lord, or to her Beloved. If we begged her, "For your Beloved's sake, Grandma!", she would chuckle and give us whatever we asked for. Slipping her hand under the pillow, she'd pull out her black leather wallet, take out £20 notes and distribute them among us equally. Then she'd wink at me, and I'd shoo them all out of the room with my finger on my mouth, saying, "Sh-h-h-h-h-h! It's about time for Umm Kulthum to come on the radio!" Then I'd sneak back in for another £20 note and rush out again before anybody noticed.

On her sixtieth birthday, I spent a whole day waiting in the gift shop near my school while the shop owner worked on arranging a legendary encounter between

my grandmother and Umm Kulthum. I'd brought him two pictures, one of my grandmother, and the other of Umm Kulthum. The picture of my grandmother showed her at a family wedding wearing the embroidered dress she always saved for weddings and holidays, sitting happily with her hands crossed over her chest and watching the celebration, while the one of Umm Kulthum showed her on stage in that famous stance of hers: handkerchief in hand, arms raised heavenward, and her mouth open wide in a prolonged "Aaaah."

"That's the best I can do!" said the shop owner after hours in front of the computer screen, cutting and adding, enlarging and reducing, moving images farther apart and closer together.

"No, no," I said, "my grandmother's too far away. Could you bring her closer to Umm Kulthum, please?", "Please make the picture in color," and "My grandmother doesn't seem to be looking at Umm Kulthum."

Then, at long last, I saw Umm Kulthum standing directly in front of my grandmother as though she were singing to her alone, while my grandmother sat with her hands clasped over her bosom, an audience of one entranced by the majesty of the Prima Donna.

When she saw the picture for the first time, my grandmother gasped and nearly fainted. "God have mercy!" she muttered as she wiped her face with her hands. She gawked at the picture, rubbing her eyes in disbelief and giggling like a little girl who's woken on the Eid to find a new dress waiting for her. I explained to her that technology can work miracles, such as collapsing distances, transcending time and place, immortalizing the departed, and joining them with the living in photographs that look convincingly real. Once she'd gained her composure, she told me she'd dreamed about being at an Umm Kulthum concert, and that when she saw the picture, she'd felt confused, not knowing whether she was still dreaming, or if the dream had come true.

She studied it at length, running her fingers over the faces under the glass. Then, pointing to the wall in front of her, she said, "Hang it there to the left of the verse." She was referring to a framed verse from the Qur'an, written in Kufic script, which had been given to her by a beggar that roamed the village with framed Qur'anic verses in his left hand, and with his right hand outstretched to the charitable as he prayed for God to grant them protection and prosperity. The verse read: "*His is the dominion of the heavens and the earth. He gives life and deals death, and He has power over all things.*"[1]

Thus, the picture came to rest next to the verse on the wall directly across from her bed. Now there were two images and two certainties that had been joined in her heart, so if doubt crept in concerning one of them, the second would come and drive it out. The first certainty was the dominion of the Lord of the Worlds over all things, and the second was her having met face-to-face with The Beloved, Umm Kulthum (the truth of the matter being known only to her clever daughter and the owner of Maher's Gift Shop).

157

Staring at the picture in consternation, the few village women who came to see her were convinced that she'd been hiding the secret of her having attended an Umm Kulthum concert once upon a time, ignoring the facts of death and life, the difference in eras, and the geographical distances that would have easily toppled her claim.

"Tell us about it!" they urged eagerly.

She explained to them proudly that her diligent teenage granddaughter was a "genie," that science could now work miracles, and that they hadn't seen anything yet. One of them would imagine a picture of herself blowing a kiss to Abdel Halim Hafez,[2] while another (as long as technology was capable of such miraculous feats) would soar on the wings of imagination to a film showing her wrapping her arms around Rushdy Abaza[3] and singing to him demurely, "'Ashi'a wa Ghalbana wa-n-nabi.'"[4]

Another person who fell for the story was the neighbor lady across the street who, standing on her terrace, called out to my grandmother at the top of her lungs, "Hey there, Umm Umar, I swear by the Qur'an and the Most Merciful, the song where Umm Kulthum sings, 'with confident steps, he walks like a king'[5] comes straight into my house. Does it come into yours?"

Smiling, my grandmother looked at her from the window of her room and replied, "No, it doesn't."

Radio in hand, the neighbor lady gave a triumphant flick of the head. Then she turned the volume up full blast so the whole neighborhood could hear that Umm Kulthum's voice had graced her house alone with the words, "With confident steps, he walks like a king," and that even Umm Umar's house had been passed by! Umm Umar would never have forgiven anybody who claimed to have a monopoly on Umm Kulthum except for the fact that this particular neighbor lady was poor as a church mouse and weak in the head, facts which ranked her among those unfortunate souls whose trespasses are forgiven, and who might even be classed as saints if their trespasses are occasioned by a passion for Umm Kulthum.

When the neighbor lady stood dumbfounded in front of the picture of Umm Umar and Umm Kulthum, my grandmother made little effort to explain to her the miracles of science and technology. After all, if this poor woman's mental capacities were so limited that she thought her radio was the only one that picked up Umm Kulthum's songs, she was sure to believe that Umm Kulthum and my grandmother really *could* appear in the same picture. It wouldn't hurt for there to be somebody besides my grandmother who believed in this possibility. Even so, she could never have imagined what impact this marvel would have on the poor woman. She no longer poked her head out her window to announce loudly which song Umm Kulthum was singing on a given evening. In fact, I don't think she even listened to her any more. Instead, she would go back and forth across the street between her house and ours, steadying her radio on her left shoulder while she fiddled with the radio dial, but without settling on one station.

As she passed under my grandmother's window, she would shout, "Umm Umar stole Umm Kulthum from our radio. I swear by the Qur'an and the Most Merciful, I saw Umm Kulthum at her house!"

For days after this, my grandmother reproached herself for the unintended setback she'd caused this neighbor. Fearful that her "sin" would strap her with a debt, she set about repaying it by doubling her prayers and prolonging her other religious observances the way she did whenever she owed an earthly debt. As she always reminded her children, "We shouldn't make other people pay for our mistakes." Eventually, the neighbor lady stopped picking fights with my grandmother every day the way she had been. This was a sign my grandmother had been waiting for, so her conscience was relieved, and she went back to her milder penance regimens. "The first time I met the Prima Donna was more than thirty years ago," she reminisced. "I went with your grandfather—God bless his soul—to Haifa to visit Ezra, the man in charge of the village's forests. Your grandfather went to ask him to release a herd of goats that had been confiscated on the pretext that he'd been grazing them in protected areas. While we were going there on the bus, he told me just to return their greeting, and not say another word. When we got there, we all sat in the living room. Ezra's busybody wife sat next me, screwing up her mouth and eavesdropping on the men's conversation. On the television screen in front of me stood the Prime Donna, singing, 'What can I tell you about longing?' I don't know how long I sat there with my eyes and ears glued to the screen, but after a while I heard Ezra brag, 'I attended a concert of hers in Baghdad in 1946. I was in the front row!'"

I cursed him in my heart. How was it that this man and his crooked-mouthed wife got the chance to see and hear Umm Kulthum, but I didn't? On our way back, I asked our grandfather if Umm Kulthum had ever sung in Haifa, and he snapped angrily, "What did we come out to do, anyway? To find out about Umm Kulthum, or the herd of goats we're about to lose!?"

I used to call them "bathroom stories," since they came enveloped in the scent of soap and the mist left by the hot water. She would trim her hair and pour water over her hair and body, while my job was to wash her hair, rub her back and listen to the details of whatever story she was telling. I used to prolong the bathroom ritual, hoping to pick up on details that were for my ears only.

"He was harsh, gruff, and jealous, God forgive him! He used to monopolize the radio, even though the only things he listened to were the news and rebab music. If he caught me listening to Umm Kulthum and humming along, he'd blow up. Then he started taking it with him to the pasture during the day. He was suspicious by nature and used to say the only people who listened to Umm Kulthum were lovers. But he's rested from his labors now and given me a rest from him!"

It wasn't just Umm Kulthum's voice, or the picture of them together, that would put a happy twinkle in my grandmother's eye, but every piece of news or information that reinforced her conviction that Umm Kulthum was a legend not only as a singer, but in all aspects of her life. I used to go hunting for tidbits about her in the

newspapers or on websites I found on the school computer. After a while, it became such a treat that if a week went by without my bringing her anything new, she would feel as though something was missing. So sometimes I would repeat old news, and she would listen to it as enthusiastically as she had the first time she heard it. My haul of news items tended to be especially generous on the anniversaries of her birthday or death, when the newspapers would publish rare photos, secrets, and details that revealed more and more about her life. I used to divide these up over the days to satisfy my grandmother's appetite for Umm Kulthum trivia, and in hopes of enjoying those looks of contentment and approval in her eyes.

I also used to rephrase and edit some of the news to bring it into line with her biases. I might suggest, for example, that if it hadn't been for Umm Kulthum, composers and writers like Riad Al Sunbati, Ahmed Rami, Zakariyya Ahmad, and Baligh Hamdi wouldn't have risen to prominence. Or I might exaggerate and say they were all madly in love with her and were dying to win her approval, speculations she would affirm with an enthusiastic nod of the head.

Sometimes I introduced the news with leading questions and watched her eyes get big, ready to devour the answers to follow.

"Do you know why she wears sunglasses?" I asked, "Or why she holds a handkerchief when she sings? Or when she visited Palestine? Did you know she started out as a Qur'an reciter, and turned to singing later? And that until she was ten years old, she dressed up as a boy?"

She shook her head in pleased astonishment.

"Did you know she quit singing after Abdel Nasser died, but Anwar Sadat persuaded her to go back to singing?"

At this she drew a deep breath.

"Did you know she was the first female lead musician?"

Here she took an even deeper breath, swelling visibly with pride.

"And that she played a major role in the campaign to rearm the Egyptian army after the defeat of '67 by giving concerts all over the world and donating her entire proceeds to the war effort?"

By this time, she was beside herself with delight.

The prelude to the song "*Hajartak*" ("I've Left You") had begun. During the long instrumental introductions that preceded Umm Kulthum's songs, we could exchange a word or two with my grandmother. But from the moment she uttered the first word of the song until she "left the stage," as my grandmother put it, all conversation was forbidden. If we made the slightest sound, she would scold us and threaten us with dire consequences, or glare at us until we shut our mouths and left her room.

It was a sacred time, and to get the point across to us, she would say, "There are two things you should never interrupt: my prayers, and my hour of rapture!"

After serious thought, we concluded from this comparison that just as "*du'a al-istighfar*," or the traditional plea for forgiveness, concluded my grandmother's

ritual prayers, Umm Kulthum's "leaving the stage" concluded her hour of rapture, and that nobody was permitted to talk until after that time.

We could see with our own eyes when our grandmother had folded up her prayer rug, hung her prayer beads around her neck, and sat down on her chair or bed, so we would know it was alright to talk again. But we couldn't figure out how we were supposed to know when Umm Kulthum had left the stage. After all, nobody could see her on the radio!

We tried to calculate, or at least guess, how long the stage was, how many steps led down from it, and how nimbly Umm Kulthum could navigate them given the fact that she was around my grandmother's age. In the end, we concluded that the average time she would need to come down from the stage after finishing her performance would be around the same as it took my grandmother to recite the plea for forgiveness and the formulas of praise after her ritual prayer.

"Sh-h-h-h ... I don't want to hear a peep out of you!"

"What time is it? In half an hour, Umm Kulthum comes on."

"I swear to God, there's no other voice like yours, my Beloved!"

Words like these taught us never to interrupt either her prayer or her hour of rapture.

Then one day, on the anniversary of Umm Kulthum's death, a certain secret was revealed by a newspaper with evidence from Umm Kulthum's life to back up the claim, namely, that my grandmother's Beloved had preferred women over men, as it were. This startling piece of information dogged me all the way home from school, and all the way up to my grandmother's room that night. I hesitated to tell her about it. This was no ordinary piece of news. On the contrary, it was scandalous enough that it would confuse my grandmother at best, and at worst, make her furious with the newspapers. But when I walked into her room and saw the peaceful look on her face as she listened to the introduction to the song of the evening, I settled the matter in my mind.

At long last, the old childish envy of Umm Kulthum had found an outlet in a tidbit of disagreeable news that would flip the equation.

It was the old defeat that I'd never accepted.

So I started reading the news items just as they'd been reported in the newspaper, pausing as usual between one sentence and the next to make sure she was listening, and in anticipation of an admiring nod of the head or a satisfied gleam in the eye. However, her hand was swifter than either her head or her eye, and it landed full force on my cheek with the words, "You shameless brat!"

Tripping repeatedly over my shamelessness, I stumbled out of her room and into my own while avoiding contact with anyone else in the house. I tripped over it again whenever someone wondered aloud about the reason for my grandmother's isolation and the absence of Umm Kulthum's voice from her room. Her children were afraid her sudden loss of interest in anything but solitary fasting, praying, and pleas for divine forgiveness might be a sign of impending death, since the 40 days before

a person dies are accompanied by cryptic signs observed by this person alone, such as recurring nightmares of an open grave.

I was less preoccupied with the imminent death others had been speculating about than I was with another fear, namely, that my grandmother would die sad, or leave this world with anger in her heart toward me or Umm Kulthum. More specifically, I was preoccupied with a wish I'd once promised to fulfill for her.

One night after Umm Kulthum had "come down from the stage" (I don't remember the song she sang that night), my grandmother had whispered to me that when she died and the three days of mourning were over, she wanted me to make sure Umm Kulthum's voice went on being heard in the house at her sacred times. She said she wanted it to be a kind of ongoing charity, given on her behalf to people in the household and passers-by.

But was this still my grandmother's wish now that Umm Kulthum had abandoned her room while she was still among the living?

After that slap, I entered her room only rarely, and when I did, I made sure our eyes didn't meet. I was avoiding that mysterious thing that gleamed in her eyes and that had stuck in my memory since that night, erasing all the cherished looks of joy, contentment, and reassurance. She also made sure our eyes didn't meet, though I don't know what she was avoiding. I would set her fast-breaking meal on her little table before the sundown call to prayer, or gather her dry clothes from the clothesline, arrange them in her closet, and make a quick exit.

But one day, as I was on my way out, an amazing thing happened.

I noticed that there wasn't a trace of my grandmother in the picture on the wall. As I crossed the two-meter distance between the closet and the door, I tried to find her, opening my eyes as wide as they'd go and scrutinizing the picture in detail. But all I could see was Umm Kulthum and her audience looking out at me from a black and white picture, an ordinary picture no different from hundreds of others I'd seen.

My grandmother wasn't there.

My eyes weren't lying, and neither was the picture.

I remembered the "weak-minded" neighbor lady, who appeared to have the kind of supernatural powers enjoyed by saints and other blessed souls. She must have expelled Umm Kulthum from my grandmother's radio, then caused a rift between me and my grandmother, and between my grandmother and Umm Kulthum. And now she was completing the punishment by concealing my grandmother from the picture. Did I dare ask other people in the house to look at the picture and help me figure out whether my grandmother had really left it, or whether she'd been in it to start with?

There was no way I was going to ask my grandmother why she'd withdrawn from the picture.

But after 40 days of solitude and worship, I heard her voice coming out of her room one evening.

Laughing serenely, she called out, "Come here, Habiba!"

I didn't believe my ears until the call came again: "Come here, Habiba!"

Seated on the edge of the bed, she was drying her long hair with a towel, then letting it cascade gently over her shoulders and thighs. Making a half-turn, she extended the comb in my direction as if to say, "Come, comb my hair." Her hands still nimble, she worked the tangles out of her long curly hair and divided it evenly into two large bunches which she then turned into a pair of thick braids that met in the form of a sated snake that lay curled up at the back of her head.

I began braiding her hair. Then, unable to contain myself, I asked her, "Grandma, have you forgiven me?"

She made no reply. Instead, she asked for her embroidered dress, put it on, then wrapped her head in her white shawl stitched with golden threads and sat down in the middle of her bed. She asked me what time it was. Then, moving the radio dial with the skill of the blind, she put it on her favorite station. In a barely audible voice, the announcer was finishing the news summary.

She sat up straight, bringing the radio closer to her. Then, pointing toward the wall, she said suddenly, "Damn it all, that picture's still crooked, Habiba!"

The chair that sat against the wall directly below the tilted picture bore the footprints of an unsuccessful attempt to straighten it. Standing on the chair, I moved the frame left and right according to my grandmother's instructions until the picture hung straight.

As I was getting down off the chair, she said suddenly, "Can you check for me to see if I'm back in the picture, Habiba?"

"Yes, you're there, Grandma," I assured her.

And there she was, her hands crossed over her chest, decked out in her colorful embroidered dress and ready to belt out enthusiastic cries of approval. Forty days of seclusion and worship had paved the way for a long life to come, both inside and outside the picture.

"*Dear listeners, until the time of the news broadcast an hour from now, we leave you with Umm Kulthum's song of the night: 'Ansak' ('I'll Forget You'), lyrics by poet Mamoun Al-Shinnawi and music by Baligh Hamdi. We wish you an enjoyable hour.*"

As usual, she turned the volume dial two complete revolutions so that everybody in the house, the neighbors, and passers-by could all hear the song of the evening.

Once the instrumental prelude was over, I returned the chair to its place. With one hand I gently closed the door, and with the other I nudged out of the room a protesting crowd that I'd pulled out of the picture.

"More, Madame, more!" they cried.

"*Sh-h-h-h-h-h,*" I whispered, my finger to my mouth.

NOTES

1. The verse is Qur'an 2:225, referred to popularly as "the Throne Verse," which reads: "God—there is no deity except Him, the Ever-Living, the Self-Sustaining. Neither drows-

iness overtakes Him nor sleep. To Him belongs whatever is in the heavens and whatever is on the earth. Who is it that can intercede with Him except by His permission?"

2. Abdel Halim Hafez (1929–1977) was an Egyptian singer, actor, and conductor.
3. Rushdy Abaza (1926–1980) was an Egyptian actor.
4. Literally, "In Love and Victorious, I swear by the Prophet!" ("*'Āshi*'a wa Ghalbāna wa-n-Nabī") is the name of a popular song performed by Sabah (1937–2014), lyrics by Mohammad Hamza (1969–).
5. A phrase from the song titled "The Ruins" ("al-Aṭlāl"), lyrics by Ibrahim Naji, music by Riad Al Sunbati, 1990.

15
Saber's Dungeon*

Maisan Hamdan

AUTHOR'S INTRODUCTION

This is an extract from my novel *Underway in Silence*. The novel is concerned with prisons and attempts to escape incarceration. These prisons can be actual jails, but they can also take the form of social, mental, political, or geographical confinement. We come to realize that collective liberation is impossible and that even the liberation of an individual, which seems feasible, is itself a kind of self-incarceration.

The novel ranges over three historical periods. In the present period, the novel tells the story of a young and queer Druze man, who is incarcerated in a military prison because he refuses to follow an order while serving in the Israeli army. Ever since 1956, Druze Palestinians have been obliged to perform compulsory military service in the occupying army. Through his time in prison, we learn about the social and political life of the so-called "Druze villages" in the areas that were occupied in 1948.

<p style="text-align:center">* * *</p>

There's no running away, pal. This nightmare will catch up with us wherever we decide to go. It'll infiltrate our conscious and unconscious. A single irritating word will interrupt our train of thought. It'll drive away all those beautiful sights we're used to seeing in our dreams, the only places where we're allowed to rest without worry. There, we'll enter prison on our own volition, without knowing for how long, without caring which cell we're to lay our bodies down in, even when the nightmare whispers its threats in our ears. We'll soar in the sky above, high up where there's nothing but the void. We'll remember that we soared in a big prison once, crammed in there together like sheep, just waiting for a corporate meat processor to grind us up and squeeze us, plus some preservatives so we don't rot, into cans to be shipped around the world.

We'll rot. And no one will pay any attention to us anymore. That's right, pal.

<p style="text-align:center">* * *</p>

Saber woke up in the cell that had become a home three months and five days ago.

The walls of the single cell felt like they'd collapse on top of each other, suffocating everything in between: a small metal bed, a window you could barely see high up on the wall facing the bed, here and there water stains, and Saber.

* Translated from the Arabic by Adam Talib.

Outside, the storm was settling.

* * *

It was six o'clock when the guard entered Saber's cell. He and Saber spoke to each other in Arabic and their accents were almost the same, except that the guard often ended words with "eh" that Saber would end with "oh."

"So what now? Are you gonna stay stubborn?"

Saber gave him a dismissive look but he didn't say anything. He turned his head toward the small scrap of sky he was allowed to see and then down at the ground, in search of some rays of light to sit beneath.

"I miss sitting cross-legged on the ground."

"Spare me. I just want you to answer my question: Are you gonna stay stubborn? I'm trying to help you. I want them to let you go."

Saber laughed and then whispered to himself, impersonating the guard's voice, "Them … them." "You're helping them. That's all any of you do. You help them."

"Saber, you still have half of your sentence left …." The guard couldn't finish his thought because Saber leapt to his feet in a rage and banged his fists against the wall of the cell as hard as he could.

"I told you I'm not going back to the army!"

"Fine, but at least cut your hair if you wanna get out of here." The guard exited, locking the door of the cell. He didn't look back once he'd left.

Saber turned around and shuffled to the right and the left, pacing back and forth in the area just in front of the cell door. He looked up and then clapped his hands twice. "Listen up, kids," he said in a soft, innocent voice. "We're going to start a new module in our Druze heritage[1] class today and I want everyone to pay attention because this is going to be on the exam. The Druze wear wool in the winter." His giggling filled the air.

* * *

His bedroom was so tidy it felt spiteful. All his possessions were exactly where they were supposed to be, observing the living like silent statues, but some of the statues did more than just observe. They were dynamic and had things to say. The wardrobe was covered in stickers from different military units: the air force, army, and navy. In the center was a sticker of a watchtower topped by an iron dome beneath which it read "Mishmar HaGvul" ("Border Police").

The bookcase didn't hold any books, but it sported a small blue-and-white flag next to a photo of a man dressed in the uniform of the Golani Brigade. The man is smiling and pointing his rifle directly at the camera. He had no idea that it would be the last photo he'd ever take.

From his bedroom window, he could see cherry and olive trees and, in the distance, southern Lebanon.

The smell of baking bread filled the air and he could hear the neighbors next door listening to "You're still on my mind, Mount Hawran."

The window was one of those silent statues, however, and all it could do was watch.

During recesses at school, he preferred to sit on his own. Being around certain people made him happy, but many of the kids at school mocked him for the things he said or the way he did things, so he found that he had more freedom to be himself when he was watching from a distance.

When you're alone, you don't have to justify your thoughts to anyone—you don't even have to share them. They emerge, and grow, and wither, and die all in the same place. Even if you're lucky not to have any enemies, just keep quiet so no one's ever able to hold you accountable.

A couple of soldiers patrolled the school yard dressed in faded green military uniforms that were stretched so tightly across their muscular bodies that the buttons nearly popped off. Heavy black objects known as weapons were strapped to their body. Every time a female student walked past, one of them would turn to the other and make a comment. It was usually about part of her body, which they'd describe, ravenously like a construction worker wolfing down a shawarma at the end of a long day before the man has even had a chance to finish the second one.

The kids at the school treated the soldiers like they were superheroes who'd just touched down from a hidden planet. With a single word, they could break up any fight or end recess early, but that wasn't what they were there for. When it was time, all the boys who had already turned 18 would gather for the training class they led once a week. They taught the boys about the various army units and gave them tips on how to apply to the most selective ones.

"How do you become the kind of heroic man who can seize authority as soon as he puts on a uniform?"

It was a question that was on the minds of many of the students. Training class was the only place where Saber could demonstrate his physical ability, to the two soldiers above all because he craved their approval.

"You're a man." That was all that Saber wanted to hear.

In Saber's section, nearly 60 students were organized into columns, each with its own particular specialization, based in all likelihood on their social class. They had no choice but to focus very closely because this was their future: mandatory conscription.

They sat there like a flock, motionless.

Meanwhile, the girls would be stuck back in their classrooms with their teachers or else they'd go for aimless walks on the school grounds talking about futures that always turned out differently.

* * *

Saber had been a very delicate child. He'd jump out of the way of any passing bug because he was afraid that he'd block its path or injure it somehow. He was especially fond of ants. At his grandfather's house there was a garden surrounded by trellises and Saber used to lie there on the pebbly ground beneath a verdant grapevine canopy and watch the ants disappearing into the earth only to crawl back up over the pebbles carrying bits of straw, which they hauled over to the happy straw pile. Saber was always taken aback when he saw a big group of ants walking single file as if a group of people are walking behind the casket of a friend whom they only began to respect after he died. It appeared that ants took anything they thought was of value with them every day.

Saber was never very talkative. He spoke very little and sometimes not at all. But he was an excellent listener and a careful observer. He eventually got good at impersonating many of the people he knew.

His grandfather, Sheikh Fares, was one of the elders in their village.

He was a pious old man with big, green eyes and a face that shone. He had a long white beard and he used to wear a striped tunic, with his keffiyeh tied around his waist, beneath a navy woolen cloak. He wore a turban, too, except when it got humid.

Sheikh Fares could be tenacious when it came to the truth and he earned a reputation for holding firm to his principles. He stayed away from the religious crowd because of their many opinions and disagreements and he even had his own particular way of praying. "What is between me and God is only between us," he liked to say.

But everything was different when Saber's grandfather Fares was a young man. Life back then was simple to the point of naivety on the one hand, and on the other, the only thing that mattered was sticking to one's principles. Perhaps it had just been one hand: naive resistance. Fighting against something wrong because of a sense of belonging. In the years that followed, Sheikh Fares saw things that left him unable to cope with our era of sell-outs and toadies, so he withdrew from society. He planted vegetables, mountain fruits, Syrian catnip, basil, sage, savory, and aloysia in his garden at home, where the air was always perfumed. He'd built the house by hand out of limestone back in the 1920s all by himself and it took him many years to finish it. He used to study each stone carefully before he placed it because he wanted to make certain that the house would be warm in the winter and cool in the summer, his refuge on towering Daydaba Hill, the tallest of the seven hills in far-north Palestine, which encompassed their village.

"Our village stretches over seven hills," the elders used to say. "Just like Rome." None of them had ever been to Rome, of course. It was just a four-letter word at the end of a hackneyed phrase.

As a child, Saber used to walk with his beloved grandfather to the shrine of Baha al-Din al-Muqtana, the fifth of five prophets in what the Druze call the "ranks." The prophets are ranked in order of prominence according to esoteric principles: Mind,

Soul, Word, Forerunner, Follower. He is known as "The Follower" and also as "Fine Wisdom."

The shrine is located on the top of Haydar Hill, another of the seven hills in the village, where you get a panoramic view that will take your breath away, squeeze your chest, and shame your eyes. You can see the Sea of Galilee on your left and the Mediterranean on your right and between them, you see mountains, streets, villages, olive orchards, and settlements.

Each time they went, Fares would sit and contemplate the beautiful landscape until one day, something looked different and over time he only found it uglier. The buildings in the settlements were all the same shape and color and they disrupted the view as though it was theirs. They weren't even the tallest buildings, but they seemed to have the biggest impact on the areas around them. Fares surveyed the landscape sorrowfully, noting the wide empty spaces that no longer belonged to his community. They were under the control of the Jewish National Fund, which was planning to turn the land into a park where no one was allowed to build so that the villages had no room to grow. Even when people did manage to build a house outside of the boundaries to live in, the demolition order always came in the end.

On a very cold day when the village was covered in snow, Saber had to travel to Tiberias to undergo physical, intellectual, and psychological testing for his military service. Postponing or canceling the appointment wasn't an option, but Saber wasn't looking for an excuse to get out of service. He was determined to follow in his father's footsteps. Nonetheless, he couldn't help feeling anxious and wary.

The soldier standing at the entrance was tall and fair with freckles that covered most of his face. "Goldstein" and a seven-digit number were engraved on the tag he wore around his neck.

He asked to see Saber's identity document, which was only a few months old, and as he flipped through it, he said, "Do you know Fady? He and I served together. He's seriously tough."

Saber shook his head. He wasn't the least bit curious about who this Fady was. Maybe the soldier thought they were related because of Saber's last name. Maybe he thought they knew each other from the village. Saber didn't care. He just wanted to get inside, get the tests over with as quickly as possible, and find out where he placed, which unit he'd be assigned to for the next three years.

He was worried about how he'd perform on the physical tests. He tried to tap into his inner confidence, which he'd been stoking for the past few months, working out in the garden at home and at the club every single day until his muscles began to show.

*　*　*

There was nothing prestigious about the body in the Druze faith because reincarantion is a central tenet. The only thing sacred is the soul, which moves

from body to body when one dies. Corpses have no value because our bodies are impermanent. Even death is transient to the Druze. You can see it in their funerals. They place the deceased in a plain wooden box and cover them with a white shroud.

They don't bury their dead in plots underneath stone slabs that preserve their names for all eternity. The human body is just a vessel for the soul, which appears at birth and departs for another body upon the moment of death. That's why the Druze are forbidden from visiting the dead.

* * *

"Today is a very important day, boys! It's Remembrance Day, Yom HaZikaron, so we're going to visit the cemetery like we do each year."

"We're going to hand out stickers for you to put on the right side of your shirts so that everyone can see our school insignia because all the schools are going to be there."

After all the students had affixed the sticker, which showed a red everlasting flower against a cloudy blue sky and the word "Remember" (*Yizkor*), to their shirts, Mr. Yusuf said, "We're going to walk up to the military cemetery so I want you to pair up and walk in a line. Don't bunch up because the roads are narrow and we don't want to cause a commotion."

Saber walked beside his classmate Ronin. They weren't friends, but the other kids excluded them both, and even bullied them at times, so they were always being put together during class activities and trips, which they couldn't get out of.

Piles of sand and dead plants lined the sides of the road up to the cemetery. Ronin reached into his backpack and took out a bag of onion-flavored Bamba,[2] which he opened and offered to Saber. "Do you want some?"

Saber took two and said, "I've got Bissli. We can share it."

"I brought a bunch of snacks for the trip," Ronin replied.

When the fifth class got to the cemetery, they found an open space full of graves and a lot of trash. Plastic bags, snack wrappers, empty bottles of soft drinks and beer.

The students spread out, some wandering, some playing, and their voices filled the air. "Kids!" The teacher shouted. "Come here right away! We're not here to visit. We're here to clean the cemetery," he said as he pulled out a roll of trash bags.

"Each group will take a bag and go clean a different section. The ceremony begins at 11 so we need to finish on time."

The boys started picking up trash in silence. They didn't even stop to look at the gravestones, which bore the names of Druze soldiers who'd died in Israel's wars. All of them except for Saber. He was wandering around the cemetery and it felt familiar to him like a maze he'd been through before. He knew where it started and where it ended and how to get between them. He knew how to zig-zag through the graves without even having to look on the way to where he wanted to go.

The trip to the cemetery meant something different to Saber.

He came to a stop in front of his father's grave. He stared at the gravestone: a name in Hebrew characters, date of death, and the war he died in. Saber stood there for a while after he finished picking up all the cigarette butts and biscuit wrappers in the vicinity. He was interrupted by the air raid siren. It was 11 a.m. The moment when everyone stops what they're doing and stands still, whether they're at work or doing housework, driving or crossing the road. Two minutes of mourning the souls of those killed in wars or skirmishes or just another day in the service. The earth has room for them, but only beneath the ground. Room for them only when they're dead.

* * *

The sound of the siren and the guard shouting woke Saber up.

Saber was spending Remembrance Day in prison for the first time. All the prisoners were expected to come out of their cells for a minute of silence. Saber had refused to go out, refused even to stand up, so that was why there was shouting. "I'm telling you you're just making it worse for yourself," the guard said. "They're going to give you more time."

"It doesn't matter," Saber responded before running back to bed. He threw himself onto his back with a thud. He stared up at the ceiling and smiled pensively. He thought about all the other Remembrance Days and how different this one was. Last year, he'd been sitting on a street corner watching groups of people climbing up to the military cemetery in the morning and in the evening, watching cars pass by flying Israeli flags as Independence Day began.

Abu Ziyad was the last communist left in the village. He was an energetic carpenter who'd spent his whole life working out of a workshop in the center of the village. As he grew older, the workshop became a storeroom where he refurbished old furniture for sale.

He didn't have many visitors, and when they did pass by, it was for a quick coffee, not to view his valuable pieces.

Abu Ziyad was irascible, and sometimes he'd lose his temper. They used to call him "Short-Fuse" because it was easy to set him off, putting an end to any conversation before it had hardly begun.

His short fuse and the passage of time had left Abu Ziyad friendless.

In the 1970s when he was a young man, Abu Ziyad headed up a secret office of the Israeli Communist Party, but some of the villagers who were clearly unbothered, but willing to collaborate with the Zionist movement, were unhappy about the secret office, so they attacked it multiple times. They even firebombed it once.

Saber used to visit Abu Ziyad's shop from time to time, especially before he went to prison.

"I don't have the energy to get along with anyone any more, Saber. I don't have the energy to fix anything. I fix furniture now. I can see the results of my work at the end of the day. I couldn't fix how the reactionaries think. God couldn't if he tried."

171

* * *

A cold draft penetrated the cell, making Saber shiver and toss in bed. He pulled his knees up to his chest and closed his eyes as he tried to remember more details from the Remembrance Day ceremony.

> In the Name of God, the Most Merciful and the Most Compassionate
> Praise be to God, Lord of the Worlds
> The Most Merciful, the Most Compassionate
> Master of the Day of Judgment
> We worship You and seek Your assistance
> Guide us on the Straight Path
> The Path of those whom You favor
> Not those with whom You are displeased
> Nor those who go astray
> Ameen

> May God have mercy on all martyrs and may He keep you.

As he finished reciting the prayer and blessing, the sheikh found himself standing in the middle of a crowd that included men, sheikhs, women, officers, soldiers, girls, and boys. The crowd may have been exceptional that day, but the location was conventional for Remembrance Day. The sheikh was usually followed by some Israeli, a different one each time, giving the same exact speech. He'd mention how many Druze had died and how important their deaths were, how important the blood bond was between the Druze and the Jewish state. Then the soldiers fire shots into the air and the ceremony closes with the Israeli national anthem, which ends on the line, "To be a free nation in our own land, the land of Zion and Jerusalem."

* * *

> Throw the towel, Throw the towel
> If you signed up for the army,
> Throw the towel.
> His mother's a whore
> His mother's a whore
> If you signed up for the army,
> Your mother's a whore.

"We used to sing that song at weddings," Abu Ziyad told him. "All the old people say that the sheikhs signed our fate. You know how much our community likes to follow anyone who claims to be representing the faith. They're complete fools. In fact, it was just one sheikh who sold us out. Jabr Muadi. He was from Yirka. He was worse than ISIS."

"He collaborated with the Zionists from the very beginning and he made a lot of money from it. All for himself. He didn't spend a cent on the community, the greedy bastard."

"When they imposed conscription on us in '56, the whole community rose up against him. We marched and signed petitions, but nothing came of it. Do you know how many of our young men escaped into the wilderness so they wouldn't have to serve?"

"The government is smart, though. It's run by pimps! They saw that we were a bunch of poor peasants, so they seized our land and told us to make the best of it."

"How long are we supposed to fight for? We had nothing to eat. They let us have one, only one, way to make a living and people need to eat. Fuck people, if you ask me."

"I can't believe how all these young men have turned into monsters. Monsters that carry out orders without even thinking. Robots."

"They tell them, 'Go! Kill!' and they go and kill. They tell them, 'Go! Arrest!' and that's what they do. They're sheep. All they know how to say is, 'The sheikh told me …. The commander told me ….'"

Saber sighed and muttered for a few minutes as though he were talking to someone inside his own shirt. Then he shouted: "I can't! I can't! I can't!"

"So just leave," Abu Ziyad said, smiling.

"Leave? You think it's that easy? It's always easier to get in than get out, and this is hell. You don't get out of hell. Have you heard of anyone getting out of hell? Do you know my family? I'm alone in hell. They all want me to be like my father. You know what happened to him? He died."

"I can't even remember him spending any time with us because he was away the entire week. He gave the army all his time. He gave his life to the army! He used to only come back to the village when someone died or got married. You could say I haven't had a dad my entire life. I lost him way before he died."

"None of them have ever asked me what I want to be. They all think that of course I should follow in his footsteps. It made me happy at first, but I was foolish. I always wanted to be the man they wanted me to be, but after I got drafted, I stopped wanting to be that man."

"Do you smoke?" Abu Ziyad asked, interrupting Saber's tirade. "Have a cigarette. Trust me. People say it's too strong, is that true? Take one. Clear your head. This is fresh stuff," he said laughing.

Saber sat down on a drooping wooden chair and took a cigarette from Abu Ziyad. He lit it, excited for a novel sensation, and took a drag. "Is this hashish?"

"I told you it's funky Arab tobacco. It's fresh."

"You're a star, Abu z-Zuz. Now we can actually talk."

"What do you mean 'now,' you prick?"

* * *

Saber leaned on the wall of his cell, shivering from the cold, thinking how much he missed Abu Ziyad. He'd felt so victorious when he'd gone to prison, knowing that Abu Ziyad was a big part of that. Prison is better than hell—prayer is better than sleep (as the supplication goes)—that's all there is to it.

"I don't know what to say, pal. I don't know if I have the energy to say anything. Our bodies eat us from the inside and they play with our minds. They seize our passions and our desires. They pull us away from anyone we have any connection to so that we're left depressed and solitary. We don't know where we've come from. We don't know how to survive."

"Do you think we can carry on?"

NOTE

1. In 1976, the Israeli state separated the curricula and dedicated a special educational program for Druze schools, which included the subject "Druze heritage." This played a major role in reshaping the new identity aligned with Zionism.
2. Bamba and Bissli are popular Israeli snacks.

16
The Theater of Life and Death*
Radi Shehadeh

Our village, al-Maghar, rests like a lion at the foot of Hazur Hill in the Upper Galilee. There the lake shore is ringed with mature Tyrian olive trees, some of which are 3,000 years old. Ours is a mixed village, with Christian, Muslim, and Druze residents, so we have a church, a mosque, and a Druze prayer-house (*khalwa*). We have no national holiday in common. Each religious community has its own place of worship, holidays, neighborhood, and even its own cemetery. Even within a single religious community, there can sometimes be differences of ritual and customs. I was born there, and it's where I disciplined my character to the extent possible. It's also where I established my first theater group in 1973, The Village Theater. At the time, I was still a student at the Hebrew University in Jerusalem, studying theater, Arabic, and pedagogy, so I had to find time for my studies in the midst of all the activities we were engaged in at the theater.

The village had never had a theater before. The ideas struck people as strange, even a little bit crazy, because the community is conservative and people weren't used to the idea of young men and women rehearsing and performing together.

The village has a lot of large public buildings where people can pray, but very few places devoted to culture, performance, or education, and the bigger the crowd, the more influence an institution has. The main hall in the church can hold up to 1,000 worshippers, while the smaller, lower hall that we were allowed to use for our productions has a maximum capacity of 150 people. The worshippers in the main hall are all Christians, and thus belong to the same community, but our theater group drew its members from all the village's religious communities and neighborhoods.

The largest gatherings in which all the different communities in our village take part are the funerals. Yet while death is our common destiny, we don't have a cemetery in common. The largest gatherings in which the different communities remain separate are religious services. The village's places of worship fill with large crowds, but these are sectarian groups by definition. Each community has its own place of worship to gather at, its own way of praying. These shared rituals knit them together more closely than the theater does. The khalwa, mosque, and church are not open to all. They're to serve their own respective communities by separating them from everyone else.

* Translated from the Arabic by Adam Talib.

Schools represent the largest intercommunal gatherings that people have to take part in, because education is compulsory. Schools also provide a big audience for our performances. Overall, I think it's a good thing because there's a captive audience and because our performances may help to create a theater-going public over time. A public made up of young people from across the village's different communities. It's worth noting, however, that the schools promote a curriculum and ethos decided by the Israeli authorities.

"We hail from the same land, the same village, the same people!" Is a slogan enough to prove that we have embraced unity, mutual respect, and camaraderie? Does living in the same village mean that we share a single identity? A unified nationalism? Does the way we act at home or at school or in our daily routines support our values? Or do many focus on their new identities instead—the ones listed in blue ink on white paper under the heading: "religion, sect, political party."

Over time, having become citizens with both rights and responsibilities, the state has imposed its discipline on us in order to Israelize us and marginalize our Palestinian identity or cause us to forget it. By force-feeding us this disciplinary curriculum from the moment we were children, the state has created a segment of the population who are Israelized or who are happy with their new identity as long as they get to maintain their religious identity as well as, to a lesser extent, their Arab identity detached from any sense of being Palestinian. That being said, I still believe that no matter how many times they try to eliminate our core identity, they'll fail.

Citizens of the same country come together and cross communal barriers, but it does take time. We don't claim that our theater group can produce radical, sudden, and quick changes, but it may contribute alongside other factors to slow and gradual progress, to an expansion of people's cultural and aesthetic horizons, and to the creation of a sense of unity among different people. In addition to providing excellent entertainment, in a way that no other artform can. The more important question is: Can theater be a more powerful vehicle than these other agendas, whose substantial advantages in the form of deep pockets and networks, give them an outsized impact? Can theater reinforce our identity by dramatizing issues in Palestinian life in both form and content?

Have things changed since our village became a city? Are cities actually different somehow? Each community had its own neighborhood and its own practices—all practices other than theater, that is. My friend Sobhi Damuni, who's from Nazareth, told me that the largest problem he faced in the 1960s and 1970s was trying to recruit enough women to act in his plays. He was astonished to hear that around the same time I'd managed to assemble a cast of young men and women for a production of the play *The Old House* by the Egyptian playwright Mahmoud Diab. How had it been possible when mixing between young men and women within a single religious community—let alone mixing between members of different religious communities—was looked askance at, was a taboo even?

There were no plays in our village before the mid-1970s—except, of course, for the noble efforts of theater-loving teachers who directed community theater starring school kids, rather than theater that was expressly political or nationalistic. There were also a few roving theater troupes in the region who visited sporadically, but they likewise mostly performed for schools. Only a very small number of their performances were ever open to the public because it has never been easy to mount an artform like theater under occupation and decades of military rule.

We've never had the luxury of developing our theater practice as it was done, or is being done, in countries that have succeeded in their self-determination and enjoy sovereignty. Countries that have developed industrially, agriculturally, technically, militarily, and technologically, while our village, like the rest of our country, has suffered 400 years of Turkish occupation followed by three decades of British occupation, and we still haven't won our independence and autonomy because the world recognized Israel as a state on our historical homeland. We were under Israeli military rule until 1966. How are you supposed to experiment with theater under oppressive occupation? Should we continue to call it an occupation, or has it become a new status quo that we have to face head-on whether we like it or not? Should we embrace our Israelization at the expense of our Palestinian-ness?

This was at a time when people were feeling socially minded and young people especially were vibrant, so some friends and I set up a cultural club in the village that we called The Village Club. There was always something happening: panel discussions, talks, film screenings, locally produced plays, and we had a library, too. The club launched in 1973 and that was the same year that we founded The Village Theater.

We were very fortunate that the church, and its flock, was led by an open-minded and educated theologian called Father Khoury.[1] He told us that he hoped that we'd stage our plays in the lower church hall where the chancel was located—that is, a place of worship, a place where people went every Sunday to offer their prayers.

The village was up in arms, and it wasn't just the Christian community either. Father Khoury was worried that rather than focusing on social and spiritual improvement and education, the issue would devolve a clash of two perspectives: one that saw the church as a holy place that should promote worship, belief, modesty, and chastity, and another which saw it as an institution that should contribute to people's happiness and their spiritual and artistic education through socially engaged, highbrow plays performed by men and women on equal terms.

The project failed, unfortunately—that is, the project of converting the church hall and chancel into a theater stage. I knew that it would. It would have failed at the mosque and khalwa, too. Though it was a question if they'd even consider it because their list of prohibitions was as long as the church's.

The cultural club, which was located on the first floor beneath the church hall in the library space—a stronghold of freedom of creativity and speech—proceeded with extreme caution, especially with regard to anything resembling acting or

theater. Libraries are safer, because people form a relationship with a book, whereas in theater people form relationships with one another. Theater is collective, performative, and charged. People come face-to-face with performers. It's a place where emotional and intellectual currents collide. It was also a new form of entertainment in a village, where the routine gatherings in places of worship had become boring and repetitive because they'd been using the same texts for hundreds of years.

It was a risk, but it was also an instant success. The audience, our parents, relatives, friends, everyone supported us. We decided to cast our first play, *The Old House*, in the village, too. We spent a lot of time adapting the play to suit our variety of Arabic and the setting of our village, but it was a good choice because it dramatizes the transition from an agricultural society to an industrial one.

We had no shortage of enthusiastic amateurs to draw on. We had more than we needed, to be frank. My sister, my cousin, my fiancee, a friend's sister, and some other friends and their relatives all came out for casting and joined The Village Theater family.

Our first audience, the people who embraced us and protected us, were the people of the village, our parents, relatives, friends, and neighbors. Then the theater virus spread to neighboring villages and cities, where we put on some modest performances of plays that I wrote and directed, like *Broken Ceiling*, *I'm the Teacher*, and *Cinderella*, in addition to *The Old House*, of course. The most daring play we performed at the time was *Peace Lost*, a play I wrote, directed, and acted in. It was sentenced to death by the Israeli censors, and the sentence was affirmed by the Israeli High Court. Its heart was snuffed out after just three shows. Three shows after more than a year of rehearsals and production. It was a political play, which the Israeli judiciary, police, and officials considered an incitement against the state because the villain in the play is a stand-in for Israel, although the name Israel is never mentioned once in the play.

We worked because we were enthusiastic and we believed in our cause, but we understood that it was risky. We persisted though we didn't know where that persistence would take us. The experience itself took our minds off of the risks. Our youthful enthusiasm blinded us to the obstacles we faced. On the other hand, the risks and the obstacles had made us more determined. We wanted things to change, and we wanted to rebel against the conservative status quo in the village. We were especially keen on getting the other half of society on stage. Egyptian movies had taught us that actresses could only be a male actor's love interest and that they might be expected to kiss, embrace, flirt, dance, remove clothing, etc. That was how people felt about actresses at the time. It wasn't like the male actors got more encouragement, however. People are always warning you that this profession isn't stable. Being a lawyer, teacher, doctor, or businessman is a much more dignified choice. In our society, theater is both unfamiliar and undesirable, and it isn't going to pay the bills.

We had to go looking for women to act in our first play, *The Old House*, but how were we supposed to recruit women when their families had all these negative preconceptions about acting? Theater isn't a day-to-day need, one that people are on the lookout for like bread and others of life's necessities. It only got harder if we needed to recruit girls from the village to participate in order to fulfill the need for theater.

We were proposing something revolutionary, but it was a peaceful revolution, not a bloody one, and at the end of the day, we were doing it for our families, our village, and our nation. The cast and crew were made up of amateurs from the village, who formed a kind of pseudo-family, and there was an equal number of men and women. Members came from every sect and neighborhood. Our only criterion was enthusiasm. We didn't assess people's abilities. It simply wouldn't have been possible in a region such as ours where there were no trained actors. We didn't have the luxury of auditioning people. If they were excited about the experience, we gave them a seat at the theatrical banquet.

Sobhi Damuni told us he envied us when he came to give us directorial notes during our rehearsals. He said that he'd never be able to recruit as many female actors for his productions in Nazareth. "How did you get all these girls from the conservative village to turn out?" He also donated makeup to the theater troupe and taught us how to apply makeup that would bring our characters to life.

The story of our theater didn't go as the village had hoped, however. It's true that we were able to use the cultural club space for the first few rehearsals of our play *The Old House*, but it wasn't very easy. We shut the door on ourselves and told everyone that we couldn't be disturbed while we were working. This provoked the curiosity of some of the club's neighbors, who started spreading rumors about the immoral things that took place when young men and women got together behind closed doors. They stopped just short of accusing us of running a brothel. Things reached a peak when one of the neighbors broke through the door during a rehearsal and shouted insults at us. She pounced on the scripts of *The Old House* and tore them to shreds. Another neighbor took heart when he heard someone denouncing the "brothel" at full volume. He thought it was the perfect opportunity to put an end to things, so he got his pistol and started shooting into the air. He said he'd shoot us if we didn't quit. And if we failed to die, he'd call the police on us.

There were plenty of good people in the village, too, of course, who defended us and encouraged us to persevere. So we did. Our opponents retreated when they realized that the theater troupe was made up of their own relatives and friends, and that was what gave us the idea to impose our own conditions on the village in the next phase. I guess the bullets that don't kill you do make you stronger.

We informed the audience that the play's opening night and subsequent performances were exclusively for families and couples. No men were allowed to attend unless they were in the company of their sisters, wives, mothers, fiancees, grandmothers, neighbors, daughters, granddaughters, etc. and that was exactly what

happened. The composition of the audience at all the performances reflected our total society, not just half of it, and it also included people from every neighborhood and class, so it was a positive step for change.

The opening night of *The Old House* was a celebration for the whole village who were gathered together in that hall as though all one family. I can't describe to you now, 50 years later, the incredible energy and emotion that bounced back and forth between the audience and the performers. But I can tell you that the violin, played by Fouad al-Nimr, was lachrymose and heartbreaking. It was the era of melodrama, and I was highly influenced by the trend at the time, so I gave Fouad a note, which he considered to be the most important note of the whole play.

"Break their hearts, Fouad. Darken your violin and make them cry as hard as you possibly can. Their tears are the best proof that the play is poignant and humane. That it evokes catharsis in the viewer-listeners (*mushami'in*).[2] Then we'll know that we've captured their hearts and enchanted them. It will be a visible sign of our success. That's how we'll know that applause and ovations await us!"

When the amateur actor Suhayl al-Naeem's mother saw her son on stage, her reaction was a wonderful spark of emotion and surprise. Suhayl hadn't even turned 20, but he was playing the part of an old man, so he had to transform himself entirely, using the makeup donated by Sobhi Damuni. His mother didn't recognize him at first, so she was shocked when she finally did. She laughed out loud and shouted that there was no way that the old man was her young son. He hadn't aged more than his own mother overnight!

These anecdotes about our production of *The Old House* exemplify the innocence, immediacy, and ease of the audience's relationship to the performers. Our audience is hungry for any work of art that speaks to their lives, any work of art that commands their attention, entertains them, and dramatizes the social and political issues that they care about. But, even more important than that, the artwork has to bring us all together under a single roof as a village community, not as distinct sects.

We were just family to the audience back then. We'd gone from being motivated amateurs who'd been inspired by the shows they'd seen to performers and actors, even though we weren't professionals, and the viewer-listeners were our neighbors.

DEATH IS MIGHTIER THAN TABOO

We wondered whether we'd have had an easier time if we put on plays for children— all the children in the village, from every sect and class— instead of *The Old House*, and an even easier time if we replaced all the actors with puppets. Perhaps the puppets would have even more freedom to use their bodies than human actors. The puppets get to appear confident and daring in front of the conservative audience, while the human actor controlling them hides behind the curtains as though they're sheepish.

After our adventure with *The Old House*, we put on shows of our puppet play *Yoya* in the same performance space for audiences made up of children from the village.[3] It was a big village before it became a city, but it didn't have any theaters; it barely had any theater-sized venues, for that matter. We had to search for a suitable venue for the new puppet play that we could make totally dark, because the performances were scheduled to take place during the day. The colorful lights we hoped would stir the children's imaginations would only work if the venue could be made totally dark. Once again, the space where we performed *The Old House* rescued us.

We'd scouted shelters, corridors, classrooms, laboratories, but we discovered that there was a shortage of rooms in the village, so even these places had been converted to classrooms, libraries, stockrooms, and offices. The acoustics in the sports halls wouldn't work for theatrical performances because they were designed to echo the fans' cheering—precisely the opposite of what we were looking for.

The only place that would work for our production was the place we'd started out in, the lower church hall, which was also used for visitations when one of the congregation passed away. Father Khoury came across as incredibly generous when he agreed to let us use the space because he knew how badly children in the village needed entertainment, but it came with what sounded like an impossible condition.

"I genuinely hope that no one from the Christian quarter dies during the run of your play because you'd have to clear out of the lower hall since it's the only place we have where people can visit the dead before they're buried."

I begged him, speaking to him as though he were the closest to God out of all of us: "I'm begging you to pray for us, Father. Ask God to postpone everyone's death until after the performance. It's a win–win. The dying get one more day, and the children get to see a puppet show."

We didn't pray for anyone to die before the performance because we didn't want to shorten anyone's life, but that's all up to God anyway, and He doesn't make exemptions for performers either.

On the first day, the performances went well and the children had a good time. Their singing, enthusiasm, and laughter were all clear evidence that they'd bested death that day. We thanked Father Khoury for his prayers postponing death on behalf of the living, and we implored him to keep it up so that we could perform for the rest of the village children the following day, but the unforeseeable happened. Just as the children, who'd been looking forward to seeing a play for the first time in their lives, arrived for the performance, we heard the death knell, and we knew that the shows that day would have to be canceled. The female mourners would soon fill the lower church hall, so we took down our set and equipment and cleared out.

"I worry you forgot to pray that no one would die during the second day of performances," I told the priest. "The show's canceled, as you can see, and I think the deceased deserved some more time. You could have prayed harder."

"I swear I asked God to defer death until the run of your play was over, but I guess He doesn't decide when to end our lives according to our wishes and prayers."

When we founded The Village Club in 1973, Father Khoury gave us his full backing because he understood the important role that theater could play in our community.

"If it were up to me and I didn't have to worry about what the congregation would say, I'd have transformed the prayer hall itself into a theater. A place of performance and prayer. I would have gone farther than giving you the lower church hall, which you share with the dead. We could have saluted the dead with prayers and plays."

Did the children understand why we had to cancel the performance that day? Did they realize that death had laid claim to their celebration? Will they hate the grim reaper because he got in the way of their enjoyment? Will they cling to life more closely as a result? Can prayers postpone death's arrival, or is it simply ineluctable and undeniable?

COMMUNING WITH THE ANCESTORS

All we wanted was to produce art and bring joy to our neighbors, but our insane adventure was always running up against obstacles which seemed nearly insurmountable. We'd taken on social, political, and religious taboos, but how were we going to take on death?

With time, we spread beyond our conservative village, which was only beginning to open up to the outside world very gradually. Fifty years later, I think it's fair to say that we didn't realize that our plays represented a revolution against the status quo.

Things got better. More and more educated men and women settled in the village, and acting soon became unremarkable. There was nothing scandalous about having equal numbers of men and women on stage.

Did those changes come about because our village became a city? Because they built a center for the elderly in the village where we could perform our plays without having to get the approval of the church, mosque, or khalwa?

The older residents of the village, who embodied the optimism our village was known for, had followed our campaign and encouraged us, their grandchildren, to persevere. They were especially encouraging of our play *Zarif*, which we performed for them and their grandchildren. Those performances made me want to write a play about aging, which I will complete one day before dementia gets hold of me.

Abu Jabr, the man who ran the center for the elderly, didn't seem very pleased as he watched us turning his place into a theater. We stacked all the chairs and tables up along the side, spread mats out on the ground, and hung black-out curtains over the windows. We needed the curtains so that we could use colored lights to maximum effect during the performance, but the darkness in particular seemed to irritate Abu Jabr.

When the elderly turned up at the center, an unhappy Abu Jabr had to turn them away because he'd agreed to turn the space over for children's performances for two days.

Where are the elderly supposed to go?" He asked angrily. "I agreed to let you use the space for the children's shows, but I didn't want to stop the older people from coming to their second home. The center is their home."

I placated him so that he wouldn't eject us from the center like death had ejected us from the church. "God will take note of what you're doing, Abu Jabr. You're bringing joy to your grandkids through the center."

The sound engineer started a track that featured the *arghul*, a double-reed pipe, which we were using for the play *Zarif*, and it stirred the elderly who hadn't been allowed into the center that day, so they stormed in. The arghul had reminded them of the good old days. They started dancing in a line and swaying, twirling their canes in the air, and would have continued if one of the elderly hadn't said to me, "Kill the music, son. This is supposed to be a show for kids, not the elderly."

The children were about to arrive, so the sound engineer turned off the music and Abu Jabr had to ask his friends to leave for the second time that day. "Let's just get through today," he said. Then he started singing, improvising the tune and lyrics on the spot:

The grandkids are coming today
God grant them long lives
Everybody's grandkids
Regardless of their tribe.

Like rushing water, the children poured into the center and filled every available space as the elderly made way for them. Just like life. One group heads toward death as another rushes in to fill their space. Have we enabled a new generation to take their rightful place?

THE THEATER RITUAL AND THE PRAYER RITUAL: A TALE OF FRIENDSHIP AND FREEDOM

Our elderly friends kindly let us use their small center for our rehearsals, but it wasn't big enough for our newly expanded troupe, so our best option was to return to the place where we'd started out, the church hall.

Our return enabled me to get to know one of the nuns at the church, whom I'd never met. I was introduced to her by a friend, who must have known her for a while because they joked at liberty, although I didn't realize it at first. When he grabbed my hand and held it out to her, he said, "This is the atheist friend I was telling you about, Sister," and I thought he was being serious!

He laughed, so I laughed, too, but men's jokes contain truth, so I ignored the accusation and attempted to extricate myself from a charged debate. I hardly knew the nun, and I had no idea why my friend had chosen to introduce me to her in that provocative way, so it took a moment for my nerves to settle.

"Ma soeur is thinking about producing a play about Christ's life," my friend explained, "and she wanted to discuss it with you. Now you've been introduced so you can talk things out. I think you're the best person to write and direct the play, but I just wanted to know whether you're actually an atheist."

I got even more embarrassed, which only made him laugh more and prolong his prank. When I finally mustered up the courage to look at the nun, I found her placid and at ease.

"What does 'atheist' mean, ma soeur?" I asked the nun.

"An atheist is someone who doesn't believe in mankind," she stated confidently.

I relaxed when I heard her eloquent and economical answer; a change from the usual, "an atheist is someone who doesn't believe in God." According to her definition, I wasn't an atheist. I was more like a fervent believer. Even my dramatic practice came out of my deep belief in mankind and humanity. The first question-and-answer brought us together, and it occurred to me that we could create something very humane together, the two of us, precisely because we were so different. She was a very religious person, whereas I didn't practice religion the way the books would have it. I found my religion in daily life, the things I saw around me, and the things I read in books written by other humans.

I started to have doubts when she started speaking, however. She said that my friend had told her that I wasn't religious—a step down from atheist—someone who had their own way of believing in God. "Some religious people practice and some don't," I said.

I continued: "We have to search for all the things that we can agree on. If we're on the same page, I don't think our differences of opinion will affect anyone's belief. I think we'll find that we have a lot, a whole lot, in common. We don't have to bring up the things we disagree about because that won't get us anywhere. We can spell it all out for each other so that the final product matches what we agreed on exactly. The artwork will speak to the issues we both care about, you a practicing believer and me a non-practicing one. After all, we can take your definition as our starting point. To believe is to believe in humanity."

There was no question that we had to spell out our vision for a new work about Jesus's life, but the nun's erudition and point of view made me feel that we'd find we had plenty in common. ·

"I think that people who don't believe in humanity are demonic heretics. We don't need to go looking for God in space. That's a pointless endeavor. We can find God by observing human beings and looking into their hearts," she said.

"Not just their hearts, but their brains, too, of course," I said in an attempt to inject science into the conversation. "This is striking. In our theater practice, which we are committed to because our deep faith in humanity, we aim to promote the audience's aesthetic appreciation, knowledge, awareness, and imagination. We want people to become more humane and more beautiful versions of themselves. As their mind reaches a new plane, they grow nearer to God and more beautiful, because God is

beautiful and beauty-loving. If that's how we both understand religious belief, then there's nothing separating us."

"We can meet to discuss the play, then."

"I'm looking forward to discussing the play with you more and to pinning down our shared vision so it becomes a reality."

I was surprised to find the nun and Father Khoury had both offered the same suggestion: a play about Jesus's life. Was it a coincidence, or had they discussed the idea already? Father Khoury led the congregation, but he wasn't from our village originally, so I assumed that he'd proposed the idea to the nun, but maybe the coincidence was a product of their shared faith, not a conversation.

Each time I met with the nun, between rehearsals for our new play, I learned more, and I was planning to start work on the play about our Nazarene neighbor, Jesus Christ, as soon as the run was over. When the rehearsals were over and we were about to start performing the new play, I went to see the nun to invite her to the opening night show. She received the invitation warmly. "Thank you. Break a leg! I'm excited for our new play about the life of Jesus Christ. Have you been inspired to start writing any scenes yet?"

"Yes, actually. I had a great idea that will help me start work on the dramatic poem I hope to write."

"A dramatic poem? What a lovely way of describing it."

PREPARATIONS FOR THE PLAY *THE SUICIDAL PIGS*

"The play has to have a philosophical message," I told her. "It has to speak to the meaning of existence, the meaning of life and death. There's so much to draw on from the Psalms and the New Testament, Chinese wisdom texts, the works of Khalil Gibran, inspired poems, philosophical texts throughout history, church hymns. Things we can incorporate, adapt, juxtapose, etc. as we create this new body."

"These ideas are somewhat vague, though. Is there any particular parable or scene that you've considered including in the play?"

"Indeed I have! The new play will have actors, but it will also have masks, puppets, singing, music, and a choir. There's a scene in the bible that captured my attention. Jesus encounters a man who's possessed by a demon, and when he asks the man his name, he responds, 'Legion.' 'Is that a name?' Jesus responds. The man explains that it's a nickname, because he feels that demons have taken root in his body and they produce cacophonous noises like a choir. Jesus blesses the man to drive the demons out, and when they emerge, they take the form of pigs. Terrified, the pigs rush into the Sea of Galilee, where they sink and disappear, and everyone assumes that the panicked pigs have ended their lives. That was how Legion was cured. But the area around the lake is still full of pigs to this day. They make their homes in the reeds by the lake, presenting an ideal hunting ground for pig-hunters. Legion's pigs knew how to dive, and swim, and deceive, I guess! They didn't kill themselves after all.

Having left Legion's body, they produced a line that survives into the present and continues to make ugly, terrifying noises. We might want to use a discordant piece of music to accompany that part of the play, to symbolize the demons escaping from the performers and artists' bodies, in order to purify our souls and entertain us."

Perhaps that scene would impel us, too, to let loose our own demons of creative genius. What can we do other than translate our cares into an exuberant and vivacious performance? Perhaps our journey in search of the divine Nazarene, who is nearest to God in His glory, would help us get there.

NOTES

1. Christians use the title "father" when addressing priests and the title "sister" when addressing nuns.
2. In the original text, this word is a neologism, *mushāmi'īn*, which the author explains in a note: "The word *mushāmi'īn* is a combination of the words mushāhidīn (viewers) and sāmi'īn (listeners) of my own coinage."
3. "*Yoya*" is the name of a Palestinian folk song.

17

The Circassians of Kafr Kama:*
Beautiful Homeland Gives Way
to Traumatic Dispersal

Hawa Batwash

When the morning sun rises, giving birth to a new day, the village stretches its limbs and yawns. The old lanes around the mosque begin to stir, as do the neat, paved streets. The light reflects in the windows of the old houses, all in a row, their inhabitants protected by tall black basalt walls. The city's narrow lanes ascend and descend, and the main street is lined with shops on either side, capped off by a mosque. Nothing makes a sound. There is only silence, wind blowing through the leaves and flowers, which have bloomed to greet the sunlight. The village stretches out all the way to the outskirts, where the modern two-story brick houses perk up alongside their productive and beautiful gardens, flashy cars, motorcycles, and electric carts. You would be surprised to see how much the residents appreciate cleanliness and order. If you head west out of the village past fields of wheat, barley, almonds, and olives with Mount Tabor looming in the distance, you'll come to the spring of Kazan, which used to be a watering hole, but is now a tourist attraction. Closer to the village are the remains of a caravanserai or *khan*.

The village awakens to the blazing sun, which shines on the houses where visitors are greeted in both Circassian and Hebrew. This is the village of Kafr Kama, a modest village in the Lower Galilee which you won't read about in the news. You might not even find a trace of it in books of history and geography. Many people don't even know it exists. Sometimes when people ask me, "Where are you from?", I tell them, "Kafr Kama," and they respond, "You mean Kafr Kanna?" I've had to explain the difference between the letters "m" and "n" countless times! That being said, the two villages have a warm relationship, but I'll get to that later. The village was founded in 1878 by Circassians who had been expelled from their homeland of Adygea in the northwest Caucasus on the shores of the Black Sea after a brutal war against Imperial Russia that lasted 100 years. The Imperial Russian Army won by using inhuman tactics such as burning villages, starvation, and genocide. After occupying the Caucasus, the Russians expelled the surviving Circassians to the lands of the Ottoman Empire, which had agreed to take them in. They were expelled from their

* Translated from the Arabic by Adam Talib.

Caucasian homeland, which is described beautifully in the 1931 poem "Adygea" by the Circassian historian and writer Aytek Namitok. Namitok wrote the poem in Paris, but it was brought by Amin Samkugh to the Golan Heights, where children like me sang it in school, full of longing for a country we'd never seen:

> Our land of Adygea
> Is the earth's most ancient
> No other surpasses it in beauty
> Our noble sons shine as brightly
> As the white peaks.

The well-known refrain follows:

> Adygea
> O glorious country
> Do not forsake us
> O beautiful mother

"We were forsaken, though," the teacher mumbled under her breath, unaware that we could hear her. That was shortly before the resumption of travel to Russia in the 1990s, when people re-established connections to the homeland, which we call Kavkaz and others call Kaukaz or Caucasus. That is how we imagine our longed-for Caucasus, a beautiful mother and paradise on earth:

> Forests as wide as the sea
> Pure rivers water the land
> Where orchards blossom
> And age withers none

In Circassian mythology, it is believed that God invited all the peoples of the earth to a meeting after the creation in order to assign them each a territory. Everyone showed up except for the Circassians, who arrived after all the land had already been divided up. "Don't we deserve a homeland?", they asked God.

"Where were you when I summoned all the peoples of the earth?", God asked.

"We were working in the fields so we didn't hear Your summons."

This excuse persuaded God, who decided to favor the Circassians. "Because you're a hard-working people, I'm going to give you the territory that I created for myself. The Caucasus, the most beautiful place on earth."

That is how the Caucasus, a crossing point for peoples migrating between east and west, became the Circassian homeland, where they established a civilization that lasted for thousands of years before it was brought to an end through brutal massacres of men, women, children, and the elderly, the burning and destruction

of countless villages, and forced displacement. The trauma of the genocide continues to weigh on the memories and souls of Circassians to this day. How could it not? They were driven from their homes and their historical homeland, and many people died from cold, starvation, drowning, and disease. Circassian corpses continued to be washed ashore by the Black Sea for years after the genocide.

One among many stories of forced displacement is the story my grandfather used to tell about his grandmother, a very beautiful young woman called Panya. She, her grandfather, and her younger brother were very lucky to survive the genocide, and they made it to the shore of the Black Sea, where they boarded a Turkish ship headed for Romania, an Ottoman province at the time. The passengers onboard were made up of the elderly, women, and children. The despicable captain took a liking to beautiful, young Panya, so he took her prisoner and demanded that she marry him, but her grandfather refused. That made the captain irate, and he threatened to throw them all overboard if they resisted. Running out of options, Panya's grandfather conceded to the captain's demand and promised that he'd marry the girl to him as soon as they reached land. He never intended to marry his granddaughter to that scofflaw, so as soon as they made it to shore, they rescued Panya, returning her to her family. As she'd been held captive by a stranger, the family felt they had to marry her off as quickly as possible before people began to spread rumors. They married her to a man called Batwash, but Panya, who'd been passive throughout, decided that she wouldn't be married in such an insulting way and refused to meet her new husband. On the day of her wedding, she leapt over the wall of their house and took shelter with another family, which caused a huge tumult. The village elders had to get involved, as they ordinarily did, mediating between the conflicting parties.

At first, they tried to persuade Panya to go along with the marriage, but they didn't get anywhere, so they suggested to Batwash that he move on, but that was also a non-starter. They finally reached an agreement that allowed Panya to remain with her new hosts for three months, during which she'd allow the groom to visit so that they could get to know each other. If he couldn't win her heart in three months, then she'd be entitled to a divorce. Batwash called on his wife every evening, and while she was dismissive and hostile to him at first, after several weeks she started looking forward to his visits. After a month and a half, she began saying, "The beautiful moon rises," when she'd see him approaching. Everyone soon realized that Panya was ready and that she'd forgotten all about running away or demanding a divorce. The couple were married with the bride's consent, a dignified and noble outcome befitting the Circassian proverb: "Women are as pure as mercury, as proud as palms, as modest as violets, and as fragrant as roses."

There are many other Circassian proverbs that testify to society's esteem for women, such as:

A good wife will build her husband's house even if he fails to lift a finger.

Homes need women like fields need crops.

Good wives bring good luck.

Don't be rude to any woman you share a roof with.

Circassian women enjoy high social status, as these old proverbs suggest, and respect for women is one of the lessons that all children are taught. Men are taught to stand up or to descend from horseback when a woman walks past, even if she's a stranger. They are taught never to commit a crime or use foul language in a woman's presence. If a fugitive or murderer takes shelter at a woman's house, he cannot be apprehended until he leaves.

In the wake of the killing, destruction, and forced displacement that befell them, they were invited to settle in the Ottoman Empire because the empire's army wanted to recruit Circassian men for its campaigns. They settled in the Balkans, a hotbed of anti-Ottoman revolution at the time. Fourteen years later, when the Ottoman Empire lost its foothold in the Balkans, the Circassians were forced to migrate once more, this time settling in other Ottoman provinces such as Turkey, Syria, Lebanon, and Palestine.

At the end of several displacements (from the Caucasus to the Balkans, then Türkiye, and finally the Middle East), the first Circassians arrived in Palestine in 1878, making their homes in several areas, including Kafr Kama in the Lower Galilee. At the time, the area featured nothing more than some Roman and Byzantine ruins as well as the black basalt that the new arrivals used to build their homes. It took them about a year to plan and build the village, during which time they were the guests of Palestinian families in neighboring villages who helped them adjust to their new environment. The Circassians moved into their new homes about a year after arriving in Palestine.

The Ottoman government had granted the Circassians land, which they divided up equally among themselves, and in no time at all they were growing food and raising livestock, as they had a knack for farming. Some Circassians joined the Ottoman army as part of the mandatory conscription, and later some would serve in the British Mandate forces and the East Jordan Border Corps.

At the time, Kafr Kama was surrounded by a number of Palestinian villages inhabited by Arabic-speaking Muslims, farmers from the western Arab World, Bedouins, and others. The Circassians maintained good relations with their Palestinian neighbors as well as the Jewish migrants who arrived later. Kafr Kama was the largest village in the area, so it soon became a commercial and agricultural center, where people from neighboring villages would come to buy vegetables, fruit, and other agricultural products. That being said, the people of Kafr Kama resisted intermarrying with other communities, and succeeded in preserving their distinctive cultural traditions and Circassian Muslim identity.

In the Nakba year of 1948, the residents of Kafr Kama waited to see who would take power. One evening, they watched as the Palestinians in a neighboring village

fled their homes. "We'll be back in a few days," they said as they departed with their families, carrying whatever they could, some on foot, others riding donkeys, on their way to Maskanah in the north. These refugees would later be displaced to other villages in Palestine or to Syria and Lebanon.

"What are you going to do?", the Circassians were asked, but the people of Kafr Kama didn't know how to answer that question. They were as Palestinian as anyone. It's true that they weren't of Arab origin, but neither were they of Jewish origin. Many of the Circassians in Kafr Kama who saw their Palestinian neighbors fleeing moved to Nazareth and neighboring villages, like Kafr Kama, Reineh, and Jaffa an-Naseriyye. Those with relatives in Jordan and Syria headed to those places, joined by many others fleeing the war.

One of the people who had decided to leave was a wealthy man who'd arrived in Kafr Kama from Syria, earning the nickname Shami. He was a merchant who had opened a shop in the village and built a large and beautiful house that included a flour mill, which served the people of Kafr Kama and neighboring villages. He also owned a big truck, which people said had seen service in the Second World War. A group of nervous, fearful people gathered in the lane outside Shami's beautiful house to ponder together the fateful question: "Who will care for the poor if Shami leaves?"

Shami left with his family and some friends and relatives in his big truck, never to return. His substantial landholdings were confiscated, and his large house was later renovated to become the Circassian Heritage Center, which welcomes hundreds of visitors each year.

One of the stories people remember about that period in the village's history reflects a high level of social solidarity. A wealthy man was preparing to leave the village with his family, so he asked his son to hitch the family's donkeys to a cart, and after he'd done so, the family—made up of the man, his wife, their four daughters, and two sons—got ready to set off with their relative, the cart-driver, alongside. At that point, the man heard a group of women shouting his name. It was the family's neighbors, a widow and her six daughters. They had nowhere to go and no one to help them get there. "What are we going to do? Where are we going to go?", they pleaded.

The man told his own family to get down off the cart, and then told the widow and her children to get on. He took them to stay with a family in the village of Kafr Kama he'd grown close to through his work. The kind family took the widow and her daughters in and took very good care of them. The man returned to Kafr Kama to retrieve his own family, and then they went together to Reineh, a mixed Christian and Muslim village near Kafr Kama, where they stayed with another family they knew.

The village notables held many meetings in those days to discuss the new status quo. They decided that young men should remain behind to protect the village, neighboring fields, and the main road, which connects the Ben Amer and Jordan

Valleys. A small group of men stayed to defend their village, homes, and fields, and it is thanks to them that the village survived the war and still survives today.

There's the sun, peeking above the horizon, painting the sky in gorgeous color, a heart-stopping sight that conveys a gentle warmth. Colorful butterflies flutter from one tree branch to the next, announcing the dawn of a new day, summoning everyone to life.

18

They Tell Me This Is Jerusalem: Grammars of Belonging in Palestine

Julia Elyachar

My grandfather was born in the Old City of Jerusalem. He grew up in the compound of his own grandfather, the Chief Rabbi of Palestine. The family had moved to Palestine following the expulsion of Muslims and Jews from Andalusia/Spain in 1492.

The Palestine my grandfather grew up in was part of larger Arab and Ottoman political worlds. Movement across the Arab world shaped his world and that of his male cousins. He studied for one year at the French University of Beirut, but had to leave in 1914, just a year after he had disembarked from Palestine at the port of Beirut. As an Ottoman citizen, he had become an enemy alien of France when the Ottoman Empire entered the First World War.

He was called up to the Ottoman army, and thanks to his fluency in German, made military liaison with the Austro-Hungarian army. He earned enough to finish his studies in Beirut, return to Palestine, and get engaged in Cairo at his cousin's house on Rue al-Khoronfich, not far from Murski Street and Harat al-Yahud. Cairo was not his home, but it was a familiar part of his world as a Sephardic Jew from Palestine—as were Istanbul, Damascus, and Beirut, where his brothers and cousins went to university.

After the war ended, my grandfather helped build roads, railroads, houses, and enterprises in Palestine, sometimes with friends from other prominent Jerusalemite families. He operated his father's stone-cutting factory in Jerusalem, and defied warnings to fire his local Arab employees and replace them with Jewish settlers from Europe entering Palestine through the Jewish Agency. He took out an ad in the Hebrew press to make his refusal public. He entered other conflicts with the Mandate government, as the engineer in charge of building a road from Jerusalem to Jericho. The conflicts continued, and in 1929 he left Palestine with his young family for the United States.

After my grandfather's death, I found a small, maroon leather suitcase in a corner of the dusty attic of his home. Inside were papers held together with clips and bands telling these and other trivial details of life and commerce in Palestine: plots of land and homes surveyed around Jerusalem, certificates of his training as apprentice to the Greek Orthodox architect Spyro Houris, banknotes of the Imperial Ottoman

Bank, letters from brother to brother across oceans and time, stones ordered, and workers paid.

Other papers show how grammars of belonging changed over his lifetime. An Ottoman exit document of his father's states his "place of birth" as "al-Quds al-Sharif" ("Jerusalem the Noble").

After the First World War, under the British Mandate the government of Palestine had a different exit form, now in English, Arabic, and Hebrew, with a new category, "Nationality," which my great-uncle filled in as "Local." Jewish was not thinkable as nationality.

Another artifact in my grandfather's suitcase was a small, black leather daily journal called "My Jewish Diary." Its claims to Jewishness were marked in English-language golden script engraved on the front. Its edges are worn. It fits in a fist or a pocket, and was likely carried around with him to keep track of his affairs. It was handed to him, I imagine, by a visiting Zionist delegation to Palestine. Inside the diary are lists. Lots of lists, for pages on end, in a hand neat and small. Flip to one page, and you might find half of a page with names in Arabic script, or in English: Ahmed, Abu Rahman, Mohammed. Next to the names is often a sum, money owed, paid, or collected. Sometimes there is a task, or a note about something to do, in Arabic, Hebrew, French, or English.

Decades later, my grandfather was visiting Jerusalem in 1986. I was living there at the time. One evening, I got a call from a second cousin. He had received a call from the proprietor of a café on Jaffa Street, at the corner of the small street where my grandfather had grown up and where his own father had built an extended family compound when they left the Old City at the turn of the twentieth century. "Please go get him," my cousin urged. I rushed down to the café to find my grandfather holding court in a booth around a marble table. Four Mizrahi Israeli men, all taxi drivers, were seated around the table on imitation leather seats. Enthralled, they leaned in, listening to my grandfather speak.

My grandfather was now aged. His memory had shifted. That night, he had left his hotel room and gone strolling on Jaffa Street. Realizing at one point that he was lost, he got into a taxi and said he needed to go home. He had been disoriented, the driver later told me, and asked the driver to take him home, to this corner of Jaffa Road where he had grown up.

The driver was an Israeli Jew from Morocco, with whom my grandfather had intuitively spoken in Arabic. At one point he had started reciting parts of the Qur'an and asked the driver if he too had memorized the Qur'an as part of his education. The driver escorted my grandfather safely into the café close by my grandfather's childhood home. The driver asked my grandfather his name, looked it up in the printed Jerusalem phone book that lay next to a telephone behind their table, found my cousin among others of our clan, and called him up.

After a few minutes, I escorted my grandfather back to the hotel where he was staying, up on a hill of West Jerusalem close to the Muslim cemetery of Mamillah/Ma'amanullah, on which the Israeli "Museum of Tolerance" would soon be built.

I went back to see him the next morning. He was feeling much better after a night's sleep. We did not speak of what had happened that evening before. We went over to the window and stood together for a few minutes, looking out over the hills and to the Jaffa Gate of the Old City. He shook his head and turned to me: "They tell me I am in Jerusalem. But I don't believe them."

About the Editors

Arpan Roy is an anthropologist researching in Palestine and the region. He is the author of *Relative Strangers: Romani Kinship and Palestinian Difference* (University of Toronto Press, 2024), and has taught and held fellowships at universities in Palestine, Europe, and the United States.

Noura Salahaldeen is an anthropologist from Jerusalem, currently based in Europe. Her research focuses on the experiences of the African Community of Jerusalem under settler colonial rule in Palestine, and in the Palestinian diaspora in Jordan.

About the Contributors

Intimaa Alsdudi is a researcher based in Gaza, interested in oral history and photographic record of the Nakba.

Eman Alyan works with cultural and artistic institutions in Palestine.

Saleem Al-Bahloly is an Assistant Professor in the Department of Fine Arts and History at the American University of Beirut.

Hadeel Assali is a writer and anthropologist based in New York City.

Hawa Batwash is a writer from Kafr Kama in the Galilee.

Khaldun Bshara teaches in the Department of Social and Behavioral Sciences at Birzeit University.

Antranik Cassem is a writer, translator, and researcher based in Madrid.

Najwan Darwish is a poet from Jerusalem.

Julia Elyachar teaches Anthropology and Middle Eastern Studies at Princeton University.

Maisan Hamdan is a writer, cook and activist from the village of Isfiya on Mount Carmel.

Sheikha Hussein Helawy is a writer from Palestine.

Aamer Ibraheem is an anthropologist trained at Columbia University.

Tyler Kynn is an Assistant Professor of History at Central Connecticut State University.

Jumana Manna is an artist and filmmaker from Jerusalem living in Berlin.

Amir Odeh is a sociologist from Haifa, researching online privacy among Palestinians in Israel.

Dalal Odeh researches popular culture and folklore in Palestine.

Nina Seferović (1947–1991) was a Yugoslav anthropologist who worked at the Ethnographic Museum and the Museum of African Art in Belgrade.

Radi Shehadeh is a theater director, playwright, actor, novelist, and researcher from the Galilee.

Salim Tamari is a Senior Research Associate at the Institute for Palestine Studies.